ARTWORLD METAPHYSICS

Artworld Metaphysics turns a critical eye upon aspects of the artworld, and articulates some of the problems, principles, and norms implicit in the actual practices of artistic creation, interpretation, evaluation, and commodification. Aesthetic theory is treated as descriptive and explanatory, rather than normative: a theory that relates to artworld realities as a semantic theory relates to the fragments of natural language it seeks to describe. Robert Kraut examines emotional expression, correct interpretation and objectivity in the context of artworld practice, the relevance of jazz to aesthetic theory, and the goals of ontology (artworld and otherwise). He also considers the relation between art and language, the confusions of postmodern relativism, and the relation between artistic/critical practice and aesthetic theory.

Robert Kraut is Professor of Philosophy at The Ohio State University.

Artworld Metaphysics

ROBERT KRAUT

OXFORD
UNIVERSITY PRESS

Great Clarendon Street, Oxford OX2 6DP

Oxford University Press is a department of the University of Oxford.
It furthers the University's objective of excellence in research, scholarship,
and education by publishing worldwide in

Oxford New York

Auckland Cape Town Dar es Salaam Hong Kong Karachi
Kuala Lumpur Madrid Melbourne Mexico City Nairobi
New Delhi Shanghai Taipei Toronto

With offices in

Argentina Austria Brazil Chile Czech Republic France Greece
Guatemala Hungary Italy Japan Poland Portugal Singapore
South Korea Switzerland Thailand Turkey Ukraine Vietnam

Oxford is a registered trade mark of Oxford University Press
in the UK and in certain other countries

Published in the United States
by Oxford University Press Inc., New York

© Robert Kraut 2007

The moral rights of the author have been asserted
Database right Oxford University Press (maker)

First published 2007
First published in paperback 2010

All rights reserved. No part of this publication may be reproduced,
stored in a retrieval system, or transmitted, in any form or by any means,
without the prior permission in writing of Oxford University Press,
or as expressly permitted by law, or under terms agreed with the appropriate
reprographics rights organization. Enquiries concerning reproduction
outside the scope of the above should be sent to the Rights Department,
Oxford University Press, at the address above

You must not circulate this book in any other binding or cover
and you must impose the same condition on any acquirer

British Library Cataloguing in Publication Data
Data available

Library of Congress Cataloging in Publication Data
Data available

Typeset by Laserwords Private Limited, Chennai, India
Printed in Great Britain
on acid-free paper by the
MPG Books Group, Bodmin and King's Lynn

ISBN 978–0–19–922812–6 (Hbk.)
978–0–19–958742–1 (Pbk.)

1 3 5 7 9 10 8 6 4 2

for Robin Ann

Preface and Acknowledgments

The artworld is a complicated place. It contains acts of artistic creation, interpretation, evaluation, preservation, misunderstanding, and condemnation. It contains club-owners violating contracts, sound engineers modifying recorded material, painters struggling for recognition, dancers starving themselves to maintain requisite body mass, poets substituting one phrase for another, and nightclub patrons too stupid and/or musically illiterate to remain attentive during sensitively performed ballads. The artworld contains citizens seeking to preserve cast-iron facades in their neighborhoods, parents attending dramatic performances at their children's schools, museum patrons puzzled about an exhibited "hyperrealist" sculpture, and amplifiers blowing output tubes during concerts. The artworld contains raging controversies about the artistic value of various objects, performances, and achievements.

The goal in what follows is to turn a critical reflective eye upon various aspects of the artworld, and to articulate some of the problems, principles, and norms implicit in the actual practices of artistic creation, interpretation, evaluation, and commodification. Most of the chapters presuppose substantial background in systematic philosophy: the issues and arguments draw heavily upon metaphysics, moral theory, epistemology, philosophy of language and philosophy of mind. Part of the goal is to clarify what actually happens in the artworld (rather than what certain theorists claim to happen in the artworld); thus some of the chapters assume reasonable familiarity with various artforms.

Biographical statements are, for the most part, out of place in analytic philosophy: personal details of a theorist's life are tangential to the soundness of arguments and irrelevant to the plausibility of explanatory theories. But occasionally the author's situation bears upon the content of the project. An author might, for example, seek to provide a holistically adequate semantic theory for a certain fragment of epistemic discourse; and perhaps different sociocultural and/or regional groups uphold different norms and permissible inferences regarding attributions of knowledge. If such variation obtains, the theorist's background is potentially relevant: if only to provide the reader with a better glimpse of what is being counted as data, what inferential norms are qualifying

as worthy of explanation, and perhaps even what is counting as an adequate explanation.

I come to philosophy from the music business. My work as a jazz guitarist spans the better part of four decades, and serves as the impetus for the present inquiry. My views about aesthetic theory result, in part, from experiences touring, recording, performing, and struggling with the internal dynamics of musicians, bands, audiences, club-owners, critics, and other aspects of the music world. I am neither musicologist, neuroscientist, music theorist, music psychologist, nor music historian: the academic side of the music world is unfamiliar to me. My perspective as a working player hardly entails incorrigible grasp of relevant principles and theories—one can easily be mistaken about the theoretical underpinnings of one's own practices. Nevertheless, this book results from the efforts of an engaged practitioner to achieve reflective awareness regarding the very practices that sustain him; the possibility of such awareness is a theme that recurs throughout what follows.

Jazz performance is an essentially interactive endeavor; anything of value I have contributed to the music world owes much to the musicians with whom I have been privileged to play and the audiences with which I have been privileged to share my energies and ideas. Fortunately or unfortunately, I bring the ensemble temperament to the academic side of my life, and my philosophical views emerge from dialogue with others. I am grateful to the many people who have been willing to share their thoughts and help me formulate my own. I thank Wilfrid Sellars, who first helped me understand what it is to think systematically about a philosophical problem, and Jaakko Hintikka, Hector-Neri Castañeda, and David Lewis, who encouraged me to reconcile the demands of systematic theory with the need for rigor and clarity. More recently I have benefited from frequent discussion with Neil Tennant, Stewart Shapiro, and Simon Blackburn. Collaboration with my students Henry Pratt, Cristina Moisa, and Patrick Hoffman has also been helpful. My son Ian Matthew and my daughter Emily Vachon have provided valuable dialogue and counterpoint, as well as a rich supply of unbiased data. I am deeply grateful to many others—both musicians and academics—who, over the years, have helped me think about various aspects of the project: these people are specifically cited in connection with individual chapters.

There is nothing easy or comfortable about simultaneously pursuing the life of a musician and that of an academic philosopher: the norms

sustained within one realm frequently conflict with those of the other. Throughout my efforts to reconcile the demands of these worlds there is one person with whom I have consistently shared the joys and indignities of both, and whose understanding and support have been a constant source of encouragement. My wife Robin Ann is the love of both my lives; it is to her that I dedicate this work, with ongoing appreciation and adoration.

Contents

Preface and Acknowledgments ... vii

1. Introduction: Artworld Data and Aesthetic Theory 1
2. Stepping Out: Playback and Inversion 25
3. Why Does Jazz Matter to Aesthetic Theory? 44
4. Emotions in the Music ... 66
5. Interpretation and the Ontology of Art 98
6. Pluralism and Understanding .. 121
7. Objectivity, Ontology ... 151
8. Postscript: Language, Speaker, Artist 177

Index ... 183

1
Introduction: Artworld Data and Aesthetic Theory

Arthur Danto, noting the "general dismal appraisal of aesthetics" as an academic discipline, observes that

> the "dreariness of aesthetics" was diagnosed as due to the effort of philosophers to find a definition of art, and a number of philosophical critics, much under the influence of Wittgenstein, contended that such a definition was neither possible nor necessary.[1]

Surely not all work in aesthetic theory qualifies as "dreary" or warrants "dismal appraisal": doubtless the field contains creative and insightful contributions. Nevertheless, Danto here recognizes a sentiment occasionally broached by others: a general skepticism about the value and prospects of aesthetic theory. Stuart Hampshire asks "What is the subject-matter of aesthetics?" and replies "Perhaps there is no subject-matter; this would fully explain the poverty and weakness of the books."[2] Nicholas Wolterstorff registers similar concerns:

> It is beyond dispute that the glory of twentieth-century analytic philosophy is not revealed in the field of the philosophy of art. If one is on the lookout for analytic philosophy's greatest attainments, one must look elsewhere. Why is that?[3]

Diagnosis aside, Wolterstorff takes the marginal status of aesthetic theory as a datum to be explained. Here is a related observation by Mary Devereaux:

> [P]hilosophers widely regard aesthetics as a marginal field. Aesthetics is marginal not only in the relatively benign sense that it lies at the edge, or border, of the

[1] Arthur Danto, "Art, Philosophy, and the Philosophy of Art," *Humanities*, 4, no. 1 (Feb. 1983), 1–2.
[2] Stuart Hampshire, "Logic and Appreciation," repr. in W. E. Kennick (ed.), *Art and Philosophy* (New York: St. Martin's Press, 1979), 651.
[3] Nicholas Wolterstorff, "Philosophy of Art After Analysis and Romanticism," *Journal of Aesthetics and Art Criticism*, 46 (1987), 151.

discipline, but also in the additional, more troubling, sense that it is deemed philosophically unimportant. In this respect, aesthetics contrasts with areas like the philosophy of mathematics, a field which, while marginal in the first sense, is widely regarded as philosophically important. A few years ago Arthur Danto quipped, and he wasn't that far off the mark, that the position of aesthetics is "about as low on the scale of philosophical undertakings as bugs are in the chain of being."[4]

Devereaux then asks "What are we to make of this situation?," and proceeds to defend the philosophical importance of aesthetics: her strategy involves rehearsing the philosophical importance of art, the relevance of humanistic inquiry to philosophy, the importance of value theory, and the recognition that "aesthetics is part of value theory."

Complaints about the quality, legitimacy, and/or status of aesthetic theory are not new. Almost a century ago Clive Bell lamented the poor state of art theory and offered an explanation:

He who would elaborate a plausible theory of aesthetics must possess two qualities—artistic sensibility and a turn for clear thinking. . . . unfortunately, robust intellects and delicate sensibilities are not inseparable.[5]

After discussing those "robust intellects" lacking in aesthetic sensibility, Bell turns to those with the reverse deficiency:

[P]eople who respond immediately and surely to works of art . . . are often quite as incapable of talking sense about aesthetics. Their heads are not always very clear. They possess the data on which any system must be based; but, generally, they want the power that draws correct inferences from true data.[6]

Bell is surely right that effective theorizing demands both sensitivity to the data and skill in theory construction: but aesthetics is not unique in occasionally attracting theorists who fall short. If there is legitimacy to the claim that aesthetic theory is "dreary," "marginalized," and/or otherwise flawed, deeper factors might be at work. My goal is to identify and discuss two such factors: a curious tendency to collapse the distinction between artworld practices and theoretical reflections upon them, and an equally curious tendency to ignore relevant data.

[4] Mary Devereaux, "The Philosophical Status of Aesthetics," available online at www.aesthetics-online.org/ideas/devereaux.html
[5] Clive Bell, *Art* (New York: Capricorn Books, 1958; first published 1913), 15.
[6] Ibid. 15–16.

I

Devereaux's classification of aesthetics as "part of value theory" is puzzling: it suggests a misleading picture of what the philosopher of art is up to. Aesthetics is no more part of "value theory" than is epistemology, the semantics of natural language, or the philosophy of mathematics. The task of the philosopher of art is to provide an accurate systematic picture of the artworld, making explicit the norms sustained therein: norms that govern recognition, evaluation, and interpretation of artistic objects and events. Admittedly the artworld contains criticism and evaluation—as do the worlds of knowledge attribution, informal argumentation, and mathematical proof—and studying the latter domains admittedly requires focus on normative assessment (whether epistemic, inductive, or proof-theoretic). But this hardly suggests that these areas are usefully subsumed under "value theory."[7]

The issue goes beyond classification. If some aesthetic theorists see themselves as engaged in the business of art criticism and evaluation—if the philosopher of art is somehow portrayed as an art critic—no wonder there are "marginalization" problems. Whatever else the philosophy of art might be, it is not to be conflated with art criticism—any more than the philosophy of physics is to be conflated with physics, or the philosophy of mathematics is to be conflated with mathematics.[8] Participation in a practice is one thing, analytical reflection upon that practice quite another.

Or so I say. Obviously, engagement in a practice—whether epistemic appraisal, mathematical proof, art criticism, or marriage—involves deployment of a certain amount of theory; a reflective participant will be aware of various aspects of the form of life in which he or she is engaged. Still, there is an important contrast between participating in a practice and reflecting upon the principles, norms, and behavioral uniformities constitutive of that practice. Physics is not the philosophy of physics (however difficult it might occasionally be to draw the line);

[7] Similar opposition to "aesthetics as value theory" is registered in Kendall Walton's "How Marvelous! Toward a Theory of Aesthetic Value," *Journal of Aesthetics and Art Criticism*, 51 (1993), 499–510; my objections on this front were formulated long before I became aware of Walton's paper.

[8] These contrasts are subtle and controversial. For a well-informed and provocative discussion see Stewart Shapiro, "Mathematics and Philosophy of Mathematics," *Philosophia Mathematica* (3) 2 (1994), 148–60.

mathematics is not the philosophy of mathematics; art criticism is not the philosophy of art (however difficult it might occasionally be to draw the line).

Playwright Harold Pinter provides a glorious (and characteristically vicious) description of the contrast between participation and reflective awareness, as Teddy—a professor of philosophy—spells out his special perspective:

> It's nothing to do with the question of intelligence. It's a way of being able to look at the world. It's a question of how far you can operate on things and not in things. I mean it's a question of your capacity to ally the two, to relate the two, to balance the two. To see, to be able to *see*. I'm the one who can see. That's why I can write my critical works. . . . You're just objects. You just . . . move about. I can observe it. I can see what you do. It's the same as I do. But you're lost in it. You won't get me being. . . I won't be lost in it.[9]

Teddy, in other words, not only engages in linguistic activity (e.g.) but engages in "higher-order" systematic reflection upon such activity: this he does via occasional forays into semantic and syntactic theory. Perhaps Teddy wonders whether his use of natural kind predicates carries commitment to Platonic universals, or whether his moral discourse is best construed descriptively (serving to "get at the moral facts") or expressively (serving to "manifest moral sentiments"); perhaps he spends his darker moments wondering whether realism or deflationism provides the better explanation of his 'truth' predicate, or whether proper names in his lexicon are semantically equivalent to definite descriptions; he might even flirt with revisionism, wondering whether to abandon his commitments to bivalence and *reductio ad absurdum*. Whatever his conundrums, Teddy not only operates "in things" (by being a competent speaker) but "on things" (by being a competent semantic theorist, and reflecting upon the norms that constrain him). He "moves about" the space of linguistic norms as others do; but occasionally he goes reflective, thereby preventing him from being "lost in it."

Strong imagery. It prompts deep metaphysical qualms about the very possibility of "exiting" a mode of discourse and surveying it from some "external" perspective. But such imagery—endemic to the entire Tarski–Carnap tradition of languages and metalanguages, and perpetuated in the Quine–Davidson tradition of radical translation and radical interpretation—does not assume the possibility of a View

[9] Harold Pinter, *The Homecoming* (New York: Grove Press, 1965), 61–2.

from Nowhere, or Absolute Standpoint, or God's-Eye Perspective. The imagery only assumes the possibility of circumscribing a region of discourse and theorizing about it from some external vantage point. This more modest possibility is itself laced with controversy, and is critically surveyed in the following chapter.

Granted: art criticism, evaluation, and creation are saturated with theory. Participation in the artworld requires background assumptions about the nature and purpose of art, the relevance of genre categories, the contextual determinants of content, the artistic "problems" a work purports to solve, and so on. One need not dispute the role of theory in practice, the "theory-laden" character of observation and intention, or the impossibility of engaging in institutional activities without substantial theoretical baggage. The point is not that participation in the artworld—as artist, critic, or consumer—is somehow "theory-neutral." It is not. The point, rather, is that participation in the artworld is not to be conflated with theoretical reflection upon participation in the artworld.

But the contrast is frequently ignored. Aaron Ridley, for example, rails against Goodman-inspired individuative questions about whether a musical performance is an instance of a given work, and laments that contemporary philosophers of music generally neglect "evaluative issues":

The question whether this or that performance, or style of performance, is actually any good, or is minimally worth listening to, is scarcely raised... If one is serious about the philosophy of music, this last fact should strike one as scandalous.[10]

I don't think so. It is not scandalous that recent work in the philosophy of mathematics contains not a hint about how to prove Fermat's Last Theorem; nor is it scandalous that philosophers of physics "scarcely raise" questions about which elementary particles are likely to exist, given the experimental data. Ridley has collapsed the philosophy of art into art criticism: unlike Ridley, when I wish to know whether a musical performance is "actually any good," I read music criticism, not the philosophy of music.

Thus there is resonance between the sentiments of Ridley and Devereaux: each of them chooses words that suggest a conflation of

[10] Aaron Ridley, "Against Musical Ontology," *Journal of Philosophy*, 100 (Apr. 2003), 208.

aesthetic theory with the activities of art criticism and evaluation. This kind of conflation—between artistic practice and theoretical reflection upon that practice—is conducive to the marginalization of aesthetic theory, insofar as it prompts the accusation that philosophers of art are doing art criticism rather than philosophy: they should, for example, be reflecting upon critical practice—codifying the norms and uniformities sustained within it—rather than engaging in it. Even if actual involvement in the production and/or evaluation of artworks provides requisite data for theorizing responsibly about these practices, the evaluation of art is not the philosophy of art; if it is permitted to collapse into it, no wonder there is marginalization of aesthetic theory.

II

This conception of aesthetic theory—as descriptive and explanatory of artworld practice—is continuous with much of what happens throughout a range of philosophical subdisciplines; but it encounters skeptical resistance from other quarters. The very idea of reflective awareness is somehow suspect; Terry Eagleton, for example, wonders whether such theorizing is even possible:

[T]heory is in one sense nothing more than the moment when those practices [which have "run into trouble" and "need to rethink themselves"] are forced for the first time to take themselves as the object of their own inquiry. There is thus always something inescapably narcissistic about it. . . . The emergence of theory is the moment when a practice begins to curve back upon itself, so as to scrutinize its own conditions of possibility; and since this is in any fundamental way impossible, as we cannot after all pick ourselves up by our own bootstraps, or examine our life-forms with the clinical detachment of a Venusian, theory is always in some ultimate sense a self-defeating enterprise.[11]

Eagleton's worries about "the possibility of theory" are, it will emerge, alien to the presuppositions of much contemporary analytic philosophy; nevertheless, his criticisms invite helpful clarification.

Note first that Eagleton's description of the reflective theoretical standpoint is peculiar: aesthetic theories of the sort considered here, for example, need hardly be formulated from the standpoint of a "clinically detached Venusian"; the standpoint of a reflective observer will suffice.

[11] Terry Eagleton, *Literary Theory: An Introduction*, 2nd edn. (Minneapolis: University of Minnesota Press, 1996), 190.

Note also the oddity of Eagleton's criticism: one expects the accusation to be that theory is "self-legitimizing" (rather than "self-defeating") insofar as it contains within itself the very apparatus that it purports to study from a distance, and thus—of necessity—treats that apparatus as legitimate. Here the problem resembles that generated by Quinean efforts to "naturalize" epistemology, wherein the norms and principles under consideration are themselves deployed during the investigation.

These oddities aside, Eagleton is on to something: if aesthetic theory were in the business of articulating "conditions of possibility" for artworld practices, and if such articulation were intended to play a *justificatory* role—that is, as serving to *legitimate* those practices—perhaps any such theory would be contaminated with circularity. Thus the question: Are aesthetic theories justificatory, or merely descriptive and explanatory?

Clearly, some work designated as "theoretical" is vulnerable to Eagleton's criticisms. Consider Roger Scruton's indictments of recent popular music as resulting from "a democratic culture, which sacrifices good taste to popularity" and as manifesting general societal decline.[12] Theodore Gracyk summarizes Scruton's position:

> [Recent] popular music represents a repudiation of taste, for it is deficient in the areas of melody, harmony, and rhythm. Scruton calls it "a kind of negation of music, a dehumanizing of the spirit of song." It invites a sympathetic response to a decadent, disordered community.[13]

Scruton's "philosophy of music" is, in part, devoted to critical assessment, praise and condemnation, and reasons for acceptance and rejection of specific artistic performances and/or genres. But Scruton here engages in art criticism, not aesthetic theory. The contrast is vital: as vital as that between substantive moral dispute and meta-ethics, or between ordinary linguistic activity and theoretical reflection upon such.

If aesthetic theory were in the business of legitimizing artworld practices, rather than describing, codifying, and explaining them, Eagleton's skepticism might be warranted in light of work such as Scruton's which is, in part, art criticism.[14] But art criticism is not aesthetic theory. An analogy with natural language is helpful.

[12] Roger Scruton, *The Aesthetics of Music* (New York: Oxford University Press, 1997).
[13] Theodore Gracyk, "Music's Worldly Uses, or How I Learned to Stop Worrying and to Love Led Zeppelin," in A. Neill and A. Ridley (eds.), *Arguing About Art* (London and New York: Routledge, 2002), 136.
[14] Of course there is good and bad criticism: Scruton's critical assessments might be faulted for provinciality and failure to accommodate essential aspects of the genres he condemns.

Consider a linguistic practice that seeks to codify aspects of itself in the form of a dictionary. The dictionary encodes information about the way things are done: the semantic equivalences that enable speakers to engage in fluid dialogue. Perhaps the dictionary is originally prompted by inner turmoil: communication breakdowns and militant struggles about which words are "offensive." The dictionary constitutes a partial theory of the language: far from providing a "neutral" tribunal for resolving disputes, it likely manifests prejudices about what is correct. This does not entail that dictionaries are impossible or self-defeating; it only suggests a need for caution in specifying what a dictionary is (or is not) supposed to do. Perhaps aesthetic theories are rather like dictionaries: though they might occasionally be invoked to *legitimize* certain practices, their primary function is to provide regimented descriptions of those practices and the principles that underlie them. Eagleton sees "theory" as a failed or self-deceived effort toward justification, and objects that

> our forms of life are relative, ungrounded, self-sustaining, made up of mere cultural convention and tradition, without any identifiable origin or grandiose goal; and "theory", at least for the more conservative brands of the creed, is for the most part just a high-sounding way of rationalizing these inherited habits and institutions. We cannot found our activities rationally. . . .[15]

But he is wrong about the purpose of theory: it is not in the business of "rationalizing . . . habits and institutions," any more than dictionaries are in that business. Such theories are, rather, in the business of description, codification, and articulation of artworld practices. There is no presupposition—of the sort criticized by Eagleton—that the theories identify fundamental metaphysical facts that confer legitimacy on those practices. Legitimization is not the task of aesthetic theory; thus such theory is safe from any marginalization that might result from sentiments such as Eagleton's.

But the plot thickens when the postmodern rhetoric gains momentum:

> There is no overarching totality, rationality or fixed centre to human life, no metalanguage which can capture its endless variety, just a plurality of cultures and narratives which cannot be hierarchically ordered or "privileged", and which must consequently respect the inviolable "otherness" of ways of doing things which are not their own.[16]

[15] Eagleton, *Literary Theory*, 201. [16] Ibid.

This is confused. Most mathematicians, linguists, and semantic theorists comfortably invoke metalanguages without—at least knowingly—falling prey to colonialism. It is hard to see how Eagleton could acquiesce in logicians' efforts to specify formal grammars and recursive truth definitions, or even provide truth-tabular semantics for classical propositional languages. Nor—on less technical fronts—could he comfortably participate in a wide range of traditional philosophical discussions.

Consider disputes about the nature of moral normativity. It is common to distinguish "first-order" claims made *within* moral discourse from "higher-order" claims made *about* moral discourse. Admittedly there are puzzle cases: Simon Blackburn and John Mackie disagree, for example, about whether claims to moral objectivity are embedded within moral discourse (thus rendering them first-order) or within a higher-order metaphysical theory purporting to explain the internal trappings of moral discourse.[17] But there are also straightforward cases: non-cognitivism—a familiar artifact of empiricist and/or naturalistic philosophy—portrays moral indicatives as serving to manifest sentiments rather than describe facts, and is obviously a higher-order theory. Non-cognitivism is not a substantive moral claim; it is a theoretical explanation of *what we are doing* when we make substantive moral claims. Whatever the merits of such explanation, it is *not* in the business of "rationalizing" moral disputation or justifying any particular moral assessment; it is a meta-ethical theory, purporting to explain normative discourse and practice from a naturalistic perspective. To think otherwise is to confuse first-order discourse—the phenomenon to be explained—with the higher-order theory that purports to explain it; if Eagleton is thus confused, his indictments provide no compelling basis for skepticism about aesthetic theory.

III

Admittedly the contrast between "first-order" practice—artistic or otherwise—and "higher-order" theoretical reflection upon it is profoundly puzzling, despite its popularity in moral theory, linguistics, and elsewhere. The imagery of stepping outside a discourse and surveying it

[17] J. L. Mackie, "The Subjectivity of Values," in *Ethics: Inventing Right and Wrong* (New York: Penguin, 1977), ch. 1; Simon Blackburn, "Errors and the Phenomenology of Value," in T. Honderich (ed.), *Morality and Objectivity* (London: Routledge & Kegan Paul, 1985), 1–22.

(without distortion) from an external perspective is unclear. It is hard to say "where we stand" in conducting such inquiries, or which resources we can import without circularity, or how to measure success, or even whether we have succeeded in stepping outside the discourse in question.[18] External viewpoints are not always available: certain regions of discourse cannot be encapsulated, climbed out of, and surveyed from the outside (example: any discourse adequate for an explanation of rational norms is itself constrained by rational norms; there exists no sanitized, non-rational haven from which rationality can be adequately surveyed).[19] Call this the *No Exit* phenomenon. In other cases—for example, the analysis of elementary arithmetic in terms of set theory—it is possible to bracket a relatively autonomous and segregable region of discourse and survey it from without.

The alleged contrast between "first-order practice" and "higher-order reflection" is rendered even more puzzling by the fact that participation in any form of life involves a certain amount of theory: a sense of what one is doing, why one ought to do it, and what sorts of conditions are acceptable or intolerable. Thus any attempt to define a "cut" between the practice and the (possibly incorrect) explanatory and/or justificatory "external" reflections upon the practice seems futile. Consider an artworld example: Picasso's *Guernica* is prompted by "theoretical" views about human nature, the limits of sovereignty, and the demands of fairness; these theoretical views are *constitutive* of artistic expression—part of the "first-order" artistic/political practice—not an artifact of some "higher-order" explanatory reflection upon that practice. Such cases suggest that institutional practices are so inextricably laden with reflective theoretical considerations that the touted contrast between practice and theoretical reflection upon that practice is implausible. But other examples pull in opposite directions: many musicians perform brilliantly despite a consummate lack of reflective self-awareness concerning the theoretical underpinnings of their performance; most competent natural-language speakers have little reflective knowledge of semantic or syntactic theory; and so on. The best way to proceed is on a case-by-case basis.

[18] Some reject the very contrast between "first-order" discourse and a "higher-order" standpoint from which it can be reflected upon and theorized about; see Ronald Dworkin, "Objectivity and Truth: You'd Better Believe It," *Philosophy and Public Affairs*, 25, no. 2 (Spring 1996), 87–139.

[19] Thomas Nagel articulated such skepticism in "The Last Word: Two Lectures on Reason," delivered as the Kant Lectures at Stanford University on 13 and 14 Dec. 1995.

Given these reflections on the contrast between a practice and a theory about that practice, either of two strategies suffices to defuse Eagleton's qualms about reflective theorizing: (1) argue that artworld practices can, in fact, be exited and surveyed from an "external" vantage point; thus aesthetic theory does not, after all, involve deployment of the very resources under study. Alternatively, (2) argue that exiting artworld practices is no prerequisite for coherently theorizing about them: after all, one need not exit English in order to theorize about English, and one need not abandon Neurath's ship in order to study its structure.

Additional questions—profound questions—lurk here about philosophical method. Explanations of an institutional practice—the artworld included—are multifaceted. They involve descriptions of the commitments formulable within it, the epistemology and ontology it embodies, the nature of its interfaces with other practices, the stimulatory conditions correlated with reports cast in its vocabulary, and the like. Some such explanations are *conservative*: they allow the practice to go on as before, even when practitioners come to believe the explanations. But other explanations of a practice have the fascinating feature of not being coherently conjoinable with continued participation in that practice: the explanation somehow undermines the very phenomenon it seeks to explain. Such explanations are *non-conservative*. Consider Freudian or Marxist explanations of religious practice: any reflective religious practitioner who comes to endorse such explanations is likely to have considerable misgivings about returning to the practice ("in good faith") and going on as before. Call this the *No Return* phenomenon.

In the context of aesthetic theory, consider Arnold Isenberg's account of the function of reasons in art criticism: such reasons allegedly serve to induce a way of apprehending an artwork, directing the audience's attention to aesthetic qualities that might have been missed.[20] Thus the truth of critical reasons (if such reasons are even truth-evaluable) adds no weight to an evaluative verdict. Isenberg's theory of critical practice is controversial: perhaps it effectively explains art-evaluative realities, but perhaps it does not. Suppose a working critic, having learned of Isenberg's account, responds by saying: "If *that* is what I am doing when I provide critical reasons in art-evaluative discourse, I shall do so no more"; and suppose this response to Isenberg's theory is fairly uniform among critics. Methodological question: does the prevalence

[20] Arnold Isenberg, "Critical Communication," *Philosophical Review*, 58 (1949): 330–44.

of such response disconfirm Isenberg's theory? Not clear: perhaps it is no requirement that a philosophical theory of a practice be such that coming to believe the theory is consistent with continued engagement (relatively unchanged) in the practice. Perhaps an aesthetic theory is rather like a psychological explanation spawned during psychoanalysis: a correct theory of Walter—his self-image included—need not be such that, upon learning the theory, he goes on as before. Perhaps correct philosophical description and explanation of institutional practice need not be conservative.

I do not know. These are profound questions concerning the shape of philosophical explanation; they apply across a wide range of philosophical areas and cast no special cloud over aesthetic theory. Indeed, any philosophical project that involves theorizing about a fragment of discourse from an external explanatory perspective must sooner or later confront questions about the methodological constraints on such explanations. There is no special basis here for skepticism about aesthetic theory, construed as codification and explanation of artworld practice.

IV

The contrast between engagement in the artworld and theoretical reflection upon such engagement is complicated by the fact that many artworks are themselves reflective commentaries upon the norms and mechanics of the artworld: thus the line between artistic practice and aesthetic theory is difficult to draw. Rene Magritte's surrealist paintings focus on the very idea of aboutness, and the contrast between representational mechanisms (both linguistic and perceptual) and the items represented; de Chirico's "metaphysical" art speculates on fundamental realities inaccessible to explicit depiction; Duchamp's work provides ongoing commentary upon commodification and the contrast between art and non-art; Lichtenstein's paintings are comments upon Abstract Expressionism and the methods by which mass media portray their subjects; Mondrian explores tensions generated by painterly resources (e.g. tendencies of colors to advance or recede from the picture plane) and the possibility of equilibrium; Kaufman and Jonze's film *Adaptation* is a curiously self-referential study of filmmaking. And so on. Such art—often designated as "art about art"—involves modernist self-awareness of the sort described by Clement Greenberg as "the use of the characteristic methods of a discipline to criticize the discipline

itself."²¹ Given such works—not only elements *in* the artworld, but also elements *about* the artworld—contrast between artworld practice and theoretical reflection upon such practice is dubious. Moreover, the alleged contrast conflicts with otherwise plausible aesthetic theories. Consider Danto's insistence that "there could not be an artworld without theory, for the artworld is logically dependent upon theory."²² If art does indeed require an "atmosphere of artistic theory," and "artistic theories... make the artworld, and art, possible,"²³ it is hardly clear that our touted "first-order vs. higher-order" or "language vs. metalanguage" or "practice vs. theory" contrasts are applicable—or even intelligible—in connection with the artworld.

We need to show that the existence of "theoretical" artworks does not vitiate the touted contrast between artistic practice and aesthetic theory. An example is helpful: Danto says of Lichtenstein's paintings that

they are... rich in their utilization of artistic theory; they are about theories they also reject, and they internalize theories it is required that anyone who may appreciate them must understand.²⁴

Consider Lichtenstein's *Portrait of Madame Cézanne* (1962): the work provides a startling black-and-white outline diagram that makes explicit Cézanne's compositional methods. In this and related works, "Lichtenstein raised a host of critical issues concerning what is a copy, when can it be a work of art, when is it real and when fake, and what are the differences."²⁵ All of this sounds suspiciously similar to issues raised in aesthetic theory: the content of these Lichtenstein paintings is (according to this interpretation) indiscernible from that of certain philosophical articles dealing with fakes, forgeries, and the nature of art. Lichtenstein's paintings are thus exercises in aesthetic theory: therefore the alleged contrast between artworld practice and aesthetic theory is nonexistent.

Not exactly; here it is useful to again consider the structure and theory of natural language. Consider semantic discourse: discourse explicitly

²¹ Clement Greenberg, "On Modernist Painting," *Arts Yearbook*, no. 1 (1961); repr. in D. Goldblatt and L. Brown (eds.), *Aesthetics: A Reader in Philosophy of the Arts* (Englewood Cliffs, NJ: Prentice Hall, 1997), 17–23.
²² Arthur Danto, *The Transfiguration of the Commonplace* (Cambridge, Mass.: Harvard University Press, 1981), 135.
²³ See e.g. Arthur Danto, *The Philosophical Disenfranchisement of Art* (New York: Columbia University Press, 2005), and *idem, Transfiguration of the Commonplace*, for extended development of the idea that "theory makes art possible."
²⁴ Danto, *Transfiguration of the Commonplace*, 110.
²⁵ Jean Lipman and Richard Marshall, *Art About Art* (New York: E. P. Dutton and the Whitney Museum of American Art, 1978), 102.

about reference, satisfaction, meaning, and truth. The existence of such discourse does not undermine the contrast between linguistic behavior and theoretical reflection upon such behavior. Let some discourse M function as a semantic metalanguage for L: M contains expressive resources adequate to formulate a predicate for truth-in-L; the fact that M sentences are "language about language" does not impugn the distinction between M and the semantic metalanguage in which M itself is interpreted. A holistically adequate semantic theory must accommodate—among other things—languages sufficiently rich to express truths of semantic theory. Likewise, an adequate aesthetic theory must accommodate artworks that express theoretical reflections upon the artworld. The existence of semantic discourse does not entail the collapse of the contrast between linguistic activity and syntactic/semantic theory; the question—given the present desire to contrast aesthetic theory with artworld participation—is whether the existence of art-about-art entails the collapse of the distinction between artworld practice and aesthetic theories about that practice.

It does not. Grant that some pieces of the artworld are about the artworld, and thus—perhaps—content-indiscernible from some statements in aesthetic theory. Nevertheless, Lichtenstein's *Portrait of Madame Cézanne* is a graphic representation—a painting—not a piece of scholarly text. Its proper interpretation requires locating it on the map of comic strips, commercial advertisements, parody, and the recent history of art. There is thus little risk that theorists engaged in discursive practice—writing philosophy articles, for example—would lapse into gestures and achievements similar to Lichtenstein's. This is obvious but relevant: the "collapse" of aesthetic theory into artworld practice—a collapse earlier hypothesized as a partial cause of the marginalization of aesthetic theory—surely does *not* involve confusion between paintings and theories about artworld practices relevant to the emergence, interpretation, evaluation, and appreciation of those paintings. The "collapse problem" rather concerns an ongoing tendency to conflate certain descriptive/explanatory enterprises with other discursive endeavors—for example, evaluation and interpretation—which partially constitute artworld practice. Reflection on the problem was occasioned by a noted tendency of some theorists to bounce—for example—between theories about art-evaluative practice and participation in art-evaluative practice.

Despite the existence of theoretically reflective art, it is *not* the job of aesthetic theorists to determine how best to understand Lichtenstein's work: that is the job of art critics and viewers. Nor is it a task of aesthetic

theory to determine, for example, that proper understanding of Barnett Newman's paintings demands scrupulous attention to number and orientation of stripes in relation to color of background. Here earlier analogies have purchase: it is not the job of philosophers of physics to provide theories of radioactive decay: that is the job of physicists themselves. It is not the job of philosophers of mathematics to prove that all positive even integers ≥ 4 can be expressed as the sum of two primes: that is the job of mathematicians themselves. Despite Danto's foregrounding of the theory-ladenness of art, and despite the existence and significance of art-about-art, there is no resulting collapse of aesthetic theory into artistic practice. Indeed, art historians themselves recognize the required contrast: "We do not go to the theories of the artists to find the answer to aesthetic problems but turn to them as materials for philosophic study."[26] The theories required by Danto's conception of the artworld—theories that "make art possible"—are themselves "materials for philosophic study." Such theories are taught in art history classes; their "philosophic study" is pursued in seminars on aesthetic theory. If aesthetic theorists (*qua* aesthetic theorists) find themselves arguing about the proper interpretation of Newman's paintings or the artistic value of John Cage's compositions, they have lapsed into artworld practice; if this happens frequently, no wonder aesthetic theory faces marginalization: philosophy is not art history, nor is it evaluative criticism. Aesthetic theories are *about* the artworld.

V

An additional puzzle remains, *apropos* of Eagleton's criticisms. Aesthetic theories—here characterized as descriptive and explanatory—are often invoked as grounds for legitimizing or condemning certain artworld practices. Clive Bell and Roger Fry did, after all, wield their formalist theory as a critical bludgeon against mimetic and/or representationalist assessments of Cézanne's work. This suggests that Eagleton is not totally off the mark in condemning aesthetic theory as futile efforts to "rationalize artworld habits and institutions."

But the fact that aesthetic theories are enlisted to do justificatory work is consistent with the conception of such theories as—first and

[26] Charles E. Gauss, *The Aesthetic Theories of French Artists* (Baltimore: Johns Hopkins University Press, 1949), 5–6.

foremost—descriptive and explanatory of artworld practices. Even a dictionary can occasionally be enlisted to justify (or proscribe) an individual speaker's word usage: a description of a collective practice can, given a drive for consensus, be invoked to justify individual activity. The situation is well described by Sabina Lovibond:

> In relation to the community itself, then, as distinct from its constituent members, linguistic rules are not prescriptive but descriptive. They are abstract representations of what is actually done by speakers: representations, in other words, of particular aspects of the use of language. As such, they are *read off from* the various collective practices which constitute linguistic behavior; they do not *govern* those practices *qua* collective.[27]

Substituting 'artworld norms' for 'linguistic rules' and 'artworld behavior' for 'linguistic behavior,' Lovibond's idea is precisely to the point: an aesthetic theory provides "an abstract representation of what is actually done" in the artworld. Thus it is "read off from the various collective practices which constitute [artworld] behavior"; but the aesthetic theory does not "govern those practices *qua* collective." If this is right, then Eagleton's criticism is defused: the fact that Formalism (for example) was enlisted to do justificatory work does not entail that aesthetic theory is "just a high-sounding way of rationalizing . . . habits and institutions" of the artworld. Aesthetic theory is descriptive and explanatory, not normative, despite its occasionally being wielded to beat someone into conformity with a standard.

This detour through postmodern themes was necessitated by the desire to sustain a notion of aesthetic theory that mainstream analytic philosophers should find nonproblematic: a notion that depicts the philosophy of art as relating to the artworld in much the way philosophy of physics relates to physics and semantic theory relates to linguistic behavior. It is true that an aesthetic theory, even if providing a systematic picture of artistic practice, might come to play a normative role, much as a formal theory of natural deduction might come to play a role in facilitating better inferences. But when this happens, the appropriate response is not rejection of aesthetic theory as a misguided and futile attempt to legitimize (from some "external perspective") artistic practices; the appropriate response, rather, is to recall that the theory is primarily in the business of codifying the canons of legitimacy sustained within those practices.

[27] Sabina Lovibond, *Realism and Imagination in Ethics* (Minneapolis: University of Minnesota Press, 1983), 57–8.

VI

Insofar as aesthetic theory is genuine *theory*—whatever exactly that means—it is based upon data. Consider a group of musically gifted children, working to develop their musical skills and monitor the progress of their peers: perhaps they often fault one another for playing things incorrectly, or "getting it wrong." Such critical discourse fosters musical and evaluative abilities—surely a fitting object of study for aesthetic theory.

And consider an "analytic aesthetician" who, upon learning of the situation, assesses the children's critical discourse as somehow illegitimate: laden with incorrect views about musical ontology and/or the possibility of criticism. This theorist's "philosophical" perspective is curiously akin to that of an eliminative materialist: seeking to delegitimize a mode of discourse by showing it to be permeated with false theory.

This is a bad way to proceed: dismissive rejection of a region of discourse is suspicious. The philosophical challenge is to understand the artworld, not criticize it. The children's evaluative behavior constitutes data: data that ought to prompt reflection upon the nature of correctness in performance, the norms implicit in critical/evaluative practice, the paradoxes of musical rule-following, and the like. But the envisaged philosopher apparently sees himself as critic: his goal is to second-guess and criticize the data, rather than accommodate it with theory.

Something has gone methodologically wrong. It is as though a working field linguist has gathered information about speech dispositions and inferential uniformities within a geographic region, and then presented the data to her peers for unification, explanation, and interpretive conjectures, only to be told (dismissively) that the data are inadmissible because her native informants speak incorrectly. That is no way to do linguistic theory: the task is to explain the linguistic data, not criticize it.

Analogously: criticizing actual practices among denizens of the artworld is no way to do the philosophy of art. Yet such infractions are familiar: Tolstoy's expressionist theory of art is a notorious example of a theory that seeks not to accommodate artworld realities but to revise them; his insistence upon sincere emotional expression and promotion of communal solidarity led him to delegitimize substantial portions of

the artworld and to designate much art of his time as non-art.²⁸ The resulting theory is thus flawed by failure to accommodate sufficient data. Such flaws are not uncommon: aesthetic theorists have a disturbing tendency to ride roughshod over the data. Some more recent infractions:

1. Victor Wooten—one of the more influential electric bassists since Jaco Pastorius—offers his students the following advice:

I think that we can all agree on the fact that music is a language. . . . When I get confused while trying to answer a musical question, I immediately think back to the fact that music is a language. . . . The next step is to then turn the music question into an English language question. If I can do that, the answer is usually obvious.²⁹

Pat Martino, a noted jazz guitarist with extraordinary technical skill, conveys a similar message:

I find that certain students have trouble perceiving music only because of the language. If they were shown that music is a language, like any other language, they'd realize it's only couched in different symbols. Then possibly they would understand that they knew things already, inherently.³⁰

Wayne Krantz, a brilliantly innovative guitarist extending traditional harmonic and rhythmic boundaries, offers a reflection upon his stylistic approach:

I call myself a jazz musician still because I improvise, and I associate improvisation with jazz. But the language of jazz, the vocabulary of it, I find myself less and less drawn to . . . I kind of rely on the spirit of what created that language to determine what I play.
. . . There's a certain truth to improvisation, it's a truth of the moment. Right now you say something; and if people are listening to you and other musicians are playing with you, a group of people can commonly agree upon one way of looking at the world just for one moment. And to me the creation of improvisation is what allows that. And that's a little different from playing a vocabulary . . . a vocabulary more suggests something we already agree on.³¹

²⁸ Leo Tolstoy, *What is Art?*, trans. Aylmer Maude (Indianapolis: Hackett Publishing Company, 1960).
²⁹ Victor Lemonte Wooten, *The Official Website*, at www.victorwooten.com Lesson #3: "Music As A Language."
³⁰ Quoted in Julie Coryell and Laura Friedman, *Jazz-Rock Fusion* (Milwaukee: Hal Leonard, 1978), 171.
³¹ This quotation is transcribed from a film by Frank Cassenti recorded for a French TV broadcast and not commercially released; the material is posted on YouTube as "Wayne Krantz, Keith Carlock, Tim Lefebvre—Marciac 1999 pt 1."

The "music-as-language" paradigm is ubiquitous among working jazz players; it is an artifact of participation in the genre. Yet theorist Saam Trivedi offers the following dismissal:

> I am continually puzzled by the insistence of many that seeing art as involving communication involves seeing it as some sort of language, a view which I deny. Taking music, for example, even if music is language-like in involving meaning, understanding, conventions, rules, communication . . . there are significant differences between music and language concerning truth, reference, predication, description, syntax, translatability, and so on, as pointed out by many.[32]

Malcolm Budd provides a similar dismissal: "Now it is in fact clear that music lacks the essential features of language."[33] The problem is that such dismissals ignore key psychological realities of artistic practice: from the "inside" jazz performance feels like dialogue. The image of performance-as-conversation dominates the genre—among both musicians and knowledgeable critics. The linguistic model of performance is so central to regions of the artworld that it is a datum to be explained, not a theory to be criticized. But the "anti-language" theorists fail to address this datum. One could, of course, engage their skepticism directly: argue that proper understanding of truth, reference, translatability, etc. removes prima facie obstacles to construing music as language. This would be an illuminating technical exercise, of interest to those working in semantic theory. But an aesthetic theory that fails to accommodate the linguistic phenomenology of music performance is inadequate, insofar as it ignores relevant artworld data. The accessibility of relevant data to those "outside" a practice involves complex issues explored in Chapter 2.

2. A similar methodological infraction occurs in Tiger Roholt's recent reflections upon musical attention and performance.[34] His concern is with perceptual focus and the abilities of a listener (and/or player) to focus simultaneously on certain musical phenomena. He notes that "There is a kind of listening, tied to performing well, that is not possible in the midst of constant focus-shifting." And Roholt has clear views

[32] Saam Trivedi, "Artist–Audience Communication: Tolstoy Reclaimed," *Journal of Aesthetic Education*, 38, no. 2 (Summer 2004), fn. 12.
[33] Malcolm Budd, *Music and the Emotions* (London: Routledge & Kegan Paul, 1985), 23.
[34] Tiger Roholt, "Listening and Performing," *Philosophy of Art: A Group Weblog* (available at http://artmind.typepad.com/artphil/2005/03/listening_and_p.html), posted 4 Mar. 2005.

about *when* such shift of focus is required: he claims elsewhere that "it is not possible to focus on two ingredients simultaneously. I mean that it is not possible, e.g., to continually focus on a vocal part and a drum part at the same time."[35] A methodological problem looms here, again involving the relation between data and theory.

It is not clear how many working musicians Roholt interviewed prior to formulating his impossibility claim: perhaps he consulted only his own phenomenology. Many players are capable of simultaneously attending to their volume, thematic development, intonation, and the audience response: without explicit awareness of these (and other) factors, proper performance would be impossible.[36] Abilities obviously vary from one musician to another; it is methodologically unwise to state with certainty what sorts of experiences are possible. Roholt's "it is not possible to focus on two ingredients simultaneously" is simply false: big band arrangers can hold in their musical psyches a bewildering array of individual instrumental voices that many musicians, as a matter of psychological fact, cannot; some players can hear reharmonizations that others cannot. In aesthetic theory, as elsewhere, one must be cautious when making claims about what is and is not psychologically possible. Inadequate data make for bad theories; but work in the philosophy of art often ignores this humble platitude. And there's more.

3. A recent book purporting to provide "an introduction to a philosophy of music" focuses exclusively upon the European Classical tradition.[37] Attention is paid to Bach, Berlioz, Brahms, Handel, Haydn, Mozart, Wagner, and related figures; there is discussion of *a capella* vocal music, tragedy, symphonies, opera, sonata form, Renaissance music, oratorio, opera comique, and Gregorian chant; Broadway musicals are mentioned in passing. Oddly enough, there are no references to Pharoah Saunders, Albert Ayler, Frankie Avalon, The Beatles, Sun Ra, Jimi Hendrix, Pantera, Duke Ellington, Tito Puente, Judas Priest, Gwar, and/or any

[35] Tiger Roholt, "The Qualia of Active Musical Experience," presented at the American Society for Aesthetics, Eastern Division Meeting, Philadelphia, Apr. 2005.

[36] One such player is myself. Recent results of such (unexceptional) phenomenological feats can be heard on *Intimately Live at the 501*, The Tony Monaco Trio (Summit Records, 2002); *A New Generation: Paisanos on the New B3*, The Tony Monaco Trio w/The Joey DeFrancesco Trio (Summit Records, 2003); *Fiery Blues*, The Tony Monaco Trio (Summit Records, 2004).

[37] Peter Kivy, *Introduction to a Philosophy of Music* (Oxford: Clarendon Press, 2002).

of countless other performers/works within countless sub-genres of jazz, rock, swing, salsa, country, blue grass, gospel, funk, fusion, metal, R&B, rap, reggae, grunge, hip-hop, punk, and so on. Nevertheless, the resulting "theory" is touted as a "philosophy of music": not merely a philosophy of European Classical music, or even a philosophy of Western tonal music, but a philosophy of music generally.

Something has gone wrong. No "philosophy of music" focused entirely upon such restricted examples and genres can possibly lay claim to theoretical adequacy.

It is true that theories are always projected from a data base that is extremely limited relative to the projected extent of the theory; so much is a commonplace of inductive method.[38] But it is also a commonplace that caution is required, lest the sample provide an inadequate basis for generalization.[39]

Thus we are led to confront a basic challenge: Would an aesthetic theory informed by examples from a wider variety of genres really differ, in significant ways, from one based entirely upon more restricted classical traditions? Perhaps not. After all—to return to the present example—music is music. An ontological theory prompted by Stravinsky's *The Rite of Spring* is surely applicable to John Coltrane's "Giant Steps"; a theory of emotional expressiveness prompted by Debussy's *La Mer* is surely applicable to Devo's "Uncontrollable Urge"; a theory of formalism and syntactic information prompted by Dvorak's *New World Symphony* is surely applicable to Led Zeppelin's "Stairway to Heaven."

Perhaps. But different genres sustain different norms, foreground different parameters, make different demands upon listeners and performers, and manifest different psychological and/or social-institutional forces. James Brown's work, for example, moves along rhythmic axes rather than harmonic or melodic ones; any listener who pays undue attention to Eurocentric classical music will be led to downplay precisely the factors that give Brown's music its brilliance and importance. They

[38] Thanks to David McCarty for pressing this point in correspondence.
[39] Thus Eduard Hanslick:

Probably no worse service has ever been rendered to the arts than when German writers included them all in the collective name of art. Many points they undoubtedly have in common, yet they widely diverge not only in the means they employ, but also in their fundamental principles. (*The Beautiful In Music* (London: Novello and Company, 1885), 16–17)

will listen for melodic and/or harmonic complexity; such a listener will not understand James Brown's music.

This suggests that theories adequate to one sort of music might not be adequate to another; questions prompted by one genre might differ from those prompted by another; lines of inquiry suggested by one artistic tradition might diverge from those suggested by another. Of course, every theorist has limited access to data: it is unreasonable to demand that an aesthetic theorist be knowledgeable about all genres. But if the goal is a general, unified theory, methodological integrity requires as broad a sampling of data as possible.

4. Consider evaluative comparisons in the arts. Such comparisons are usually made within genres: Picasso's Cubist paintings are deemed superior to Léger's, Debussy's harmonic textures subtler than Ravel's, Donne's poetic similes richer than Wordsworth's, Sullivan's later architectural works less coherent than his Wainwright Building, and so on. But artistic comparisons occasionally *cut across* genres: a sonata might be deemed more restful than a specific painting, a literary text might be judged less unified than a given architectural structure. Such cross-genre comparisons are part of the data: they occur within the artworld, and the challenge is to articulate the background principles that render them possible. Any theory of aesthetic evaluation that impugns such comparisons—as resting upon errors about art, evaluation, and/or comparison—is defective: the task is to explain artworld practices, not undermine them. Yet such defective theories occasionally appear on the horizon.[40]

Not all work in aesthetics commits such infractions: Theodore Gracyk's philosophical theories of music by Led Zeppelin, Nirvana, and other rock artists include no efforts to disenfranchise work central to various genres.[41] Danto's theoretical musings are brilliantly *en rapport* with actual artwork practices. Sherri Irvin offers a theory of "artist's sanction" prompted by relatively *outré* developments in the artworld (specifically, objects that dramatically decay over time), and offers no critical verdicts about those developments: she merely tries to understand

[40] See e.g. George Dickie, *Evaluating Art* (Philadelphia: Temple University Press, 1988); Henry Pratt provides other examples of such theories in his "Comparing Artworks" (Ph.D. diss., The Ohio State University, 2005), esp. ch. 4.

[41] Theodore Gracyk, *Rhythm and Noise: An Aesthetics of Rock* (Durham, NC, and London: Duke University Press, 1996); Theodore Gracyk, "Valuing and Evaluating Popular Music," *Journal of Aesthetics and Art Criticism*, 57 (1999), 205–20.

them.⁴² Robert Howell's reflections on the ontology of literature are keyed to the subtle details of actual interpretive practice.⁴³ And so on. Much work—perhaps most work—in aesthetic theory is properly grounded in artistic realities and upholds the contrast between artworld practice and theories of artworld practice; but enough work fails in this regard that there is cause for concern.

VII

If aesthetic theory is somehow "dreary," "marginalized," and/or otherwise flawed, perhaps it is the result of a tendency to ignore relevant data, and to confuse actual artworld practice with theoretical reflection upon such practice. The latter confusion is perhaps inevitable: the artworld is saturated with self-reflective theory, and efforts to uphold a rigid contrast between artworld practice and theoretical reflection upon it might thus appear misguided. But I have argued that however theory-laden a practice might be, there is a vital contrast between the practice and a theory of the causal and normative forces that sustain it: physics is not the philosophy of physics; mathematics is not the philosophy of mathematics; artworld practice is not aesthetic theory.

In his 1964 Messenger Lectures physicist Richard Feynman, having been introduced to his audience as an amateur musician, offered a remarkable observation:

> It is odd, but on the infrequent occasions when I have been called upon in a formal place to play the bongo drums, the introducer never seems to find it necessary to mention that I also do theoretical physics. I believe that is probably because we respect the arts more than the sciences.⁴⁴

I think Feynman is wrong about this: "respect[ing] the arts more than the sciences" would require, at the very least, efforts to codify, understand, and explain the artworld. I have suggested that such efforts are frequently flawed: aesthetic theorists occasionally lose sight of data, and occasionally blur the line between artworld practice and theoretical

⁴² Sherri Irvin, "The Artist's Sanction in Contemporary Art," *Journal of Aesthetics and Art Criticism*, 63 (2005), 315–26.
⁴³ Robert Howell, "Ontology and the Nature of the Literary Work," *Journal of Aesthetics and Art Criticism*, 60 (2002), 67–79.
⁴⁴ Richard Feynman, *The Character of Physical Law* (Cambridge, Mass.: MIT Press, 1965), 13.

reflection upon such practice. Similar methodological infractions surely occur elsewhere in the world of theory construction, but philosophical theories of the arts are curiously prone to them. Genuine "respect [for] the arts" requires making sense of what artists, critics, and art consumers actually do; respect for the artistic data might serve as a partial antidote to the skepticism occasionally directed against aesthetic theory.

But it might not be obvious whether a given philosophical story manifests the requisite respect: whether it accommodates the data or merely signals their presence. It is vital to determine whether certain forms of philosophical explanation—familiar in other areas—are adequate to theorizing about the artworld.[45]

[45] This chapter benefited from correspondence and/or discussion with Laura Bernazzoli, Lisa Shabel, Robert Batterman, Rick Groshong, Henry Pratt, Neil Tennant, Kendall Walton, Allan Silverman, Pedro Amaral, and Robin Vachon-Kraut; special thanks to David McCarty and Patrick Hoffman for extensive comments on earlier versions.

2
Stepping Out: Playback and Inversion

Consider a studio jazz musician, listening to playback of his own recent performance. It isn't a happy experience. Time and again, he is struck with ways his solo might have been better: tensions he might have built here, tonal centers he might have established there, patterns he might have restated for greater coherence, complex arpeggios which, though technically impressive, undermine the groove and contribute little. The solo lacks thematic consistency; it could, and should, have been played differently. The phenomenology of playback is shot through with possibility: musical possibilities that might have been explored but were not. Take Two.

That isn't the way the situation looks—or sounds, or feels—on the other side of the glass, during recording. The performer's goal is to make musically explicit the sounds in his head: he tries—as musicians often put it—to play what he hears. He hears what the coercive forces of the genre, the other players, the audience, and additional contextual factors dictate. He plays what *must* be played: there is a strong sense of taking the music where it demands to be taken. The performance experience is not that of choosing a trajectory through a space of possibilities; the experience is, rather, shot through with necessity.

The situation is not like this for all players, or for any players all of the time; but it is like this for some players some of the time, and that suffices for present purposes. For this situation provides a helpful "root metaphor" in much of what follows. One's activities become a target of attention and theorizing from some outside vantage point: one is not quite an "alien" observer—after all, it is *one's own performance* under scrutiny—but neither is one actively engaged in the performance at the time. Playback is remarkable: what the performer experienced (during performance) as melodic coherence might be discerned, during playback, as absence of melodic coherence. Given such possibilities, a theorist concerned with explaining artistic realities might do well to

focus not on the coherence of the performance, but on the musician's experience of coherence during performance.

I

Such considerations obviously apply beyond the artworld: engaged performance is one thing, theoretical reflection upon it quite another. Philosophically interesting puzzles emerge when one's own *discursive* and/or *conceptual* performances are the target of attention. A mathematician, for example, might reflect upon his or her own mathematical practice. There is something it's like to engage in mathematical reasoning: mathematical truths appear to be necessary, *a priori* knowable, and about abstract objects. Suppose that during playback—during reflection upon one's own mathematical activities—the best explanation of mathematical practice depicts mathematical truths as having none of these notoriously puzzling properties. What then?

Or consider moral practice: when engaged in moral assessment, we feel ourselves to be discovering truths about moral correctness and facts about moral properties. Suppose that during playback—during theoretical reflection upon our own moral perceptions, deliberations, and pronouncements—attributions of moral correctness are best explained in some "irrealist" fashion: as expressions of moral sentiments, or as articulations of commitments to certain reasons for acting. Such non-descriptivist explanations of moral practice might appear inconsistent with the phenomenology of engagement in the practice. What then?

Perhaps the "external" theoretical vantage point—analogous to that of the studio musician listening to playback of his own performance—is deceptive and/or incomplete, somehow losing touch with relevant facts visible from within the practice that one seeks to understand.

But this entire line of inquiry is puzzling. As noted in Chapter 1, the imagery of stepping outside a discourse and surveying it (without distortion) from an external perspective is problematic. It is not clear where we stand in conducting such surveys, or which resources we are permitted to deploy without falling prey to circularity, or even whether we have succeeded in stepping outside the discourse in question.

Still, when the meta-ethicist raises the familiar question "What are we *doing* when we moralize?", the underlying imagery is that of playback: self-aware theorists reflecting upon their own moral deliberations while not engaged in them, seeking a better understanding of themselves as

moralizers. The situation requires distancing oneself from one's own practices—much as our studio musician distanced himself from earlier performance; the clearest structural analogue of this predicament is a semantic theory of some language L cast in a metalanguage distinct from L.

It was noted earlier that external viewpoints of this sort are not always available. There might be discursive frameworks from which there is No Exit: no vantage point "external" to them, because their resources are "fundamental and inescapable" (Thomas Nagel's apt phrase) and permeate any framework in which reflective inquiry can be conducted.[1] Examples: explanations of deductive inference are cast in discourse that deploys the norms of deductive inference; discussions of epistemic virtue and cognitive dysfunction assume a rich background of epistemic norms. Such cases prompt familiar worries about circularity, the coherence of epistemological skepticism, reminders that theorists cannot crawl out of their skins when aspiring to reflective self-awareness, and inquiries into whether the resources under study are, after all, identical to those mobilized in the study. In other cases Exit is non-problematic: elementary number theory can be circumscribed and studied from the vantage point of Zermelo–Fraenkel set theory; Cubist representational conventions can be discussed within a framework unconstrained by such conventions. Still other cases remain controversial: it is not clear that the atheist can evaluate the epistemic credentials of atheism without assuming atheistic standards of rationality, or that classical logic can be surveyed from a standpoint that does not itself assume classical logic.

No Exit is an intriguing phenomenon; but it is not obvious what it shows. Suppose that there is No Exit from the norms of classical logic—that is, that any inquiry into the structure and/or legitimacy of classical logic is itself constrained by classical logic.[2] Does this demonstrate that such norms enjoy special ontological status, and

[1] See Thomas Nagel, *The Last Word* (New York: Oxford University Press, 1997), 101.
[2] Beginning logic students occasionally find proofs of consistency of the propositional calculus to be suspect, insofar as such proofs deploy the very rules of inference the legitimacy of which is at issue. A customary response is to observe that such proofs aim only at relative consistency: "the propositional calculus is claimed to be consistent only to the extent that one accepts some relatively weak mathematical theory (about finite, inductively definable objects, such as sentences and proof-trees) within which the consistency proof can be codified" (Neil Tennant, personal communication). But this strategy for defusing concern about circularity is unsuccessful: the inference rules of the calculus are introduced as representations of our actual inferential practices, not as mere artifacts of some easily encapsulable formal system. Thus the underlying (and legitimate)

somehow limn the structure of reality? Perhaps it demonstrates only that we cannot, given our natures and/or computational capacities, transcend such norms. If some discursive resource appears inescapable, perhaps the ground of such inescapability lies in features of ourselves, rather than in basic ontological features of the world.

Put aside the complexities associated with No Exit. Nevertheless, playback might be a poor model of reflective philosophical inquiry. After all, certain practices—perhaps most—embed their own explanations: the moralist, for example, sees herself as "getting at the moral facts" (whatever this means), and sees her moral claims as descriptive rather than expressive. This suggests that "exiting" moral discourse in order to view it from an external standpoint might not, after all, be required by the meta-ethicist's "What are we doing when we moralize?" inquiry. Perhaps the imagery of a studio musician listening to playback of his own performance is a misleading model of philosophical reflection.

II

In *Wittgenstein on Rules and Private Language* Saul Kripke discusses a strategy he dubs "inversion of the conditional":

Many philosophers can be summed up crudely (no doubt, not really accurately) by slogans in similar form: "We do not condemn certain acts because they are immoral; they are immoral because we condemn them." "We do not accept the law of contradiction because it is a necessary truth; it is a necessary truth because we accept it (by convention)." "Fire and heat are not constantly conjoined because fire causes heat; fire causes heat because they are constantly conjoined" (Hume). "We do not all say $12 + 7 = 19$ and the like because we all grasp the concept of addition; we say we all grasp the concept of addition because we all say $12 + 7 = 19$ and the like" (Wittgenstein).[3]

Kripke is skeptical about such strategies: "Speaking for myself, I am suspicious of philosophical positions of the types illustrated by the

philosophical concern is the one articulated by Thomas Nagel: "Certain forms of thought can't be intelligibly doubted because they force themselves into every attempt to think about anything." (Nagel, *Last Word*, 61). For a helpful discussion of the situation see Neil Tennant, "Rule-Circularity and the Justification of Deduction," *The Philosophical Quarterly*, 55 (Oct. 2005), 625–48.

[3] Saul A. Kripke, *Wittgenstein on Rules and Private Language* (Cambridge, Mass.: Harvard University Press, 1982), n.76.

slogans, whether or not they are so crudely put."⁴ Jerrold Katz is similarly skeptical, regarding such inversions as misguided, and motivated by "naturalism"—a philosophical orientation he rejects. According to Katz,

> The strategy of inverting the conditional is clearly designed to absolve naturalism of the responsibility for giving an account of immorality, necessary truth, etc... Hence, instead of being required to account for the ought of ethics, logic, etc. without going beyond the bounds of empirical psychology, naturalists are required only to give an account of such natural phenomena as conventional agreement, condemning behavior, acceptance, etc.⁵

On Katz's view, giving an "account" of immorality or obligation is one thing, but giving an account of conventional agreement, social patterns of censure, etc. is quite another; giving an "account" of necessary truth is one thing, but giving an account of communal acceptance or other forms of linguistic behavior is quite another. And so on.

The problem, according to Katz, is that there is *more* to normativity than group behavior, *more* to necessity than communal assent, *more* to causation than constant conjunction. Efforts to portray the philosophically puzzling notions in terms of social behavior and/or regularities are thus misguided. Universal condemnation of X does not entail that X is *worthy* of condemnation; universal assent to S (and inability to make sense of those who dissent) does not suffice to render S a *necessary* truth; constant conjunction of fire and heat is no sufficient condition for the former *causing* the latter.

Consider a theory that construes morality in terms of social behavior: crudely, the rightness of an act is *constituted by* its tendency to prompt communal approval. Such a theory is obviously inadequate: communal approval can fail to fit the moral realities. Citizens can praise things for the wrong reasons, or fail to see the immorality of some contemplated act. The key point is that acts of appraisal are themselves subject to appraisal: approval of an action, for example, is itself an action that can be misguided, mistaken, or morally inappropriate. The *correct* reason for morally condemning certain acts is that *those acts are immoral*: the immorality of an act provides the *justificatory ground* for the behavior of condemning the act as immoral.

⁴ Saul A. Kripke, *Wittgenstein on Rules and Private Language* (Cambridge, Mass.: Harvard University Press, 1982), n.76.
⁵ Jerrold Katz, *The Metaphysics of Meaning* (Cambridge, Mass.: MIT Press, 1990), 302.

But—Katz alleges—efforts to analyze normative concepts in terms of social behavior fail to accommodate this normative element; thus "purely descriptive" accounts don't get at the normativity:

[C]ondemnation of an immoral act is not in and of itself sufficient. Condemnation can be morally inappropriate; e.g., when people condemn a thing because everyone is condemning it or because they have been raised to condemn it. Thus, an immoral act must be condemned *for the right reason*. Since the right reason for condemning it is that it is immoral, it must be condemned because it is immoral. But, if so, appropriate condemnation contains the normative element seemingly lost in the inversion.[6]

The basic criticism is that appraisal of social behavior must itself be grounded in something external to that behavior; that external ground, in turn, reintroduces the very property the inversionist sought to explain in terms of social behavior. The inversion strategy thus begs the question; it "makes the mistake of putting the determiner in the place of the determined and the determined in the place of the determiner."[7]

Strong words. But the argument is not compelling. It is true that people might censure an act for bad reasons: peer pressure or childhood brainwashing, rather than sincere belief about what is Good. But inversionism is consistent with the possibility of criticizing such censure. The inversionist need only acknowledge (upon going reflective) that the moral properties he or she cites—against the backdrop of which the appropriateness of other people's behavior is assessed—are in turn subject to inversionist explanation.

By his own admission, Kripke's sloganistic formulations of inversionist strategies harbor inaccuracies: but they are gross inaccuracies. It is no part of Hume's view that fire causes heat because they are constantly conjoined; Hume's view is, rather, that *we are led to attribute causation* because of constant conjunction (rather than the other way around): it is a view about "what we are doing" when we engage causal concepts. The customary order of explanation is thus inverted.

The inversion is easily misunderstood. It is tempting to construe Hume as offering a *reduction* or *meaning analysis* of causal discourse, claiming that attributions of causation are (equivalent to) attributions of constant conjunction: how could they be anything else, if causal claims are selectively sensitive only to the property of constant conjunction?

[6] Jerrold Katz, *The Metaphysics of Meaning* (Cambridge, Mass.: MIT Press, 1990), 302.
[7] Ibid.

Stepping Out: Playback and Inversion 31

But this is not Hume's view. The fact that a given attribution is *prompted* by certain stimulatory inputs does not thereby limit the *content* of that attribution to reports of those inputs. Indeed, this is the key insight underlying "irrealist" explanatory strategies. Simon Blackburn articulates the point well:

> Consider for instance Hume's treatment of causal necessity, perhaps the classic projective theory in philosophy. The central thought is that dignifying a relationship between events as causal is spreading or projecting a reaction which we have to something else we are aware of about the events—Hume thought of this input in terms of the regular succession of similar such events, one upon the other. Exposed to such regularity, our minds (cannot help but) form habits of expectation, which they then project by describing the one event as causing the other.... [Hume] is merely explaining our normal sayings, our normal operations with the concept, in terms of the reactions we have, after exposure to a reality which exhibits no such feature.[8]

On this view, the fact (if it is a fact) that attributions of causation are prompted solely by regular succession does not thereby limit the content of such attributions to mere reports of regular succession: causal attributions go beyond such reports, and serve to dignify certain relations among events as worthy of authorizing inferences within scientific inquiry.

Of course there are problems: the very idea of a reality that prompts talk of causal connections while not actually containing such connections might be incoherent (after all, "prompting" is itself a causal notion). Blackburn acknowledges the difficulties:

> Perhaps we have to use the concept of a causal connection to describe the world at all (ordinary descriptions involve *things* with all their *powers*). In that case there is no way to explain our causal sayings as projections generated by something else, for there will be no stripped . . . vocabulary in which to identify the something else.[9]

Thus the point is not that the Humean irrealist about causal necessity has an easy time of it: the No Exit problem is clearly present, insofar as efforts to theorize about causal discourse are permeated with deployment of that very discourse. The point is rather that the Humean strategy is non-reductive: there is no purported translation of talk about causes into

[8] Simon Blackburn, *Spreading the Word* (Oxford: Oxford University Press, 1984), 210–11.
[9] Ibid. 212.

talk about constant conjunction. Causal claims have a richer meaning, one that goes beyond mere reports of stimulatory conditions.

Kripke's quick formulations suggest misleading sketches of other inversionist strategies: it is no consequence of Quine's treatment of analyticity, for example, that

P is not conventionally endorsed because it is a necessary truth; rather, P is a necessary truth because it is conventionally endorsed.

This is not Quine's view (even "crudely"). Oversimplifying—and ignoring Quine's misgivings about *convention* as an explanatorily bankrupt notion—the idea is that a sentence P *is designated* a necessary truth if S is perceived as endorsed under all stimulatory conditions. It is not the fact *that P is a necessary truth* that is explained in terms of stimulus analyticity, uniform endorsement, and/or centrality within the web of belief; it is rather the fact *that P is treated as a necessary truth* that is thus explained. We might say: Quine offers an account of *what we are doing* when we engage in discourse about analyticity, a behavioristic account cast in terms of patterns of communal assent. The account is "inversionist" insofar as it reverses the customary order of explanation: analyticity plays no role in explaining or justifying linguistic behavior; rather, *attributions of analyticity* are explained in terms of communal linguistic dispositions.

The inversions in question involve an intriguing "stepping out" of a conceptual region: an effort to assess it from some outside vantage point (that of behavioristic psychology, or purely extensional relations, or non-normative facts). Quine theorizes about the resources of intuitive semantics—analyticity included—in terms of stimulatory conditions and behavorial uniformities; Hume theorizes about causation in terms of extensional relations (conjunction, regularity) among event-types; expressivists theorize about moral practice in terms of affective states and the semantic resources (e.g. "projection") involved in their manifestation. The explanatory inversions in question result not from the demands of naturalism as such, but from the more general phenomenon of attempting to assess a discourse from a vantage point external to it. *Any* philosophical attempt to portray all objects, states, and events as reducible to, or supervenient upon, or explicable in terms of, some designated set of properties and principles (whether naturalistic, platonistic, or idealistic) would generate problems akin to those cited by Katz.

Not quite. Inversion is no inevitable result of playback; additional factors are required. To see this, note that reflection upon one's

own moral deliberations—attempting to understand "what constitutes morality"—might result in no inversions: morality might emerge, at the end of the inquiry, as a real phenomenon that explains and/or legitimizes social behavior, rather than a phenomenon to be explained in terms of such behavior. Similarly, the mathematician, curious about her attributions of necessity to the propositions of mathematics, might take necessity to be a real property of some propositions, a property that explains or legitimizes patterns of endorsement and convention. The source of inversionism is not playback as such, or naturalism as such, but playback conjoined with rejection of the explanatory efficacy of the notions under study. Insofar as the goal is to specify "what we are doing" when engaging in discourse and/or thought about some phenomenon, the route to inversion is the premise that the problematic notion itself does not figure in the best explanation of our deployment of that notion.

It would have been closer to the historical mark to sum up inversionist philosophical strategies crudely (no doubt, not really accurately) with slogans of the following form:

"We do not condemn certain acts because they are immoral; we *regard* them as immoral because we condemn them." "We do not accept the law of contradiction because it is a necessary truth; we *treat* it as a necessary truth because we accept it (by convention)." "Fire and heat are not constantly conjoined because fire causes heat; we *regard* fire as causing heat because they are constantly conjoined" (Hume).

Here the explananda have shifted: from an act being immoral to its being *regarded as* immoral; from S being a necessary truth to S being *treated as* a necessary truth; from fire causing heat to fire being *regarded as* causing heat.

Such shifts are critical. It is one thing to explain why S is analytic, quite another to explain why intuitions dictate that S is analytic. It is one thing to explain the immorality of an act, quite another to explain why the act is deemed immoral. It is one thing to explain order and harmony in the world, quite another to explain the fact that the world is perceived (by some) as orderly and harmonious. Insofar as "inversion of the conditional" actually captures venerable philosophical strategies, it involves altering not only the order of explanation *but also the explanandum*. That is a radical shift indeed.

Recall Katz's earlier criticism that inversionist strategies beg the question, making "the mistake of putting the determiner in the place of the determined and the determined in the place of the determiner." On

present construal, such strategies involve a more profound mistake: they change, rather than beg, the question. But perhaps this is no mistake: under certain circumstances, changing the question may be the optimal strategy.

III

We might ask why God created humanity; or we might instead ask why Christians *believe* that God created humanity. We might ask why S is a logical truth; or we might instead ask why S is *designated as* a logical truth. In each such case, the second question of the pair involves critical reflection upon conceptual/discursive practice. Such reflection is remarkably similar to playback.

Playback is the process of distancing oneself from one's own conceptual and/or discursive activities and seeking to "make sense" of them from some "external" standpoint. This process might involve questions about various aspects of these activities: their legitimacy, the purposes they serve, the role they play within the larger physical and institutional world, the distal stimuli that prompt them, the epistemology and metaphysics required to sustain them, and the like. Inversion results when playback is conjoined with an explanatory strategy that does not deploy the actual concept under scrutiny: an explanation of moral discourse, for example, that does not advert to moral properties, or an explanation of discourse about analyticity that does not advert to analytic truth, or an explanation of causal discourse that does not advert to causation.

A particularly vivid example of this process concerns theistic commitment. Reflection upon one's religious practices might suggest, in light of other beliefs and commitments, that theism plays no helpful role in the best explanation of theistic practices; one is thereby led to an inversionist strategy: "We are not inclined to pray because of God's influence upon us; we are, rather, led to believe in God's influence upon us because we are inclined to pray." Perhaps such inversions are in bad faith, or ultimately incoherent: after all, a thoroughgoing theism surely demands theistic explanations of one's own theistic commitments. Perhaps for the committed theist there is No Exit from theistic discourse (thereby suggesting the futility of efforts to separate Church and State).

To vindicate Kripke/Katz skepticism about inversionist strategies, it suffices to show that playback is not a suitable mechanism for achieving

understanding, or that playback is not an accurate model of reflective philosophical inquiry, or that considerations of explanatory priority are irrelevant to the sort of understanding aspired to by philosophical reflection. We consider these possibilities in turn.

Perhaps efforts to theorize about a practice from some external vantage point are misconceived: in exiting a discourse we thereby lose touch with the very content of the claims we seek to illuminate. There is *something it's like* to moralize, to think mathematically, to worship, to play music: a way the world presents itself to practitioners; certain facts are accessible and readily apparent from that vantage point. But externalist explanations allegedly fail to capture such facts; such explanations are thus incomplete, failing to do justice to the objective realities of the inner scene.

This suggests that playback is no accurate model of reflective philosophical inquiry. Perhaps the relation between the studio musician and his recorded performance is not, after all, relevantly similar to the relation between the meta-ethicist and her moral deliberations, or that between the philosopher of mathematics and her engaged mathematical computations.

So the question is whether there is a vital connection between a discourse and the facts expressible within it, a connection that renders it impossible to exit a discursive framework without losing sight of the relevant facts, thereby subverting efforts to understand what is going on. Perhaps reflections upon psychology from some "outside" vantage point (for example, that of neurochemistry) are ill conceived, hampered by inability to discern the very states of affairs (involving beliefs and desires) that must be invoked to make sense of how and why psychology works as it does. Thomas Nagel addresses precisely this point:

> The perspective from inside the region of discourse or thought to be reduced shows us something that is not captured by the reducing discourse. Behavioristic reductions and their descendants do not work in the philosophy of mind because the phenomenological and intentional features that are evident from inside the mind are never adequately accounted for from the purely external perspective that the reducing theories limit themselves to, under the mistaken impression that an external perspective alone is compatible with a scientific worldview.... the "external" account of the mind must somehow incorporate what is evident from inside it.[10]

[10] Nagel, *Last Word*, 73.

Perhaps only bats are qualified to speculate about bat psychology, only women qualified to do feminist theory, only theists qualified to write about the philosophy of religion, and only musicians qualified to speculate about music aesthetics. Non-participants in a practice have no business theorizing about that practice: they cannot discern the relevant data. There might be something to this, but as formulated it is obviously implausible. In many cases non-participation is no obstacle to respectable theorizing: a field linguist eliciting judgments of grammaticality from her native informants, for example.[11] In other cases participation is a matter of degree: the contrast between participants and non-participants is correspondingly vague. And the very notion of *participation* is riddled with individuative complexities: a non-theist, failing to participate in prayer and forms of religious ritual, might engage in relevantly similar practices on other fronts; a male not subject to gender discrimination might be victim of sufficiently similar modes of marginalization to sensitize him to feminist concerns;[12] a non-artist might be afforded access to portions of the view from within the artworld by her own creative efforts as a physicist. And so on. Depending upon the specificity involved in characterizing a form of life, different agents will qualify as participants.

The good thing about Nagel's observation is its countenancing facts and features "evident from inside" a discursive framework. But Nagel provides little clue as to what it would be to "capture" or "adequately account for" or "incorporate" such facts and features; moreover, he appears to confuse explanation with reduction. Reduction of a discourse demands that each projectible predicate within it be correlated with a nomologically coextensional predicate in the reducing discourse. Such correlations are unlikely,[13] but externalist explanations do not purport to provide them: externalist explanations are not reductions. Emotivism provides no translational paraphrases or "meaning analyses" of normative discourse; Hume offers no definition of 'A causes B' in terms of regularities or purely extensional notions; "naturalistic" accounts of religious belief make no effort to provide meaning-preserving

[11] Thanks to Berit Brogaard for suggesting this example.
[12] I am informed—by a reliable source—that at the annual Australasian Association of Philosophy conferences in the late 1980s male philosophers were not permitted to raise questions from the floor in response to papers by feminist philosophers; apparently the males acquiesced in this arrangement.
[13] See, e.g., Jerry Fodor, "Special Sciences (or: The Disunity of Science as a Working Hypothesis)," *Synthese*, 28 (1974), 97–115.

paraphrases of theistic into non-theistic discourse. It is vital to see that externalist explanations are not in the business of "conceptual analysis," reduction, translation, or definitional equivalence; they are in the business of explanation.

Moreover, it is one thing to *share* a perspective but quite another to *accommodate* it (insofar as *accommodating* a perspective is a matter of *explaining* it). If, for example, the philosopher of mathematics can explain *why* mathematical claims appear (to those in the throes of mathematical reasoning) to be necessary, or *a priori* knowable, or about abstract entities, that is accommodation enough. If the expressivist can explain *why* participants in moral deliberation reject expressivism as an inadequate portrayal of their own moralizing, that is accommodation enough. If the secular humanist can explain *why* practicing Christians reject secular humanism as an inadequate portrayal of their own religious practices and experiences, that is accommodation enough. If our improvising studio musician can explain why he felt a need to execute a whole-tone arpeggio—although playback perspective discloses it to be inappropriate—that is accommodation enough. It suffices to explain why the phenomenology of engaged participation is the way it is.

It is worth noting that this theme lies at the foundation of a chronic misinterpretation within twentieth-century philosophy. Quine's critics—especially those of Sellarsian persuasion—frequently complain that normativity is somehow forsaken, minimized, or downright eliminated within Quine's philosophical worldview. Quine is often portrayed—in contrast to Sellars—as having lost touch with normative dimensions of language use. Here is Jay Rosenberg's recent statement of the complaint:

For Quine's philosophical vision is, as it were, purely descriptive. His is a world of 'is's without 'ought's, and of regularities without rules. It is, one might say, a *de facto* world. And that makes it, in one clear sense, a world without *us* in it. For, as Sellars also rightly insisted, "it is no merely incidental feature of man that he has a conception of himself as man-in-the-world", and

> anything which can properly be called conceptual thinking can occur only within a framework of conceptual thinking within which it can be criticized, supported, refuted, in short, evaluated. To be able to think is to be able to measure one's thoughts by standards of correctness, of relevance, of evidence.[14]

[14] Wilfrid Sellars, "Philosophy and the Scientific Image of Man," in his *Science, Perception and Reality* (Atascadero, Calif.: Ridgeview Publishing Co., 1963, repr. 1991), 6.

Hence, although, as I also observed early on, Quine's philosophical message characteristically has the form: "We can do without...", the discussion has now arrived at the point at which this impetus to austerity necessarily finds its limit. For *we* cannot do without normativity. Without normativity, there is no *we*.[15]

As a matter of interpretation, this is incorrect. Perhaps we cannot do without normativity, but Quine does not invite us to do so. Quine's theories of linguistic behavior are saturated with references to "the critic, society's agent," the dynamics of "train[ing] the individual to say the socially proper thing," and "outward conformity to an outward standard."[16] There can be no critics, social propriety, or outward standards unless there is normativity: that is what it *is* for there to be normativity. So Quine's world is not without *ought's*. But Quine's stimulus–response view prompts some readers—especially devout Sellarsians such as Rosenberg—to read Quine as having turned away from real normativity and substituted a behavioristic *ersatz*.

This is an interesting interpretive error, one that merits explanation. Quine provides an externalist perspective on normativity; he makes no effort to say what it feels like to be constrained by norms. But his critics somehow confuse his strategy with reduction and/or meaning analysis. Perhaps their idea is that Quine seeks to do for normativity what analytical behaviorists (such as Ryle) sought to do for experiential states and propositional attitudes: translate claims about them into claims about behavioral dispositions and regularities. But Quine proposes no such translation or reduction: the author of "Two Dogmas of Empiricism" would propose no such thing, because such a thing is—according to Quine—impossible. Quine looks at normativity in playback mode; that is fully consistent with its reality.

As with language, so with art: adequate aesthetic theories must accommodate artworld norms; but interpretive skirmishes (such as the above) concerning Quine's treatment (or neglect) of linguistic normativity foreground difficulties in recognizing such accommodation. The methodological point is that aesthetic theories that parallel Quine's "externalist" treatment of linguistic behavior do not necessarily ignore, or advocate the elimination of, artworld normativity.

[15] Jay Rosenberg, "Sellars and Quine: Compare and Contrast," forthcoming in a collection of Rosenberg's essays on the work of Wilfrid Sellars, to be published by Oxford University Press.

[16] See W. V. Quine, *Word and Object* (Cambridge, Mass.: MIT Press, 1960), esp. ch. 1.

Stepping Out: Playback and Inversion 39

The more general issue concerns possible connections between discourse and the facts expressible within it: connections that might render externalist explanations impossible. Perhaps, as Ian Hacking's reading of Foucault suggests, "objects constitute themselves in discourse," in which case it is folly to exit a discourse while presuming to keep an eye on the very objects and properties that serve as truthmakers for sentences formulable within it.[17] Perhaps ontology is so intimately related to ideology—the store of predicates available in a language—that inquiries into the legitimacy and function of a discourse cannot be carried on without deploying the tools of the discourse itself.[18]

These are fascinating complexities, all of which highlight the need for caution in theorizing about a framework from an external vantage point. But it was acknowledged at the outset that our studio musician experiences things differently during performance than during playback, without thereby depriving playback of explanatory and/or epistemological validity. The goal of playback is not to speculate about causes or explanations: the musician wants to hear what he played and how it sounds—if only to determine whether the last few hours of recorded material should be distributed to the public. Granted, he might be led to formulate causal hypotheses: that instruments were improperly miked, or that excess alcohol undermined his rhythmic sense, or that fatigue led to repetition of hackneyed riffs. But such explanatory conjectures are ancillary.

The goal of philosophical reflection, more often than not, is to locate a region of thought or talk on a larger map: to discern its connections with other regions. Such connections might be reductive, explanatory, justificatory, and/or constituted by patterns of similarity and difference. Inversionist philosophical explanations of the sort challenged by Kripke and Katz implement the sense that certain regions of discourse—which, for whatever reason, have become targets of reflective awareness—are best explained in terms that lie outside of that discourse. Any given instance of such explanation might be wrongheaded: perhaps causal discourse is not best explained in terms of regularities, or moral discourse in terms of expressed sentiments, or rule-following discourse in terms of feelings of confidence, or discourse about analyticity in terms of

[17] Ian Hacking, "Michel Foucault's Immature Science," *Noûs*, 13 (1979), 51.
[18] Further discussion of the dependence of ontology upon ideology can be found in W. V. Quine, "Grades of Discriminability," *Journal of Philosophy*, 73 (1976), 113–16; idem, "Identity, Ostension, and Hypostasis," *Journal of Philosophy*, 47 (1950), 621–32; see also my "Indiscernibility and Ontology," *Synthese*, 44 (1980), 113–35.

stimulus and response, or discourse about necessity in terms of linguistic convention, or theistic discourse in terms of Freudian wish-fulfillment, or discourse about aesthetic taste in terms of social and class-hierarchical pressures. But there is nothing intrinsically inadequate about inversionist explanatory strategies.

IV

And so it goes in the artworld. A bewildered viewer of Duchamp's *Fountain* or Andy Warhol's *Brillo Boxes* might surmise that the objects are displayed not because they are art, but that they qualify as art because they are displayed. Such sentiment finds natural expression in George Dickie's "institutional" theory: crudely, we do not confer artworld status on artifacts because they are art; they are art because we confer artworld status on them.[19] The root idea is that *art* is a *cultural* rather than *natural* kind: thus we do not explain the artworld practice of designating an object as art by citing the fact that the object is art; rather, the object's being art is explained by citing such practice. Here we have an inversion in the customary order of explanation.

The claim is not that artworld social-institutional practices are mysterious and inexplicable, or that no real features of Warhol's *Brillo Boxes* enter into explanations of why those objects are treated as art, or that members of the artworld (whomever that might include) are completely irrational and lack any reasons to confer upon an object the status of *candidate for appreciation as a work of art*. Not at all. The claim is more modest: the property *being art* is constituted by artworld practices, and thus plays no role in explaining them. We do not treat Duchamp's *Fountain* as art because it is art, and we are selectively sensitive to such facts; rather, it is art insofar as we treat it as art. The explanatory (and justificatory) work is done, in turn, by sociocultural, economic, political, and historical properties.

Such a theory raises profound questions about the relation between ontology and social practice: for it depicts social behavior as constitutive of certain properties rather than explicable and/or evaluable in terms of them. In light of our ongoing concern with the shape of adequate

[19] See George Dickie, *Art and the Aesthetic* (Ithaca, NY: Cornell University Press, 1974); idem, *Art and Value: Themes in the Philosophy of Art* (Oxford: Blackwell Publishers Ltd., 2001); idem, *The Art Circle: A Theory of Art* (New York: Haven Press, 1984).

theorizing about artworld practice, one question is especially urgent: whether the theory falls prey to the skepticisms articulated by Katz and Nagel (and voiced in passing by Kripke) against inversionist strategies generally.

It does not. Recall Katz's criticism: social behavior is itself subject to assessment, and such assessment must be grounded in something external to it; inversionist strategies make the mistake of "putting the determiner in the place of the determined and the determined in the place of the determiner." Although Katz does not have artworld phenomena in his sights, his anti-inversionist sentiment applied to artworld realities might take this form:

Great artists are frequently ignored; inept artists are frequently celebrated as geniuses. Fraudulence, scandal, and unjustified reward or neglect are facts of life within the artworld. Artworld denizens can be mistaken about what is, and what is not, art: massive error is possible. But Dickie's institutional theory cannot accommodate such facts, and should thus be rejected.

The argument is obviously flawed. Nothing about inversionism prevents the verdict that the artworld was massively duped—for example—in coming to see John Cage as an artist whereas in fact he was not. Indeed one might—fully in keeping with institutional theories such as Dickie's—acknowledge Cage's status as artist and then proceed (if so inclined) to reject his work as lacking artistic merit. One aspect of artworld practice is *critical dialogue*; another is *negative evaluation*; yet another is *attributions of fraudulence*. All of this is consistent with the idea that art is constituted, rather than discovered, through institutional practice. There is room to criticize the criticism of others.

Here a subtle theme emerges—broached earlier in connection with Danto's version of institutionalism—concerning the ontological grounds of normativity. Danto's theory, like Dickie's, does not purport to locate some feature that serves to legitimize an object's being singled out for recognition as an artwork. Rather, a disputed object is an artwork if and only if it is treated as such; the requisite mode of treatment involves conceptualizing and/or privileging the object in special ways (to be specified by the theory). "Social practice" theories of art do not identify some property invariant across artworks (for example, emotional expressiveness, significant form, or mimetic representation), a property tracked by selectively sensitive denizens of "artworld publics." Rather, to be art is to occupy a certain position relative to the artworld public.

But institutional theories of this kind do not render artworld decisions immune to critical evaluation. It is legitimate to demand reasons and justifications for an object's occupying the position it does relative to the artworld public. Consider controversial cases: recognizing tenor saxophonist Albert Ayler's music as a "candidate for appreciation" might be grounded in interpretive benefits (perhaps some aspect of Don Cherry's music is thereby illuminated); recognition of Robert Rauschenberg's *Monogram* as art might be justified by its facilitating better understanding of the relationship between Kitsch and High Art, or better grasp of the evolution of Abstract Expressionism. And so on. The justificatory story told in any given case will be subtle and complicated—especially when a work violates entrenched norms; but there is always a story. The substantive claim in Dickie's institutional theory is that the property expressed by the predicate 'x is art' plays no role in such a story.

The other concern about inversionist explanation—viz. that it fails to accommodate certain facts visible from within a given discursive framework—is more difficult to assess. Granted: there is something it is like to interact with artworks and artworld institutions. There is a special experiential rapport between viewers of Rothko's work and the works themselves; there is something it is like to engage in collaborative musical improvisation; there is a way it feels to be drawn into Stravinsky's harmonic complexities. Often it is difficult, if not impossible, for denizens of the artworld to convey to others a sense of the depth and profundity of their artistic experiences. Just as neurochemists have no business telling us what it is like to be a bat, so social-institutional theorists like Dickie have no business telling us what it is like to connect with artworks. This suggests that institutional theories distort the data: a jazz lover's experience of her favorite performance does not contain, as a phenomenological constituent, the fact that the performance was singled out by the artworld as a candidate for appreciation.

Such criticisms are confused. It is no part of Dickie's theory—or of any related theory that denies explanatory and/or justificatory power to the concept *art*—that personal relationships with art are explicitly mediated by social-institutional concepts, or that such concepts are part of the "content" of artistic experiences. Here the philosophical analogies are striking: it is no contention of a suitably implemented emotivism that moral endorsements *feel like* expressions of emotion; it is no premise of Freudian explanations of theistic practice that religious experience presents itself to theists as grounded in feelings of helplessness toward

nature and the desire for security. Such theories offer *explanation*, not conceptual and/or phenomenological *analysis*. Similarly, it is no goal of theories such as Dickie's to capture the phenomenological and/or conceptual content of artworld experiences. The claim is more modest: insofar as such experiences are susceptible to explanation, the concept *art* plays no essential role.

Working artists thrown into reflective theoretical contexts (for example, art students reluctantly enrolled in required aesthetics courses) often resist the very activity of theorizing, lest "unanalyzable" and "intuitive" aspects of artworld experience be violated. This is a mistake. It is true that artworld experiences are subtle and complex, and that a wide range of special experiences are accessible to those engaged in artistic production and appreciation; but this no more blocks the possibility of aesthetic theory than do the subtlety and complexity of interpersonal relations block the possibility of psychological theory. Even inversionist explanation is a legitimate theoretical strategy, despite prevalent rhetoric about the view from within and the external inaccessibility of relevant facts. Insofar as playback perspective is possible, no general skepticism about inversionist explanation is warranted. This conclusion broadens the range of adequate theories, aesthetic and otherwise: there is more than one way to respect the data.[20]

[20] Thanks to Neil Tennant, Adam Podlaskowski, Berit Brogaard, Henry Pratt, Declan Smithies, and Cristina Moisa for helpful comments on earlier versions of this chapter.

3

Why Does Jazz Matter to Aesthetic Theory?

> The aesthetician, if I understand his business aright, is not concerned with dateless realities lodged in some metaphysical heaven, but with the facts of his own place and his own time.
>
> Robin George Collingwood

Jazz is a form of art: thus jazz performances are the sorts of events that aesthetic theory is in the business of trying to understand. Insofar as aesthetic theory is genuine *theory*—whatever exactly that means—it is based upon data. Jazz performances are part of the data, and thus part of the tribunal by which aesthetic theories must be tested and evaluated. Any aesthetic theory that makes good sense of Shakespeare's sonnets, Bach's fugues, and Picasso's Cubist paintings, but somehow neglects and/or disenfranchises the music of John Coltrane or Jimmy Smith, is incomplete and/or defective.

But even here, in setting out our problem, methodological choices must be made: an aesthetic theory that ignores the work of Kenny G., or relegates "Smooth Jazz" performances to the scrap heap of elevator music or acoustic wallpaper, might not thereby qualify as inadequate: indeed, such verdicts might serve as positive confirmation of the aesthetic theory, depending upon prior evaluations of Kenny G. or "Smooth Jazz." So we need to know more about what an aesthetic theory is supposed to do—what sorts of questions it is intended to answer, what sorts of explanations and/or justifications it is supposed to provide; we also need to know more about what sort of music counts as jazz. Armed with tentative answers to these questions, we can ponder the role, if any, that jazz might play in motivating and/or evaluating an aesthetic theory.

Why Does Jazz Matter to Aesthetic Theory? 45

I

Start with the second question—the nature of jazz. One can search for an "essence" of jazz: features necessary and sufficient for a musical event to qualify as jazz. There are likely places to look: certain harmonic structures—e.g. VI–II–V^7–I chord progressions—are more characteristic of jazz than of Country Western or Speed Metal; certain scales and rhythmic patterns are more characteristic of jazz than of other musical forms. But most of these features can be found outside jazz, and some jazz lacks these features.

Ted Gioia, in attempting to isolate features distinctive of the genre, stresses the spontaneous, improvisatory aspect of jazz: the way players, against the backdrop of specified rhythms and chord changes, invent as they go along, driven by the other players, the audience, and perhaps a host of other factors.[1] Admittedly, much jazz is about improvisation: but note that heavy improvisation occurs in much rock and R&B (Maceo Parker is no less an improviser than Wayne Shorter); and surely there is much impromptu invention in other musical forms. I agree with Gioia that improvisation is a salient part of what jazz is about. Later I will foreground a different feature.

General metaphysical qualms about essentialism aside, it is inadvisable to seek essences and definitions in the artworld—partly because of the way genres overlap and stray from central paradigms. Keith Jarrett's performances often move in strongly neoclassical directions; Lonnie Plaxico's recent work resonates with the work of James Brown, Sly Stone, Steve Coleman, and other funk/R&B/Hip-Hop sources.[2] Hammond Organ jazz—the music of Jimmy Smith and Jack McDuff, for example—is deeply rooted in Gospel and Soul. It is difficult to specify what qualifies as "pure jazz"; nor is such specification necessary. Like other artforms and genres, jazz offers various central paradigms about which there is little if any controversy (but even Miles, in later stages, was occasionally said to have abandoned jazz;[3] and Coltrane, when

[1] Ted Gioia, *The Imperfect Art: Reflections on Jazz and Modern Culture* (New York: Oxford University Press, 1988).
[2] Hear, e.g., Lonnie Plaxico, *Melange* (CD: Blue Note Records, catalog #32355, 2001); *idem, Live at the 5:01 Jazz Bar* (CD: Plax Music, 2002).
[3] Hear, e.g., Miles Davis, "Time After Time," on his *Time After Time* (CD: Sony, catalog #5113982, 2003).

playing with Rashid Ali and Pharoah Saunders, was sometimes said to have evolved out of jazz and into some other form[4]). Clearly, various standards of similarity and difference are deployed when determining whether a musical event lies "sufficiently close" to paradigm cases to qualify as jazz. Often there is room for dispute; such disputes about style and genre categorizations are familiar (and perhaps essential) throughout the artworld.

The other question—what an aesthetic theory is, what it's supposed to do, how we know when we have a plausible one, etc.—is far more complicated, and takes us through fairly intricate philosophical territory. Unfortunately, much work in aesthetic theory suffers from failure to be explicit on precisely these points: it sometimes happens that different aesthetic theories, far from being "competitors," aren't really in the same line of work at all, insofar as they seek to answer different sorts of questions. One theorist might attempt to illuminate some aspect of actual artistic practice—e.g. she or he might seek an explanation of the way the artworld actually selects those objects and events which it valorizes as "art." Another theorist might be in a more revisionary line of work: seeking to redraw boundaries between art and non-art, or exclude certain works from the museums or concert halls, or prompt audiences to reassess controversial work. Some aesthetic theories (aim to) describe; others (aim to) *pre*scribe. Of course a theory might do both; moreover, the line between description and prescription isn't always clear. Nonetheless, theoretical bookkeeping would be easier if we had a sense of what a given aesthetic theory is trying to do, and thus how it can be held accountable.

II

A certain amount of aesthetic theory has, unfortunately, been focused upon the question "What is art?". This leads to countless disputes about whether art has an essence, whether *art* is an "open concept" resistant to analysis in terms of necessary and sufficient conditions, whether the definability of 'art' would somehow undermine the creativity and innovation sustained within the artworld, etc.

Suppose aesthetic theory is in the business of providing a definition of the word 'art', or an analysis of the concept *art*, or an explanation

[4] Hear, e.g., John Coltrane, *Meditations* (CD: Impulse!, catalog #199, recorded 1966).

of uses of the word 'art' in the community. This leads to immediate methodological questions: Whose use of the word 'art' are we theorizing about? Who is included in "the community"? Whose intuitions about what does and does not count as art are supposed to matter? It is unlikely that there is uniform use of the expression throughout the population: those with elitist tendencies might exclude top-40 rock and Seattle Grunge from the class of artworks, whereas others take such performances as paradigm cases. Who matters, and why? Are there "experts" in the use of the expression 'art'—perhaps analogous to those experts invoked by Putnam in providing semantical theories of natural kind terms?[5] Are there speakers whose uses of the expression constitute privileged data points? If so, who gets to be an expert, and how? Does a person's having a degree from the Berklee School of Music, or having performed with Brother Jack McDuff, make a difference? Does Chick Corea's having greater knowledge of music theory than Grant Green make a difference? Does the fact that someone is a working player, whereas another is merely an informed, musically sensitive listener—perhaps with a few years of piano lessons to his or her credit—make a difference? Why?

I don't know how to answer such questions in any principled way; I would prefer an approach to aesthetic theory that makes no requirement that we answer them.

Perhaps an aesthetic theory is not—or should not be—in the business of providing definitions of terms or analyses of concepts. The task is metaphysical, not semantic or definitional: just as the metallurgist wishes to understand the nature of gold, and the physicist wishes to understand the nature of gravitational attraction, so the aesthetician wishes to understand the nature of art. Admittedly these questions in the "material mode"—i.e. questions not about words but about things—are but a short distance away from questions about the analysis of words and concepts. Indeed, some philosophers (e.g. Carnap) argue that the metaphysical questions are themselves a misleading notational variant of "formal mode" questions about the way language works or the sorts of "linguistic frameworks" we ought to adopt.[6] Nevertheless, our world contains not only asteroids, universities, people in love,

[5] See, e.g., Hilary Putnam, "The Meaning of 'Meaning'," in his *Mind, Language and Reality: Philosophical Papers*, Volume 2 (Cambridge: Cambridge University Press, 1979).

[6] Rudolf Carnap, "Empiricism, Semantics, and Ontology," repr. in Rudolf Carnap, *Meaning and Necessity* (Chicago: University of Chicago Press, 1967).

economic crises, and urban sprawl, but artworks and an artworld devoted to sustaining and discussing them: the aesthetic theorist's task is—perhaps—to better understand what makes an artwork an artwork.

Clive Bell—an English art critic and theorist, a member of the Bloomsbury Group writing in the early twentieth century—tries to answer this question in terms of an elaborate account of "significant form." He wants to pin down that "one quality without which a work of art cannot exist."[7] Beginning from the "starting-point" that there is some "peculiar emotion provoked by works of art," Bell seeks an explanation of that special emotion in terms of structural features internal to the work itself: some combination of lines, colors, tones, etc., which "stir our aesthetic emotions." Bell dubs this special structural property "significant form."

It's a remarkable theory, one that purports to have explanatory power. Bell uses it to explain the failures of Futurist pieces as works of art, the success of primitive art, the glories of Cézanne, and a host of other phenomena.

It is common for theorists to take aim at Bell's theory, and it seems an easy target: it assumes the existence of a special aesthetic experience, distinct from other experiences; it denies the relevance of cultural context, representational content, and a vast array of emotions frequently prompted by artworks; it assumes that "significant form" can be defined in ways that beg no questions; it assumes (and tries to explain the fact) that great art is universal and eternal.

Despite the unpopularity of Bell's theory, and despite its implausibility when applied to various genres of painting, architecture, and literature, music notoriously lends itself to his sort of formalist analysis. There is *something* plausible about Bell's remarkable claim that

> to appreciate a work of art we need bring with us nothing from life, no knowledge of its ideas and affairs, no familiarity with its emotions. Art transports us from the world of man's activity to a world of aesthetic exaltation. For a moment we are shut off from human interests, our anticipations and memories are arrested; we are lifted above the stream of life.[8]

Bell's phenomenological description of musical experience is not totally off the mark. But his systematic denunciation of contextual information

[7] Clive Bell, *Art* (New York: Capricorn Books, 1958), 17. [8] Ibid. 27.

is overstated: it is doubtful that a musical event can be understood in isolation from factors involving medium, genre, and history (even if such factors remain unconscious during listening and/or performing). A listener's capacity to understand and appreciate Wes Montgomery's solos, for example, requires familiarity with Western tonal music, the work of other jazz guitarists, the limits and possibilities of the instrument, and various other parameters which provide a "framing" for proper experience of that important musician's work. As a matter of psychological fact, it is doubtful that correct perception of tonal centers, metric tension, pitch intervals, and thematic development is totally isolated from elements encountered within and outside the artworld, as Bell conjectured.[9] Nevertheless—on Bell's behalf—it is likely that perception of the internal coherence and structural complexity of Wes's solo on "Lover Man"[10] requires no knowledge of the fact that Wes grew up in Indianapolis, or that the pianist and bassist on this track are his brothers. So we need an inventory of the contextual features which are relevant to musical understanding, and an explanation of that relevance. Nevertheless, in the context of jazz performance and appreciation, Bell's "isolationist" intuition is not without merit.

[9] Here lurks a familiar controversy. One view is that music can be appreciated "for itself" without any contextual information: music somehow wears its aesthetic significance on its surface. Thus aesthetically relevant features are somehow "given" in the auditory experience of a musical performance, independent of collateral information about genre, performer psychology, etc. A clear statement of this sentiment is provided by Bill E. Lawson in "Jazz and the African-American Experience: The Expressiveness of African-American Music," in Dale Jamieson (ed.), *Language, Mind and Art: Essays in Appreciation and Analysis, in Honor of Paul Ziff* (Dordrecht: Kluwer Academic Publishers, 1994), 131–42. The opposing sentiment, of course, is that proper experience of music requires substantial familiarity with the relevant genre (and perhaps other factors), which in turn demands substantial background information and experience. A comprehending jazz listener must, for example, hear melodic choices against the backdrop of the harmonic structure (she or he must be able to "hear the chord changes"). A comprehending jazz listener must, for example, discern thematic understatement, which in turn requires familiarity with the tendency of other players in the genre to fill up space with gratuitous arpeggios. And so on. Hearing a musical performance is thus analogous to hearing a linguistic utterance: without appropriate knowledge of the genre, or of the language, relevant aesthetic features are not discerned. For further discussion and defense of this theme see my "Perceiving the Music Correctly," in Michael Krausz (ed.), *The Interpretation of Music* (Oxford: Clarendon Press, 1993), 103–16.
[10] Wes Montgomery, *The Montgomery Brothers* (LP: Fantasy 3308, 1960); re-released on Wes Montgomery, *Groove Brothers* (CD: Milestone MCD-47076-2, 1998).

Maybe. Examples culled from other regions of the jazz world pull in different directions: jazz is, after all, a deeply "expressive" form, and this suggests that formalism does not tell the entire story. Consider Billie Holiday's vocal performances, which pack extraordinary power, and arguably draw upon the dreadful misfortunes and emotional traumas that saturated her life. Her style of phrasing and intonation is grounded in loneliness, fear of isolation, and disappointment. Any listener unfamiliar with these darker aspects of the human condition cannot hear much of what makes Holiday's work so profoundly significant.

The formalist has a ready reply here: it is undeniable that Holiday would sing differently if she had different life experiences; but it is premature to rush toward "expressionism" about musical significance. To see this, consider a simple analogue: Rahsaan Roland Kirk enters the recording studio shortly after a particularly violent argument with his wife Edith. Despite his focus upon the music, he is haunted throughout the session with a cloud of anger and annoyance. Listeners familiar with Kirk's work discern unusual aggressiveness and an uncharacteristically staccato attack in his phrasing; any psychologist seeking explanations of performance behavior might trace the stylistic variance to Kirk's recent marital squabble and his resulting emotional states. But this does *not* entail that Kirk's recorded solos are somehow "about marital annoyance," or that his playing "expresses" these emotions in any aesthetically relevant way. A comprehending listener need not hear marital strife in Kirk's playing in order to understand the music: the strife and annoyance are part of the cause, not part of the content.

It is true that Billie Holiday's life experiences are relevant—from a causal/explanatory perspective—to her vocal style. One can freely acknowledge this without rushing to the conclusion that proper aesthetic appreciation of her vocals requires hearing the music as expressing loneliness and despair. After all, *any* human performance has causal-historical antecedents, some of which are emotional states. The fact that Holiday's vocal performances are prompted by pain and personal struggle is no assurance that such factors constitute part of the aesthetically relevant content of her work.

This line of argument against an "expressionist" treatment of jazz assumes a distinction between cause and content, and is unlikely to convince theorists already convinced that art is, above all, a medium for the expression and/or transfer of emotion. Such expressionism will be addressed in the following chapter. But the argument serves

to shift the onus back to the expressionists: they must show that a musician's emotional life is not merely a causal/explanatory antecedent of a performance, but an aesthetically relevant constituent of the performance as well.

The point of this digression is that Clive Bell's insistence upon the "irrelevance" of "life's emotions" to the appreciation of art is not patently absurd, despite the usual aphorisms about jazz and human emotion. The fact that jazz musicians have rich emotional lives which figure in the causal etiology of their music does not signal inadequacies in Bell's formalism. But there remains the more compelling challenge, broached above: appreciation of formal, structural features of an artwork often requires familiarity with facts about social-historical context, the medium, and other works in the genre. These are factors Bell deems irrelevant to the proper experience of art. The best strategy for meeting this challenge requires separating Bell's *isolationism*—a view about the irrelevance of *context* to the aesthetic experience—from his *formalism*—a view about the irrelevance of representational and emotional elements. Jazz points toward a formalist aesthetic—at least, if the formalism accommodates the relevance of contextual framing. But in this regard, jazz differs little from various other musical and non-musical artforms. Thus we have yet to identify a respect in which jazz matters to aesthetic theory.

III

I said at the outset that different aesthetic theories appear to be in different lines of work. A notable example of a theory that contrasts with Bell's in this regard is the theory of "the artworld" provided in Arthur Danto's earlier writing.[11] Danto sought a philosophical theory that would explain the appearance of Warhol's facsimiles of Brillo boxes, Rauschenberg's beds, and Jasper Johns's targets, in the artworld. These items are not only real objects: they have somehow been transfigured into denizens of the artworld. Danto's theory attempts to explain this transfiguration. But the theory does not identify some feature intrinsic to the object itself (e.g. significant form or emotional expressiveness), which is reliably detected by vigilant art experts, a feature the presence

[11] See Arthur Danto, "The Artworld," *Journal of Philosophy*, 61, no. 19 (1964), 571–84.

of which warrants the object's being treated as art. Danto's idea is, rather, that to be an artwork is neither more nor less than to be treated a certain way within a specified institutional framework ("The Artworld"), and this in turn involves the object's being discussed in certain terms (specifically, using "the 'is' of artistic identification"). Thus the key idea is that an object is art if and only if it is treated as art, which in turn requires that the object be conceptualized in certain ways. It's a complicated story, one that highlights the social-institutional aspects of art.

But note that Danto's theory does not address the question that Bell's theory seeks to answer: for Bell purports to identify some *feature* (whether monadic or relational) of an object in light of which the artworld might be *justified* in treating it as art. There is such a thing as an object's *really being art*—if it possesses the requisite art-making feature; a perceptive artworld will say of what's art that it's art, and say of what's not art that it's not art. Danto's theory pulls in a different direction, bypassing those features of an object that might merit its being treated as art, and instead focusing on the community treatment of the object as itself constitutive of art. The theory gives pride of place to social-institutional context: *being art* consists of *being acknowledged as art*, which in turn depends upon the experiences and behavior of individual observers.[12] How, if at all, does jazz bear upon the sort of aesthetic theory that Danto provides? The connection is tenuous at best. Danto does not consider examples culled from the world of music; but it is doubtful that treating sounds as music consists in conceptualizing them with the 'is' of artistic identification. The only relevance of jazz to the sort of institutional theory advocated by Danto is this: occasionally

[12] Deeper analysis reveals that Bell's theory harbors similar observer dependence. On one reading, his notion of *significant form*—that property in terms of which 'art' is defined—is constituted by the responses of sensitive observers. For an object or event to have significant form *just is* for it to be disposed to induce the "aesthetic emotion" among sensitive perceivers. Thus construed, "significant form" has the status of a Lockean "secondary property": a property constituted by dispositions to induce certain responses among observers. If this is right, then Bell's definition of 'art' in terms of *significant form* rests essentially upon the perceptual/emotional reactions among those within some relevant population. Such an interpretation would enable him to avoid the charge of circularity: for the interdependence of *significant form* and *the aesthetic emotion* would emerge as yet another instance of conceptual holism. The key point here is that the contrast between Bell's theory—which highlights properties possessed by certain objects and events—and Danto's theory—which highlights social-institutional reactions within certain populations to certain objects and events—might not be such an extreme metaphysical contrast after all.

there is controversy about whether a certain tonal event qualifies as music. The work of Albert Ayler, for example, struck many jazz players as meaningless, inept gibberish, of the sort that inspired one critic to observe that "the *avant-garde* is the last refuge of the untalented."[13] Eric Dolphy's playing struck traditional, hard-bop saxophonist Sonny Stitt as incompetent rubbish. But nothing in Danto's theory will help us understand the legitimacy of Ornette Coleman's work, or the reasons for which people reacted to it as they did. Of course, Coleman's early work—like any innovative and controversial work—might provide a case study for better understanding the mechanisms by which art and artists find their way to legitimacy. Despite the non-standard details of the situation (Coleman playing a white plastic alto saxophone, exploiting modal rather than chordal approaches to improvisation, etc.), Coleman's early work mobilizes traditional forms and rhythms: Charlie Haden and Billy Higgins provide recognizable, solid foundation for Coleman's and Cherry's improvisational experimentation.[14] This might explain why Coleman was drawn into the pantheon of jazz (despite rancorous controversy), in a way that Albert Ayler was not.[15] Similar considerations apply to the impact of guitarist James Blood Ulmer, whose frame of reference remains more stable and familiar than that of Sonny Sharrock. The point here is that these *avant-garde* jazz players, analogous to their visual-arts counterparts such as Warhol, Rauschenberg, Rothko, and others, might provide insight into the actual processes by which the jazz world does, or does not, countenance a player as worth taking seriously. And this would surely be helpful if our goal is to craft an aesthetic theory: there is a line between fraudulence and competence, and focusing upon controversial jazz players might provide valuable insight into the mechanisms by which the artworld draws that line. But it is doubtful that examples culled from jazz are more helpful in this regard than examples culled from other regions of the artworld.[16]

[13] I am unable to locate the source of this quotation; Christopher Bakriges informs me that the remark was made by composer George Russell in an article entitled "Where Do We Go From Here?," in Don Cerulli, Burt Korall, and Mort L. Nasatir (eds.), *The Jazz Word* (New York: Da Capo, 1960), 238–9.
[14] Ornette Coleman, *The Shape of Jazz to Come* (LP: Atlantic SD 1317, 1959).
[15] Hear, e.g., Albert Ayler, *Spiritual Unity* (LP: ESP Disk No. 1002; recorded 1964).
[16] I attribute this "institutional" theory to Danto solely on the basis of his 1964 essay "The Artworld." But both Robert Stecker and Richard Eldridge have impressed upon me (in private communications) that Danto later moves away from such a theory, and at

IV

Another way that jazz might matter to aesthetic theory is this: perhaps jazz contrasts sufficiently with other artforms—even other musical forms—that traditional theories fail to accommodate it. If this were the case—if jazz were markedly unlike any other artform—then focusing upon jazz might prompt the rejection of an otherwise plausible aesthetic theory; conversely, focusing upon otherwise plausible aesthetic theories might prompt the rejection of jazz as somehow undeserving of artistic attention. Perhaps jazz is only a second-class citizen of the artworld.

Ted Gioia wrestles with precisely this predicament in *The Imperfect Art: Reflections on Jazz and Modern Culture*. After noting "how peculiar jazz is in comparison with other arts," Gioia says:

> [W]e may despair of justifying it as a true art form rather than as an elaborate craft. Improvisation is doomed, it seems, to offer a pale imitation of the perfection attained by composed music. Errors will creep in, not only in form but also in execution; . . . Can our imperfect art still stand proudly alongside its more graceful brothers—such as painting, poetry, the novel—in the realm of aesthetic beauty?[17]

Gioia's response is to advocate that we look

> not at the art in isolation but in relation to the artist who created it; [and to ask] whether that work is expressive of the artist, whether it reflects his own unique and incommensurable perspective on his art, . . . whether it makes a statement without which the world would be in some small way, a lesser place.[18]

Gioia's idea is that "we are interested in the finished product (the improvisation) not as an autonomous object but as the creation of a specific person." He takes this to go against the grain of various "deconstructive" theories which somehow treat the artwork as an autonomous object, isolated from the individual or cultural situation

points even disclaims having ever endorsed it. See, e.g., Arthur Danto, *The Transfiguration of the Commonplace* (Cambridge, Mass.: Harvard University Press, 1981), and esp. *idem*, "Responses and Replies," in Mark Rollins (ed.), *Danto and His Critics* (Cambridge, Mass., and Oxford: Basil Blackwell, 1993), 193–216. For present purposes, it suffices that some time-slice of Danto is plausibly described here.

[17] Gioia, *Imperfect Art*, 66. [18] Ibid.

that produced it. The upshot is that jazz does indeed matter to aesthetic theory, insofar as it fosters an "aesthetics of imperfection"—which accepts and glorifies the "imperfections" found in improvised music, and this spills over into the way we look at other portions of the artworld.

Well, I don't know. I wouldn't want to argue about whether John Coltrane's solo on "Giant Steps" contains more "imperfections" than Stravinsky's harmonizations in *The Rite of Spring*, and thus whether it demands a different sort of aesthetic theory. I don't know what notion of "perfection" is at work here, and how to make such comparative judgments; moreover, I find Gioia's contrast problematic. It strikes me that Chick Corea's solo on "Captain Señor Mouse"[19] is as "perfect" as anything in T. S. Eliot's *The Wasteland* or Mussorgsky's *A Night on Bald Mountain*. The trick, I suppose, is to assess "perfection"—or, less rhetorically, artistic quality—by the relevant standards. Then the profound question in aesthetic theory becomes: What are the relevant standards of criticism for a given work, and what makes them relevant? This is a deep issue, concerning the relation between categories of art and the norms sustained therein; I doubt that jazz can make any special contribution here.

In his chapter "What Has Jazz to Do with Aesthetics?," Gioia turns to another aspect of jazz in relation to other artforms: crudely speaking, it is the improvisational *process*, rather than the resulting *product*, that seems to matter. His idea is this: for the vast majority of artworks, it is the finished object that we value as the artwork; Picasso's *Guernica*—a physical object that occupies public space—is what matters, not the process that led to its creation. Gioia claims that jazz contrasts with most other artforms, in that the improvisational process is somehow more important than the resulting product.

The distinction between process and product is interesting; Gioia suggests that traditional aesthetic theory has focused upon the product—the painting, the sculpture, the musical composition, the architectural structure—and somehow de-emphasized the process of creation that goes into producing it. But this seems historically inaccurate. One need only note that expression theories—which foreground the role of art as a medium for the communication of feeling and emotion—have

[19] On "Return To Forever," *Hymn of The Seventh Galaxy* (CD: Polydor 825 336-2, recorded 1973).

a venerable past. As Leo Tolstoy puts it, "it is upon this capacity of man to receive another man's expression of feeling and experience those feelings himself, that the activity of art is based." Tolstoy's aesthetic theory—grounded in the idea that art is subservient to sociopolitical ends—stresses the role of art as a means of achieving solidarity with others, "joining them together in the same feelings, and indispensable for the life and progress toward well-being of individuals and of humanity."[20] Thus Tolstoy's version of expressionist theory, whatever its merits, draws attention away from the artistic *object* and toward the *process* of infecting others with the feelings one has lived through: the object is merely an intermediary in the artistic process. More recently—and more plausibly—Denis Dutton has argued that artworks must be understood as representative of particular performances: no artwork is separable from the human activity that produced it, and "our understanding of works of art involves grasping what sort of achievement the work represents."[21] Such a view enables Dutton to contrast the aesthetic properties of forgeries and originals: despite their presenting the viewer with indiscernible sensuous surfaces, the forgery and the original constitute quite distinct human achievements. Aesthetic theory is concerned with objects and events *qua* resulting from specific performances, rather than in isolation from the acts that produced them. Thus aesthetic theory—unaugmented with special categories—provides sufficient conceptual space for accommodating improvisational music: it is simply another instance of artistic performance. Jazz requires no special treatment here.

Gioia invokes the analogy of action painting, noting that just as Jackson Pollock's work celebrates the very activity of painting, so an improvised solo celebrates the very act of innovation and expression. I appreciate Gioia's analogy; but one needn't look to Abstract Expressionism to make the point: it is everywhere in art, insofar as artistic objects must be understood as achievements resulting from specific artistic activities. *Pace* Gioia, improvisational music does not fall substantially outside the paradigms accommodated by traditional aesthetic theories. Thus, as artforms go, no special categories (e.g. the category of "action painting") are required to accommodate the realities of jazz.

[20] Leo Tolstoy, *What is Art?*, trans. Aylmer Maude (Indianapolis: Hackett Publishing Company, 1960).
[21] See, e.g., Denis Dutton, "Artistic Crimes," in Denis Dutton (ed.), *The Forger's Art: Forgery and the Philosophy of Art* (Berkeley: University of California Press, 1983), 183.

Why Does Jazz Matter to Aesthetic Theory? 57

Thus the problem persists: How, if at all, does jazz matter to aesthetic theory?

V

Pat Martino ranks among the outstanding jazz guitarists of the last few decades: a gifted player with a keen grasp of mainstream jazz. Martino's work with Jack McDuff, Jimmy McGriff, and Don Patterson is well known to jazz organ aficionados. His trenchant observation—cited earlier—about music education and language is sufficiently dramatic to merit repetition:

I find that certain students have trouble perceiving music only because of the language. If they were shown that music is a language, like any other language, they'd realize it's only couched in different symbols. Then possibly they would understand that they knew things already, inherently.[22]

Martino's view that "music is a language, like any other language" is widespread among jazz musicians. Here, for example, is a musician's description of guitarist Jim Hall:

"His concept of time is a model to emulate," says drummer Joey Baron. *"Jim plays but a few notes, leaving space for conversations with me."* According to Jim, *"listening is still the key."*[23]

Such "conversational" imagery dominates the genre: from the "inside," jazz performance feels like dialogue. A particularly vivid description is provided by drummer Max Roach:

After you initiate the solo, one phrase determines what the next is going to be. From the first note that you hear, you are responding to what you've just played: you just said this on your instrument, and now that's a constant. What follows from that? . . . It's like language: you're talking, you're speaking, you're responding to yourself.[24]

And the imagery is hardly confined to performers: jazz writers, noting the constant interplay and feedback sustaining the collaborative improvisational process, inevitably lapse into a "linguistic" perspective;

[22] Quoted in Julie Coryell and Laura Friedman, *Jazz-Rock Fusion* (Milwaukee: Hal Leonard, 1978), 171.
[23] Cited in *Europe Jazz Network Musicians: Jim Hall* (E_J_N_-JIM HALL.mht).
[24] Quoted in Paul Berliner, *Thinking in Jazz* (Chicago: University of Chicago Press, 1994), 192.

thus Martin Williams: "Ornette's musical language is the product of a mature man who must speak through his horn. Every note seems to be born out of a need to communicate."[25]

Note that no *arguments* are involved here: Martino's claims—and related remarks throughout the jazz world—are based upon immediate acquaintance with a range of performance and composition experiences.[26]

But from the perspective of theorists with background in logic, linguistics, and the philosophy of language, Martino's claim is puzzling. Not all collaborative activities are languages (soccer, e.g., is not a language, despite the tremendous collaborative effort and interplay among the participants). Linguistic behavior requires propositional content. Languages require a well-defined, countable lexicon, plus a set of syntactic rules for generating well-formed sequences, plus a set of semantic rules for interpreting well-formed sequences, plus a set of pragmatic rules for interpreting indexical constructions. And so on. Linguists and logicians frequently depict languages as set-theoretic entities, susceptible to codification and study with the resources of linguistic theory. Much of this bodes ill for thinking of music in linguistic terms: neither musical compositions nor musical performances are set-theoretic entities; nor is it clear that anything approximating lexicon, syntactic rules, semantic rules, etc. can be specified for musical genres.

Thus there is basis for skepticism about Martino's theoretically innocent claim that "music is a language"; and it gets worse. Donald Davidson suggests that a social practice qualifies as *linguistic* only if it is susceptible to a Tarski-style theory of truth that yields empirically confirmable biconditionals (the so-called *T-sentences*) which pair sentences of the language with their truth conditions; and this leads

[25] Liner notes for Ornette Coleman, *The Shape of Jazz To Come* (see n. 14).

[26] "Knowledge by acquaintance" and reports of "the phenomenologically given" must be treated with epistemological care; observation reports are notoriously theory-laden. A theist who claims "direct experiential knowledge" of God's existence must be reminded that no amount of introspection verifies that God, rather than some other phenomenon, stands at the originating causal node of the experiential event; similarly, a musician must be reminded that music might not be a language, appearances notwithstanding. Nevertheless, an adequate aesthetic theory must explain such appearances; it should, moreover, explain the connection between the way music is experienced by performers such as Martino and the way it is experienced by listeners with a variety of other backgrounds (thanks to Geoffrey Hellman for raising the latter issue in this form).

to *translatability* as a criterion for languagehood.[27] But surely artistic objects and performances do not admit of English translations; thus the prospects for assimilating musical performance to linguistic activity are bleak. So much the worse for the "music-as-language" paradigm.

Note the methodological tension here.

On the one hand, Pat Martino—a jazz musician with impeccable credentials—asserts that music is a language (presumably, different musical genres are different languages). Martino understands the genre from an "internal" perspective: he is thus (presumably) optimally situated to specify the nature of his artform. Any adequate aesthetic theory must do justice to Martino's description of the situation.

On the other hand, participation is no infallible route to truth: responsible theorists might reject Martino's characterization, despite his credentials. Experts do not always generate true theories about their own practices: skilled mathematicians occasionally provide incorrect (or incoherent) theories of mathematics; skilled moralists frequently provide inadequate theories about the nature of morality; gifted artists frequently provide unintelligible descriptions and incoherent explanations of their own artistic endeavors. A gifted musician is not an epistemically incorrigible theorist; Martino might simply be wrong. Perhaps music is not a language, after all.

This is an instance of a more general philosophical tension. On the one hand, an expert participant, having turned reflective, claims a practice to have certain features: such claims are made not on the basis of argument, theory, or inference to the best explanation, but on the basis of immediate experience ("Here is what it's like to engage in this practice"). Surely such testimony must be taken seriously, as data to be accommodated. On the other hand, a theorist might simply disagree with the artist's own testimony—refusing, e.g., to treat Martino as an incorrigible source of information about music. Maybe Martino is wrong: music isn't a language. Reflecting from a vantage point "external" to the practice, the aesthetic theorist might dispute the artist's own theoretical reflections, thereby riding roughshod over the very data she or he is obligated to explain.

No paradox lurks here: simply a familiar theoretician's dilemma concerning the status of expert testimony. Martino might or might not

[27] See, e.g., Donald Davidson, "Truth and Meaning," repr. in his *Inquiries into Truth and Interpretation* (New York: Oxford University Press, 2001), 17–36.

be right about the linguistic character of music. Nevertheless, the role of theory—this includes aesthetic theory—is to *account for the data*: these data surely include the perspectives and experiences accessible to the artists themselves. However we adjudicate tensions between "internal" and "external" vantage points, it is useful to take Martino's words at face value and explore their consequences.

Recall our central question: "Why does Jazz Matter to Aesthetic Theory?" The tentative answer is disjunctive: either (1) jazz provides compelling evidence that some artists think of their genres as languages; or (2) jazz provides compelling evidence that some artistic genres are languages. The idea behind (1) is that an aesthetic theory must accommodate an artist's own perspective on his or her own practice, whether or not that perspective is deemed correct. Martino's candid, reflective testimony is part of the data to be explained by an adequate aesthetic theory: whether or not music is actually a language, it is important that Martino *thinks* it is. Thus reflection upon jazz dramatizes the need for sufficiently robust theoretical resources to address questions about language: what it is, how it contrasts with other problem-solving mechanisms, how it contrasts with other collaborative devices, etc. Martino's perspective must be explained.

On the other hand, Martino's testimony might be taken as correct, and might—pending further directives—ramify throughout aesthetic theory, by suggesting the bold hypothesis that *all* artistic genres are languages. Such a generalization is perhaps premature—some artforms might be languages, others not—but it is of enormous theoretical interest. Thus jazz matters to aesthetic theory by foregrounding the dialogical, linguistic character of the musical interaction among players; this, in turn, motivates an art-as-language paradigm. Jazz provides a compelling source of evidence for the aesthetic hypothesis that art is language-like.

This hypothesis carries enormous theoretical weight. It prompts inquiries into the relation between artistic interpretation and natural-language translation. It prompts the hypothesis that contextual factors such as causal ancestry and social-institutional setting enter essentially into artistic understanding (thereby spelling doom for Bell's "isolationist" approach to the arts) in precisely the way in which contextual factors enter essentially into attributions of semantic content. It prompts the idea that artistic genre categorizations are essential to artistic understanding, in precisely the way in which linguistic categorizations are

essential to proper translation.²⁸ It prompts valuable analogies between artist's intentions (and the relevance of such intentions to artistic interpretation) and speaker intentions (and the relevance of such intentions to natural-language translation). It prompts fruitful analogies between "the artworld" and "the linguistic community." It prompts questions—inspired by Quine's puzzles about translational indeterminacy—about whether there exists a unique correct interpretation of a work of art, and whether there are "facts of the matter" to which "correct" artistic interpretations must conform (these questions are pursued in Chapter 6). All such inquiries and analogies—whatever their upshot—are of tremendous theoretical value: insofar as they are encouraged by focus upon the dialogical nature of jazz, jazz matters to aesthetic theory.

But, once again, it is doubtful that a focus upon jazz provides any special perspective or data unavailable elsewhere in the artworld: for this "linguistic" way of thinking about music—and other artforms—is already rampant in critical discourse. Art historians and theorists frequently invoke phrases such as "Cézanne's contributions to Cubist vocabulary", "the Impressionists' language of broken color," and "the architect's language of space and material"; Ernst Gombrich refers to forms of pictorial representation as "visual languages."²⁹ Such phrases are perhaps metaphorical—in which case the prevalence of the metaphor must be explained—but perhaps not. R. G. Collingwood provides an elaborate aesthetic theory according to which art is expressive "in the same way in which speech is expressive"; indeed, Collingwood urges that "Art must be language," and stresses that

[artists] become poets or painters or musicians not by some process of development from within, as they grow beards; but by living in a society where

²⁸ Thus aesthetic properties depend essentially upon the artistic category to which an artwork belongs. The idea was advocated by Kendall Walton years ago, independent of any art-as-language thesis. But note that the category relativity of aesthetic properties emerges as a corollary of the art-as-language thesis, by the following argument: (1) artistic genres are languages; (2) semantic properties depend essentially upon the language to which an utterance or inscription belongs; (3) aesthetic properties are a species of semantic properties; therefore aesthetic properties depend essentially upon the genre and/or style to which an artwork belongs (suppressed premises should be provided by the reader as an exercise). See Kendall Walton, "Categories of Art," *Philosophical Review*, 79 (1970), 334–67.
²⁹ See Ernst Gombrich, *Art and Illusion* (Princeton: Princeton University Press, 1956).

these languages are current. Like other speakers, they speak to those who understand... The aesthetic activity is the activity of speaking.[30]

And Wittgenstein tells us: "What we call 'understanding a sentence' has, in many cases, a much greater similarity to understanding a musical theme than we might be inclined to think."[31] Neither Wittgenstein nor Collingwood were led to such views via any special concern with jazz.[32]

The point is that Mr. Martino is hardly alone in his insistence upon linguistic models in the arts: other artforms pull in similar theoretical directions ("semiotic" approaches to the visual arts have long flourished, independently of considerations about jazz). Jazz has nothing new to add here. Nevertheless, by highlighting the dialogical, linguistic character of musical interaction among players, jazz provides a compelling source of evidence for those aesthetic theories (such as Collingwood's) according to which art is language-like: jazz performance is so *conspicuously* dialogical that it renders irresistible the art-as-language model.

Earlier we noted that the assimilation of artistic practice to linguistic activity is risky. Nonetheless, a theoretically sophisticated aesthetician might rise to the challenge. One might, for example, resist Davidsonian arguments, and sever the concept of language from the concepts of translation and truth. Instead of focusing upon the relation between language and truth conditions, one might foreground the relation between language and *assertibility conditions*. There is, after all, such a thing as an "apt" or "inappropriate" linguistic performance: to understand a language is to grasp the rules of correct usage—the circumstances under which particular utterances are warranted (think of Introduction and Elimination rules governing truth-functional connectives in symbolic languages). Foregrounding these aspects of natural language—rather than truth conditions and denotation—renders less implausible the assimilation of art to natural language. For clearly there is such a thing as an "apt" or "inappropriate" musical phrase, relative to the genre and context in which it is formulated: the rules of the genre are learnable (at least, by students possessed of requisite tonal sensitivities and other

[30] R. G. Collingwood, *The Principles of Art* (London: Oxford University Press, 1938), 317.
[31] Ludwig Wittgenstein, *The Blue and Brown Books* (Oxford: Basil Blackwell, 1958), 167.
[32] For a perceptive exploration of the forces behind Collingwood's claim that "art must be language," see Garry Hagberg, *Art As Language* (Ithaca, NY: Cornell University Press, 1995), ch. 2.

Why Does Jazz Matter to Aesthetic Theory? 63

discriminative skills). To understand an artform is to know, *inter alia*, the circumstances under which a particular musical phrase or other artistic gesture is warranted. Analogies between rules of artistic genre and rules of natural-language inference are worth pursuing here; analogies between syntactic parsing/natural-language comprehension and the computational processes involved in artistic understanding are likely to prove valuable.

But the analogies have their limits: the entire art-as-language model strains not only at our sense of language—cf. Davidsonian and other *caveats* voiced earlier—but at our sense of art. It is not clear, for example, that understanding Futurist paintings requires syntactic parsing and/or semantic evaluation; it rather requires seeing those works as efforts to capture a sense of sequential movement, mechanical power, and the dynamism of modern life. It is not clear that Magritte's surrealist paintings are best construed as statements in a "painterly language"; better to see them as efforts to induce feelings of strangeness and wonderment by importing familiar objects into unfamiliar contexts. It is not clear that Art Deco buildings of the 1920s are best construed as statements in a language of space, volume, and massing; better to see them as efforts to maximize floor-to-area ratios while conforming to various zoning ordinances and design requirements. In each such case it seems most helpful to view artistic creation *not* as a species of *linguistic behavior*, but rather as a species of *problem-solving behavior*: that is, as artistic attempts to solve certain kinds of problems—pictorial problems, tonal problems, architectural problems—within the constraints of specific genres.[33] Not all problem solving is language use. One must thus resist any inclination to generalize from the dialogical character of jazz to other artforms: "art-as-language" might yield fewer theoretical dividends than "art-as-problem-solving." Nevertheless, jazz contributes a compelling series of data points for aesthetic theory, forcing consideration of where to draw the line between linguistic and non-linguistic modes of problem solving, and why.

But here, once again, jazz forces nothing *new* upon the aesthetic theorist: art historians, critics, and theorists have long employed linguistic

[33] Michael Baxandall provides a richly detailed exploration of "art-as-problem-solving" in his *Patterns of Intention* (New Haven and London: Yale University Press, 1985). The painter is depicted as analogous to a bridge-builder: both aim at solving problems in particular situations, and both produce cultural artifacts that cannot be understood in the absence of information about the problems they sought to solve and the constraints placed upon the solutions.

concepts when discussing the arts, comfortably invoking such phrases as "Cubist syntax" and the "architect's language of space and material." Such theorists owe us an account of what they *mean* by 'language': what is going on when they treat artistic genres as linguistic forms, and why the art-as-language paradigm is of greater explanatory utility than the art-as-problem-solving paradigm. The theoretical interest of jazz is that it strikes so many performers and sophisticated observers as a form of discursive practice, thereby rendering more urgent the theorist's need to explain these "art-as-language" ways of speaking. It prompts the theorist to acknowledge that some artforms are languages, or, alternatively, to explain the prevalence of the intuition. The theorist might proceed by articulating a *general* notion of languagehood, equally applicable to natural languages (like English), formal languages (like first-order quantification theory), and artistic genres; or, alternatively, she or he might undertake an elaborate explanation of why at least some artistic genres are consistently regarded — if incorrectly — as linguistic, while maintaining a contrast between artforms and "genuinely" linguistic practices. Either way there is theoretical work to be done; jazz matters to aesthetic theory by underscoring the urgency of such work.[34]

Aesthetic theories occasionally suffer from failure to treat certain artforms with sufficient respect. Non-representational artforms cast doubt on mimetic theories; emotionally expressive works cast doubt on formalist theories; artforms aimed primarily at solution of pictorial problems (e.g. Seurat's explorations of lighting and atmosphere) cast doubt on expressionist theories; deconstructivist architecture (e.g. the work of Eisenman and Graves), grounded in postmodern polemics, casts doubt on "nativist" accounts of architectural practice and theory.[35] And so on. In each such case, an otherwise plausible aesthetic theory

[34] Ethnomusicologist Paul Berliner offers the following:

[B]assist Chuck Israels says "playing with musicians is like a conversation. If when I speak, you interject some comment of your own, that keeps me going." This chapter is an attempt to expand on this metaphor, frequently repeated by jazz musicians. The chapter raises such questions as: What does it mean to call musical interaction a "conversation"? How is it like a conversation?

These are precisely the right questions; unfortunately, Berliner makes little theoretical progress toward answering them. See Paul Berliner, "Give and Take: The Collective Conversation of Jazz Performance," in R. Keith Sawyer (ed.), *Creativity in Performance* (Greenwich, Conn. T: Ablex Publishing Corporation, 1997), 9–41.

[35] See, e.g., the theory of innate pattern languages provided by Christopher Alexander in *The Timeless Way of Building* (New York: Oxford University Press, 1979).

is shown inadequate, and the recalcitrant artform is seen to matter to aesthetic theory by making the inadequacy explicit. It is doubtful that jazz matters to aesthetic theory in this way. I have suggested that aesthetically relevant features of jazz can be found in other artforms as well. Nevertheless, jazz presents itself to engaged performers and listeners as a mode of linguistic activity: the phenomenology of *musical conversation* dominates the genre. This perspective, when generalized, ramifies across the fabric of aesthetic theory, and colors views about artistic interpretation, meaning, evaluation, understanding, and the nature of artistic rules. Focus upon jazz thus encourages the idea that artforms—even those that appear to be understandable "in isolation"—must be approached as instances of conversational, linguistic phenomena. Jazz matters to aesthetic theory by foregrounding the need to take seriously the dialogical, art-as-language paradigm: to explain its prevalence and explain its utility. The artwork is a complicated place: if jazz encourages a paradigm that provides direction for approaching some of its complexities, so much the better.[36]

[36] This chapter originated as a talk given to the Departments of Philosophy and Music at Illinois State University, in conjunction with performance in their "Music Under the Stars" concert series (Jan. 2003); it was subsequently published as "Why Does Jazz Matter to Aesthetic Theory?" in *Journal of Aesthetics and Art Criticism*, 63 (Winter 2005), 3–15. Thanks to Jim Swindler for his gracious hospitality, and to Bruce Hartung, Henry Pratt, Julian Cole, Lee Brown, Daniel Farrell, Ted Gioia, William Lycan, Geoffrey Hellman, Eddy Zemach, Ken Walton, Jerrold Levinson, Pedro Amaral, Mark Lance, and Philip Alperson for helpful discussion and comments on earlier versions. Special gratitude to Tony Monaco and Louis Tsamous—my interlocutors in the "seamless groove machine"—for ongoing stimulation and support.

4

Emotions in the Music

> On the one hand it is said that the *aim* and *object* of music is to excite emotions—i.e., pleasurable emotions; on the other hand, the emotions are said to be the *subject-matter* which musical works are intended to illustrate.
> Both propositions are alike in this, that one is as false as the other.
>
> Eduard Hanslick

There is ongoing fascination—in some quarters—with the relation between music and the emotions. Music, it is claimed, packs emotional content: it expresses emotions. Usually this is asserted not as the conclusion of an argument, but as an intuitive observation about the way music is experienced. One hears anxiety in Mussorgsky's *A Night on Bald Mountain*, happiness in Vivaldi's *Spring* Concerto, sadness in Chopin's funeral marches, and the like. The idea is that "qualified listeners"—who need not have a degree from Juilliard, only a reasonable sensitivity to the music—are able to discern this emotional content. They can hear the foreboding in the music, if it's there; they can hear the despondency in the music, if it's there; and so on.

Having gone this far, there's an inclination to ask how the emotions expressed by (or "present in") the music contrast with the emotions related to non-musical situations—the despondency one experiences at a faculty meeting, for example. Perhaps "musical emotions" are less fine-grained, or differ in other interesting ways, from "garden-variety" emotions. Tantalizing questions lurk here: about the phenomenology, intentionality, and justification of musical emotions, the relation between musical emotions and contextual factors, and so on. Philosophers, psychologists, music theorists, and musicologists sustain an ongoing literature on these topics. It's a robust research program.

I do not have much sympathy for the program. Despite ongoing interest in the emotions and longtime involvement in the music industry, I have not the slightest inclination to foreground the emotions when thinking about interpretation, understanding, experience, and/or evaluation of music. I don't think music has anything special to do with the emotions. Nor am I alone in this view; thus Nick Zangwill:

Should we understand music in terms of emotion? I agree with Eduard Hanslick: the answer is 'No'. Let me count the ways that there is no essential connection: it is not essential to music to *possess* emotion, *arouse* emotion, *express* emotion, or *represent* emotion. Music, in itself, has nothing to do with emotion.[1]

I think Zangwill and Hanslick are right about this; but perhaps my rejection of expressionism rests upon musical insensitivity: inability to hear the emotional content in the music.[2] Failure to discern pastoral relaxation in Stravinsky's *The Rite of Spring* hardly entails that such relaxation is absent; perhaps I simply cannot detect it, just as I cannot detect the propositional content of sentences formulated in unfamiliar languages, or cannot detect (owing to visual defects) the colors of objects.

Perhaps. Another possibility is that the emotion isn't really there, and those who think otherwise are confused, musically unsophisticated, or in the throes of a false (though prevalent) theory. There might be listeners who, when engaging Stravinsky's piece, experience harmonic, rhythmic, and melodic subtleties, thematic development, and a mode of musical engagement—characterized by complex sensory-perceptual episodes—that has nothing to do with emotion. It is an intense engagement, often deeply personal and fulfilling—but no more constituted by emotion than is involvement in mathematical proof. Insofar as such listeners are reliable indicators, music does not express emotions at all.

[1] Nick Zangwill, "Against Emotion: Hanslick Was Right About Music," *British Journal of Aesthetics*, 44 (Jan. 2004), 29–43.
[2] Such insensitivity might result from my work as a jazz guitarist; technical expertise deafens me to important properties. Larry Jost speculates that my rejection of expressionism derives from intimate involvement with the technical aspects of music: preoccupation with formal structure prevents me from hearing the emotional content. I reject this. I recognize—and, in my own playing, strive for—various aesthetic properties: I know where the groove is; I appreciate coherent thematic development; I discern the difference between beautiful and banal reharmonizations. But emotion has nothing to do with any of this. The reason I do not hear emotion in the music—except as a symptom of a player's psychology—is that it isn't there.

Thus the perplexity: despite occasional assurances that "emotion is immediately, not mediately, presented in music,"[3] many listeners think (and hear) otherwise. The experiences associated with musical engagement vary across subjects: we all hear with different ears. Moreover, there is room for dispute about whether an ontology of emotional-expressive properties provides the best explanation of the phenomenological data. If music does indeed express emotions, argument is required to establish this.

I

We need to back up and sharpen our focus. Music is undeniably related to emotion in various ways: the slogan "Music expresses emotions" is thus susceptible to various interpretations. It might be a claim about music's tendency to *arouse* emotions in listeners, or about music's capacity to *manifest* the emotions of performers and composers, or about the phenomenology of musical experience, or even an awkwardly formulated *prescriptive* claim about the relative importance of various properties: a claim about "the right way" to listen to music.

Yet another interpretation—call it "content expressionism"—concerns the *underlying ground* of music's capacity to arouse emotion. Content expressionism is a causal-explanatory hypothesis about *why* the music strikes some listeners as having an emotional dimension: the theory posits a real feature of the music—i.e. "what the music expresses"—and claims that a musical event prompts competent listeners to discern the presence of a certain emotion in the music *because* the music *expresses* that emotion. This expressive content is alleged to be a *real, causally efficacious and explanatorily relevant* feature of the music, discernible to sensitive listeners. The jury is still out about how, precisely, the emotion expressed by the music makes itself known: either it is evoked in the listener, or it prompts another sort of perceptual episode. Whatever the method of detection, the emotion is there, and competent listeners hear it.

Here is an analogy from the non-musical realm of natural-language comprehension. A given sentence S moves competent hearers to occupy certain cognitive states, engage in certain inferences, and undertake

[3] Stephen Davies, *Musical Meaning and Expression* (Ithaca, NY, and London: Cornell University Press, 1994), esp. ch. 5.

certain actions. *Why* does the sentence have this impact? Answer: the sentence expresses a certain proposition; it has a certain meaning or semantic content. This is a real, causally efficacious property of the sentence, to which selectively sensitive speakers are responsive. It is *because* the sentence 'Snow is white' expresses a proposition about snow that it prompts comprehending listeners to form beliefs about snow. Analogously (according to musical content expressionism): it is *because* Beethoven's Fourth Piano Concerto in G Major expresses tranquil gratitude that it moves comprehending listeners to discern tranquil gratitude in the music—either by feeling it themselves or by somehow discerning that it's there. The point is not that affective content of music is assimilable to propositional content of sentences; the point is rather that the concept of *expression*—whether applied to sentential cognitive content or musical affective content—earns its keep by doing causal-explanatory work. Content expressionism is a causal-explanatory strategy; the question is whether that strategy is plausible.

Expressionist theories attract a substantial following; this in itself deserves explanation. Perhaps the attraction rests upon "arguments from experience": arguments that draw quick ontological conclusions from premises about individual phenomenology. The argument is simple: start with the observation that Jones experiences the music as desolate ("hears desolation in the music"), and conclude that the music is, in some sense, desolate (why *else* would he experience it that way?). But such arguments are tenuous at best, and no more plausible than inferring the existence of faces in clouds from the fact that people often see faces in clouds: these visual experiences merit explanation, but the postulation of faces in clouds isn't the most plausible. More venerable instances of arguments from experience involve inferences to the existence of God (based upon religious experience), or to real moral properties (based upon moral phenomenology), or to platonism (based upon the phenomenology of mathematical proof): whatever one's assessment of theism, moral realism, or platonism, the correctness of these theories cannot be immediately inferred from phenomenology alone. Perhaps Jones's musical experiences are best explained by adverting to emotional-expressive properties in the music itself, but perhaps not; his phenomenology provides no incorrigible evidence for the reality of such properties. Are there other reasons for countenancing the existence of emotional-expressive properties in the music?

Perhaps. There is, John McDowell tells us, a form of explanation that goes beyond the causal, and if we don't deploy this form of explanation, then we "deprive ourselves of a kind of intelligibility that we aspire to."[4] To *really* understand ourselves is not merely to know the distal stimuli and sensory prompts to our experience and behavior; it is also to know how our experiences and behaviors are proper or improper, merited or unjustified, in light of the world around us. McDowell discusses, as an example of this, our tendency to fear things. When I reflect upon myself as a fearful person, part of my reflective wonderment concerns whether my fear is *merited*—that is, a fitting response to the circumstances. The question is not what prompts the response, but what justifies it. Parallel considerations apply to ongoing temptations (in some quarters) to locate emotions in music. Our connections with music are, in many cases, intimate and cherished: when we turn reflective, we wish to understand not only why we respond to the music as we do, but why we are justified in doing so. Thus we confront not only a causal-explanatory question, but also a normative one: we wish to see our experiential reactions to the music as somehow *warranted*. The postulation of "emotions in the music" has purchase here.

The idea—familiar to readers of Heidegger, Wittgenstein, Sellars, Rorty, and McDowell—is that we tend to seek ontological grounds for our normatively constrained practices. There must be (we tell ourselves) more to the *correctness* of our thinking or experiencing than mere conformity to our peers: this is the moral of Plato's *Apology*. And so it goes in our transactions with music: we seek legitimizing foundations for our judgments of correctness and incorrectness in the performance, appreciation, and experience of music. If, for example, we experience the music as despondent, then we seek to locate *something in the music that renders that experience legitimate*: the obvious candidate is that the music expresses despondency, that despondency is somehow "in" the music. That's why it is correct to hear it that way.

So I suggest that the perennial attractiveness of expressionist theories of music is a resultant of two forces: (1) a causal-explanatory effort; (2) an effort to locate a justificatory ground for (some people's) musical experiences. Both efforts are legitimate; but musical expressionism is not, I think, an adequate reaction to either. Pending a compelling argument to the conclusion that music expresses emotions, I am unable

[4] John McDowell, "Values and Secondary Qualities," repr. in *Mind, Value, and Reality* (Cambridge, Mass.: Harvard University Press, 1998), 131–50.

to participate in arguments about the precise way in which music expresses emotions without lapsing into bad faith. I cannot puzzle, for example, about the relation between the emotions expressed by the music and the emotions evoked by the music because I do not think the music expresses any emotions at all.

A final *caveat*. It is often assumed that emotional expression is a fact of musical life, and that the philosopher's task is to make sense of it. Jenefer Robinson, for example, says: "I am assuming that music frequently expresses emotional qualities and qualities of human personality such as sadness, nobility, aggressiveness, tenderness, and serenity."[5] In the present context it is vital that no such assumption be made: emotional expressiveness of music must *not* be treated as a starting datum—a ground-level "Moorian" fact to be theorized about but not challenged. It cannot be assumed (without argument) that Debussy's *La Mer* expresses pastoral relaxation, or that Schubert's String Quartet No. 13 in A Minor expresses overwhelming sadness, or that Chopin's *Polonaise* expresses rebellious anger and hope, or that James Brown's "Get on the Good Foot" expresses mirthful exuberance, or—for that matter—that "Jingle Bells" is inexpressive. These expressive claims are part of an explanatory (and/or justificatory) theory, not part of the data to be assumed at the outset. Our task is to assess the plausibility of the theory.

II

Igor Stravinsky denies that music expresses emotion:

For I consider that music is, by its very nature, essentially powerless to *express* anything at all, whether a feeling, an attitude of mind, a psychological mood, a phenomenon of nature, etc. . . . *Expression* has never been an inherent property of music. That is by no means the purpose of its existence. If, as is nearly always the case, music appears to express something, this is only an illusion and not a reality. It is simply an additional attribute which, by tacit and inveterate agreement, we have lent it, thrust upon it, as a label, a convention—in short, an aspect which, unconsciously or by force of habit, we have come to confuse with its essential being.[6]

[5] Jenefer Robinson, "The Expression and Arousal of Emotion in Music," *Journal of Aesthetics and Art Criticism*, 52, no. 1 (1994), 13–22.
[6] Igor Stravinsky, *Stravinsky: An Autobiography* (New York: Simon and Schuster, 1936), 83–4.

If the goal is to reject prevalent folk wisdom that "music expresses emotions," Stravinsky's denial prompts obvious puzzles:

1. Not every real property is an "inherent" property. Stravinsky denies that expression is an inherent property of music; it is, however, consistent with this denial that emotional expression exists in music as a non-inherent, relational property.

2. Not every real property derives from "purpose" or intention; some properties of an artifact are independent of the purpose for which it is fashioned. An expressionist theory that construes emotional content as accruing non-intentionally—rather than flowing from "the purpose of [music's] existence"—is consistent with Stravinsky's denial.

3. Not every real property is an essential property. Perhaps anxiety is no essential component of Mussorgsky's *A Night on Bald Mountain*, but it might be a component nonetheless. Emotional expressiveness might be a real, contingent feature of music. Stravinsky's denial that emotional expressiveness flows from music's "essential being" is consistent with the claim that music expresses emotion.

4. Stravinsky acknowledges that music "nearly always . . . appears to express something," but dismisses such appearance as illusory (note: the denial goes beyond emotional expression. *All* expressive properties are deemed illusory). The denial assumes an appearance/reality distinction: a contrast between *apparent* expression (which might be illusory) and *real* expression. Thus (for example) the fact that listeners (including the composer!) take *Petroushka* to express "the sorrowful and querulous collapse of the poor puppet" is no sufficient condition for the piece actually possessing this expressive feature; the fact that (experienced) listeners take John Coltrane's "Central Park West" to express melancholy provides no assurance that it does. The *esse* of musical expression is not *percipi*. Stravinsky's denial thus deploys a robust notion of *expression* that allows a contrast between *merely apparent* expressive qualities and *actual* expressive qualities.

But if widespread appearance of emotional expressiveness, or belief in such expressiveness, does not clinch the issue, what would? At this juncture it is vital to determine what it would *be* for music to actually express emotions, and what operational criteria might be deployed to verify whether or not it does.

5. Attributes which "by tacit and inveterate agreement, we have lent... [and] thrust upon" objects and events around us—perhaps as a matter of "convention"—do not thereby cease to be real attributes. The correctness of driving on the right in the USA is a matter of convention but nonetheless real; the attribute of *being departmental Chair* was "lent and thrust upon" poor George by a conspiring faculty, but it is nevertheless true that he is the Chair. Social-institutional properties are real properties; properties grounded in conventional agreement are real properties.

Upshot: even if emotional-expressive attributes of music are "projected" rather than discovered, or grounded in the contingencies of artistic convention, or attributed on the basis of "tacit and inveterate agreement," there is still space for the claim that music expresses emotions.

And so on. Given the metaphysical subtleties, it is difficult to see precisely what Stravinsky is denying: with interpretive maneuvering his disclaimer is consistent with various forms of expressionism. Nevertheless, given his authoritative stature, it is unwise to construe his sentiments as obviously confused, or dismiss them for lack of rigor. Stravinsky takes himself to deny an important proposition about the emotional expressiveness of music that most people affirm; if he is right, then many people are wrong. The challenge, in part, is to isolate a notion of *emotional expressiveness* sufficient to render his denial both intelligible and interesting.

III

Music is—for the most part—composed and performed by people. Thus there is an obvious sense in which a musical performance or composition is (or can be) an expression of emotion. A performed solo is a human gesture: it might be executed with anger or melancholy; such emotions might, in turn, generate abrupt, staccato phrasing or lilting, hesitant phrasing. A sequence of chords might be played hurriedly and sloppily, thereby manifesting the performer's impatience. A blues riff—given its timbre, intonation, and phrasing—might indicate the performer's mournfulness.[7] A perceptive listener often discerns a player's

[7] I ignore obvious contrasts among "A is a sign of E," "A manifests E," "A is a symptom of E," "A is (partially) caused by E," etc. Distinctions among these notions are critical in certain contexts: signification involves convention in a way that causation does not; symptoms of E are not always caused by E; and so on. Here, however, the distinctions are irrelevant.

emotional state on the basis of his or her performance, just as one discerns an interlocutor's emotional state on the basis of behavioral cues. Rahsaan Roland Kirk played music angrily when he was angry; the result was—in some sense—angry music.

None of this is surprising, or unique to the production of music. It is a simple consequence of the fact that emotional states are partial determinants of human behavior—music performance included. All human action is the resultant of an agent's psychology. Artistic production is no exception: to that extent artistic performance and the products thereof express the personality—including the emotions—of an agent. Perhaps the connection between emotion and performance is mediated by convention: variation in social-institutional conditions (and artistic education) might yield variation in emotion–behavior correlations; thus familiarity with relevant artistic conventions is a prerequisite for correct inference from performance to underlying emotions. Or perhaps the connection is purely "natural," unmediated by provincial artistic norms. Either way, music performance often manifests performers' emotions; surely Stravinsky does not wish to deny this platitude.

But the musical performance—a human action—should not be confused with *what is performed*: the performance is one thing, the content quite another; causal forces which generate performance behavior do not thereby become part of the composition performed. Perhaps the question is not whether "Giant Steps" can be performed angrily—of course it can—but whether the composition itself is angry. Perhaps the anti-expressionist seeks not to deny a claim about the production of music, but rather a claim about the music itself. A performance—*qua* gesture—can express emotion; perhaps a composition cannot.

The distinction between cause and content is profoundly significant; various disputes in semantic theory depend upon its proper articulation. But in the present setting, the alleged contrast between performance and composition is illusory. It is true that a performer can take liberties, make mistakes, or depart substantially from a score: one can, for example, forget to move to $C^{\#}min^7$ when playing the bridge to "Cherokee." But *the act of composing is itself a performance*, and the composition—the product of that act—is thus the result of emotional causal forces operating within the composer. Consider: Thelonious sits at the keyboard struggling to formulate a coherent opening to "Epistrophy"; sooner or later—if he is lucky—his melodic explorations and meanderings strike his ear the right way, and he writes down the winning sequence. His choice of pitch intervals, chords, and phrasings

manifests, *inter alia*, his emotional state (had he been in a different mood, different choices would have been made). The "composition" is simply a codification of his compositional performance and his decisions about how things should be done in the future. We need not be drawn into disputes about the "ontological status of artworks" and whether musical compositions are themselves abstract entities. Stravinsky's *The Rite of Spring* can admittedly be distinguished from last night's performance of it by the Cleveland Symphony Orchestra; and one can wonder—if one has nothing better to do—whether Wes Montgomery's rendition of "Besame Mucho" is really a rendition of "Besame Mucho" (given that he plays it in ¾ time whereas the original is written in 4/4). But these individuative puzzles are beside the point (and relatively uninteresting, unless the issue is copyright infringement).[8] The point here is that musical composition is itself something people *do*, and musical composition*s* are codifications of such doings: thus a "musical piece" is every bit as capable of "expressing emotion" as any other bit of behavior. Once we acknowledge that "the tune itself" (concerto, fugue, symphony, etc.) is simply a representation of a particular set of musical compositional gestures and recommendations—which subsequent performers can emulate if so inclined—we see that a musical piece, like a musical performance, can "express emotion" in straightforward ways. The anti-expressionist had better not deny this, lest he or she fly in the face of obvious facts about the power of emotional states to affect behavior. The contrast between performance and composition has no purchase here.

IV

Grant that emotions play a role in the causation of music performance and/or compositional behavior, and, consequently, that such behavior manifests emotions. If this claim is not in dispute, what other claim might the anti-expressionist seek to contest?

Perhaps the disputed claim concerns the tendency of music to cause ('bring forth,' 'prompt,' 'arouse,' 'elicit,' 'evoke,' etc.) emotions in

[8] Similar scorn is heaped upon such "individuative" questions (e.g. "What *is* it for a performance to be of the work it purports to be of?") in Aaron Ridley, "Against Musical Ontology," *Journal of Philosophy*, 100 (Apr. 2003), 203–20. Unfortunately Ridley casts too wide a critical net, claiming all musical ontology to be pointless; I do not share that view.

listeners. But no sensible person would deny this tendency: Crowbar's "Existence is Punishment" conveys a dark, gothic sense of psychotic depression; Yanni's musical (?) escapades prompt contempt for the musically illiterate masses; Dvorak's *New World* Symphony evokes feelings of optimism; Tower of Power's "Squib Cakes" induces an experience of energized funk; Art Blakey's performances arouse humility toward our musical ancestors; The Beatles' "I Saw Her Standing There" induces a sense of well-being. Some of these emotions—if they are emotions—are intentionally directed toward the music itself, whereas others are admittedly focused on factors external to the music.

Very well: grant that music customarily evokes various emotions in various listeners. What other connection might anti-expressionism plausibly dispute?

Perhaps anti-expressionism is not—despite appearances—a descriptive claim. Perhaps it is no denial of any obvious empirical generalization about music's power to manifest or arouse emotions. Perhaps Stravinsky's denial is rather a prescription: a normative/evaluative recommendation about the right way to listen to music. Thus construed, the anti-expressionist claim manifests the sentiment that music *should not* have emotional effects, and that listeners *should not* strive to be thus affected.

There is precedent for such normative recommendations within aesthetic theory. Clive Bell, for example, railed against those of lesser artistic sensibility who treat artworks as opportunities to wallow in the ordinary emotions of life. He urged that proper appreciation of art should focus upon formal-structural elements—considered in isolation from representational and/or contextual features—and strive for pure aesthetic emotion. The latter state is alleged to be isolated from ordinary human interests and emotions, and resembles mathematicians' experiences of abstract structures.[9] Perhaps Stravinsky's anti-expressionism is best construed as normative: a rejection of the way (most) people focus on emotional expression in music. This interpretation is borne out later in his autobiography:

[P]eople will always insist upon looking in music for something that is not there. The main thing for them is to know what the piece expresses, and what the author had in mind when he composed it. They never seem to understand that music has an entity of its own apart from anything it may

[9] See Clive Bell, *Art* (New York: Capricorn Books, 1958; first published 1913), esp. ch. 1.

suggest to them. . . . When people have learned to love music for itself, when they listen with other ears, their enjoyment will be of a far higher and more potent order. . . . Obviously such an attitude presupposes a certain degree of musical development and intellectual culture, but that is not very difficult of attainment.[10]

But normative claims about the proper way to engage music require a metaphysical ground: they derive force from more basic claims about what properties the music actually possesses, or what properties deserve attention and why. That is: recommendations about "proper musical perception" require metaphysical assumptions about the nature of music (viz. what properties it possesses) and/or the relative importance of such properties.

A general point lurks here concerning the dependence of normativity upon ontology. Any claim about proper interpretation, evaluation, and/or experience of art must rest upon theories about the ontology of art—just as claims about proper arithmetical manipulation must rest upon theories about the nature of numbers, or claims about the unacceptability of tracking gender, ethnicity, and religion during job interviews must rest upon theories about the essential nature of the job, or claims about humane treatment of animals must rest upon theories about the capacity of animals to experience despair and suffering. Formalism in aesthetics is often portrayed as the theory that "the representative element in a work of art . . . is irrelevant"[11] or that "all concerns for narratives and messages in art are misplaced—the only thing important in a painting is with what aesthetic effect the paint is arranged on the canvas."[12] But formalism thus construed requires an ontological ground: if representational content is "irrelevant," and concern with it is "misplaced," this is because of what artworks *are*, and thus what properties they possess.[13] If artworks possess social-contextual, historical, representational, and/or emotional-expressive properties, any formalist recommendation heralding the "irrelevance" of such properties constitutes a directive to ignore properties that are really there; it is hard to see why any such directive should be taken seriously.

The point, then, is that Stravinsky's anti-expressionism construed as a (misleadingly formulated) prescriptive claim—viz. the claim that

[10] Stravinsky, *Stranuisky*, 256–7. [11] Bell, *Art*, 27.
[12] Terry Barrett, *Interpreting Art: Reflecting, Wondering, and Responding* (Boston: McGraw-Hill, 2003), 49.
[13] Or: what *aesthetic perception* is, and thus what properties it involves.

focus upon emotional expression in music is misguided—assumes that expressionism involves the *metaphysical* error of ascribing to music qualities it does not have. But it is not yet clear what it would *be* for music to have the kind of emotional-expressive properties which Stravinsky claims to be illusory; and once this has been specified, it is not clear what arguments might be deployed to cast doubt upon the reality of such properties.

Given the *prima facie* resemblance between anti-expressionism and formalist aesthetic theories, it is worth noting that Stravinsky's denial goes far beyond Bell's formalism. Bell acknowledges that artworks possess representational features, but downplays such features as irrelevant to proper appreciation and evaluation of art. Stravinsky, in contrast, speaks like a modern-day eliminativist, urging that the alleged emotional-expressive features of music do not exist. His denial thus goes beyond the normative, and touches the ontology of music.

Upshot: if Stravinsky's anti-expressionism denies the power of music to arouse emotion, it is obviously false; if it denies the causal efficacy of emotion in generating musical performance and/or composition, it is obviously false. If, however, his claim is an evaluative recommendation about the "proper" way to experience music, it cannot stand without further demonstration that music does indeed lack emotional-expressive properties; unfortunately, he does not specify what it would *be* for music to possess such properties, so it is not clear what, precisely, he denies.

We have yet to find a plausible construal of Stravinsky's anti-expressionist claim.

V

Return to *content expressionism*: the thesis that music expresses emotion in a way importantly analogous to the way an indicative sentence expresses a meaning or proposition. Whatever one's theory of sentential meaning—there are many candidates—meaning is a substantive property of some utterances, a property invoked to explain various semantic and psychological phenomena: linguistic comprehension, correct translation, truth, inferential entitlement, and the like. Perhaps Stravinsky is best construed as denying that music relates to emotion in anything like the way linguistic utterances relate to their semantic contents. Philosopher W. V. Quine is often construed as denying the reality of sentential meaning and arguing that the concept of *meaning* has no

essential place in the austere enterprise of explaining and predicting human behavior; perhaps Stravinsky means to endorse a similar denial concerning emotional expression and music. This would be substantive and interesting.

But content expressionism provides little guidance about music and emotion unless conjoined with a theory about the relation between linguistic utterances and their semantic contents: if expressionism is the theory that music expresses emotion in a way analogous to that in which an indicative sentence expresses a meaning or proposition, one needs to know how an indicative sentence expresses a meaning or proposition. Unfortunately, the nature of linguistic meaning is so fraught with complexity and ongoing controversy that the analogy exploited by content expressionism provides little illumination.

It might be possible to sidestep the complexities and controversy. Whether linguistic meaning is best understood in terms of speaker intention, Gricean maxims, Fregean sense, nomological covariance, causes, norms, stimulus and response, inferential role, truth conditions, social coordination, or other familiar candidates, some notion of *meaning* is implicit in ordinary interpretive practice. However meaning is ultimately "analyzed," it is a property about which competent speakers routinely offer verdicts; perhaps this is sufficient to exploit the analogy suggested by content expressionism.

Imagine, then, that Karl is a musician: engaged not only in verbal behavior, but also in music performance and composition. Coming to know Karl as a person requires coming to know not only his beliefs, desires, and the meanings of his words, but also the emotions expressed by any musical event in which he is the productive agent. If, for example, the opening measures of Karl's solo on "All The Things You Are" express angst-ridden hysteria, all correct interpretations must disclose that fact; to ignore it is to miss something important about the emotional content of Karl's artistic performance, and thus something important about Karl. Thus the task of "radical interpretation" is extended to accommodate the fact—if it is a fact—that music expresses emotions.[14]

It is hard to see how musical expressionism facilitates better explanation of the behavioral data than anti-expressionism, and thus why it should be preferred. It is already acknowledged—by all parties—that

[14] The dynamics of radical interpretation (modified here to accommodate musical data) are lucidly discussed in David Lewis, "Radical Interpretation," *Philosophical Papers, Vol. I* (New York: Oxford University Press, 1983), 108–21.

Karl's musical output is partially determined by his emotional states, and thus that his emotions play a role in the explanation (and prediction) of his performance and composition behavior. But the question is whether *additional* explanatory benefits accrue from treating musical events as bearing emotional-expressive content; it is hard to see how such content does any work not already done by cause–effect relationships between psychology and behavior.

The argument parallels a familiar strategy in the philosophy of religion: it has not been shown that theism is capable of explaining anything that cannot be explained just as well in some non-theistic way; thus the postulation of a Judeo-Christian God cannot be justified on explanationist grounds. Anti-expressionism echoes this strategy in rejecting the existence of musical emotional content: expressionism, like theism, packs no explanatory power; thus there is no reason to accept it.

This strategy leaves open the door—as does its religious counterpart—for familiar arguments about simplicity, economy, and robustness of explanation, explanatory superiority, the relation between ontology and explanation, and the like. It also shifts the burden of argument: just as Hume's Cleanthes must locate some genuine explanandum better accommodated by theism than its denial, so the expressionist must identify some phenomenon better explained by expressionism than its denial. Stravinsky—as construed here—doubts that any such identification is forthcoming. The explanatory enterprise is not served by emotional-expressive properties of music; therefore there is no reason to countenance them.

But explaining Karl's performance and composition is only one side of the story; he is a consumer as well. He hears music and responds to it. His perception of—and reaction to—the music must be explained; we need to understand how music moves him in the way that it does. Emotional-expressive properties might have purchase here.

And they might not. Grant that Karl hears anxiety in Mussorgsky's *A Night on Bald Mountain*, and festive joy in Kool and the Gang's "Celebrate": how, precisely, would the postulation of emotional-expressive properties facilitate explanation of Karl's musical experiences? How does the fact—if it is a fact—that anxiety is "embodied" in Mussorgsky's piece or festive joy "expressed" in Kool and the Gang's piece, provide an understanding of Karl's perception of and reactions to the music?

The musical events reaching Karl's ears are, on some basic level, changes in sound pressure over time. They are describable in terms of pitch, loudness, duration, and timbre. On more abstract structural

levels, the events are describable in terms of diatonic patterns, harmonic motion, melodic contour, pitch intervals, voice leading, tonal centers, pitch inflections, minor-pentatonic scales, and countless other music-theoretic properties familiar to music theorists and psychologists. These properties constitute the realities of musical stimuli.

The question is whether these properties constitute the *only* realities of musical stimuli, or whether some feature (e.g. emotional expressiveness) has been left out. For here we have an "austere" conception of musical stimuli, likely to prompt the complaint that "there is more to music than the properties and relations countenanced in physics and music theory"; such a complaint has obvious counterparts in other artistic genres: surely there is more to a painting than pigment on a canvas, more to a meaningful poem than inscriptions on a page, and so on. Nevertheless, the anti-expressionist believes such an austere conception of music to be sufficiently rich for the explanation of Karl's experiences of the music—including his perceptions, if such there be, of emotional content.

Several metaphysical complications loom here.

(1) *Explanation* is shouldering a tremendous ontological burden: for the anti-expressionist assumes that properties not required for the explanatory enterprise are not worth countenancing, and thus that emotional-expressive properties of music, if not deployed in best explanations of music production, perception, and experience, do not exist.

(2) The fact—if it is a fact—that emotional-expressive properties are not explicitly cited in best explanations of music production, perception, and experience does not entail that such properties are absent from the picture. Perhaps they exist as "higher-order" constructs, constituted by certain combinations of psycho-acoustic properties; or perhaps they supervene upon such properties. In other words: Stravinsky's expressionist opposition might deploy *ontological reductive* themes, urging that emotional-expressive properties have not, after all, been vanquished from the explanatory scene, but are still present as higher-order structural properties and relations. Perhaps emotional-expressive properties are nothing more than constructions out of structural properties such as pitch, timbre, arpeggiation, and the like.

Here is how this theme might be implemented: suppose the expressionist argues—for example—that a musical event's *expressing desolation* consists in that event's containing a double-plagal cadence with a modal basis, or that Hendrix's "Spanish Castle Magic" *embodies paranoid suspicion* insofar as

[the ear is distracted] from the underlying minor-pentatonic scale with chromatic passing tones, all treated the same as structural tones in forming root-position open fifths. The underlying pentatonic descent, C–Bb–G–F–Eb–C, is presented vocally and clarified metrically but is disguised by a series of chromatically descending power-chords, Bb5–A5–Ab5.[15]

If these structural phenomena somehow *constitute* the musical expression of paranoid suspicion, then the reality of emotional expression in music is not subject to challenge (that's because no parties to this dispute have, thus far, challenged the reality of such structural properties). Thus we need to confront venerable puzzles about property reduction and property identity. The anti-expressionist must argue—in response to the observation that the disputed expressive properties are, after all, present in the music—that there is little prospect for "reducing" emotional-expressive to musical-structural properties.

But the expressionist is encouraged by traditional reductions of familiar properties to their microstructural bases. The fact—if it is a fact—that temperature is constituted by mean molecular kinetic energy is no argument against the existence of temperature; the fact—if it is a fact—that psychological properties are constituted by neurochemical properties is no argument against the reality of psychological properties. Just so—the argument goes—music's emotional-expressive properties are constituted by non-contested structural properties, thereby earning the disputed properties a legitimate place in the ontology of music.

The anti-expressionist might begin by seeking to cure the expressionist of such reductionist zeal: reduction is notoriously tricky business. Consider a venerable precedent: physicalist claims about the nature of mind and mentality met with sobering reminders—courtesy of Fodor, Davidson, and others—that theoretical reduction requires nomological coextensionality of properties, projectibility of predicates, bridge laws, and other stringent conditions the satisfaction of which is unlikely.[16] Despite a huge reactive literature on multiple realization, supervenience, varieties of reduction, and related technical issues, it is still not clear what is reducible to what, or how best to understand the

[15] Walter Everett, "Making Sense of Rock's Tonal Systems," *Music Theory Online*, 10, no. 4 (Dec. 2004), sec. 24. I do not suggest that Everett would endorse the reduction of expressive to structural properties envisaged here.

[16] See, e.g., Jerry Fodor, "Special Sciences, or The Disunity of Science as a Working Hypothesis," *Synthese*, 28 (1974), 97–115; Donald Davidson, "Mental Events," in his *Essays on Actions and Events* (Oxford: Clarendon Press, 1980).

distinction between eliminating a property and reducing it to something else. There is, at present, little basis for optimism about the reduction of economics, psychology, and other "special sciences" to physics or neurochemistry; the anti-expressionist might urge that there is, analogously, little basis for optimism about the reduction of emotional-expressive to structural properties. Thus Stravinsky must, in order to prevail, once again shift the burden of argument to the expressionist, and some rather delicate metaphysical argumentation about property reduction vs. elimination is likely to ensue.

But the dialectic has not deteriorated into vacuous shifting of burden: there is progress. It now appears that if the austere, structural conception of musical stimuli provides adequate resources for explaining Karl's musical experiences, and if emotional-expressive properties are not, in any interesting way, "reducible" to musical-structural properties, there is no reason to countenance emotional-expressive properties in the music. The key question, then, is whether musical-structural concepts are adequate for the explanation of musical experience: that is, whether talk of harmonic motion, diminished triads, voice leading, non-Western Mixolydian scales, unmoving tonic pedals, and related structural notions—combined with everything we know about Karl's psychology—enables us to understand Karl's musical experiences. Here the anti-expressionist must hold the line, and remain optimistic about explaining what must be explained without invoking emotional-expressive properties.

Even if prospects for the touted property reduction are grim, some less demanding relation might afford comfort to the expressionist: perhaps emotional-expressive properties *supervene* upon properties such as pitch intervals, timbre, and other structural features, in the sense that the latter properties *determine* the former. But this metaphysical strategy begs the question at hand. A-properties supervene on B-properties if and only if objects/events indiscernible with respect to B-properties are indiscernible with respect to A-properties; equivalently, there cannot be an A-difference without a B-difference. The intuitive idea is that certain properties *determine* other properties; such determination requires explanation. One possible explanation is reductive: the A-properties are constituted by the B-properties (that's why the determination relation holds), thereby endowing the A-properties with as much ontological respectability as the properties in the supervenience base. But in the

present context the very exemplification of the A-properties is disputed: for the claim is that music *lacks* emotional-expressive properties (or rather: that there is, pending further discussion, no compelling reason to countenance such properties). Discussions of the alleged supervenience of such properties upon more basic structural properties are thus beside the point.

VI

There is more to musical life than causes and explanations. The fact—if it is a fact—that emotional-expressive properties play no essential role in the explanatory enterprise is only part of the story. Music—the way we experience it, react to it, compose and perform it—is shot through with normativity: our musical experiences and musical behaviors are proper or improper, merited or unjustified, fitting or inappropriate. Some emotional responses to a given harmonic transformation are unwarranted; some ways of experiencing rhythmic complexities indicate lack of understanding; some accompanists do a better job than others of fitting the mood, pulse, and phrasing of the vocalist's performance; some audience behavior is inappropriate to the genre and energy of the composition. And so on. Music criticism is a fact of life. Earlier I noted that musical expressionism results, in part, from efforts to provide a justificatory ground for (some listeners') musical perceptions; but the relevant data go beyond listeners' experience: most aspects of music production and reception are subject to normative assessment. Perhaps emotional-expressive properties have purchase here. If so, the fact that such properties play no role in the causal-explanatory order does not suffice to secure their eliminability (and thus their nonexistence).

In the 1960s there was heated controversy concerning the validity, significance, and proper interpretation of "free jazz": the work of Cecil Taylor, Ornette Coleman, Sun Ra, John Coltrane, Albert Ayler, Sam Rivers, Archie Shepp, Pharoah Saunders, and other *avant-garde* jazz players. Critical controversy is common in the music world, but the issues raised by this genre were especially rancorous. The very musicality of the music was at issue; another point of contention concerned the emotional content, if any. Some listeners and critics discerned anger in the music, which they tied to Black Nationalism, civil unrest, and

various radical political movements in which many of the players were involved. Here is a lucid description of the situation:

[T]he atonal clusters and dissonant harmonies of Cecil Taylor may well express for him the sound of a discordant society. The sometimes harsh or strident screeches heard from the reeds are often interpreted as anger and outrage, a kind of "tonal desperation." Collective improvising, too, in which no single voice is dominant, does aspire toward an egalitarianism that has never been a reality for blacks in America.... In view of these correlations, the listener must be aware of jazz's historical and emotional bases.[17]

But there could be an informed listener who discerns no anger or outrage in Cecil Taylor's music: only the liberation of melody from preset chord changes and fixed tempo, the creation of sound-surfaces by the use of tonal coloration, creation of sound-fields by the use of instrumental density, and the like.[18] A critical question thus arises—not inevitable but reasonable—as to whether Taylor's music actually expresses anger. If so, those who fail to discern it are missing something in the music; if not, they are not. Hearing the music as angry is warranted only if the anger is, in some sense, really there.

Or consider a more modest critical dispute. In his review of a concert by jazz organists Dr. Lonnie Smith and Tony Monaco, music critic Curtis Schieber describes Smith as "displaying a generous sense of humor and a musical wisdom," and as "forthcoming with melancholy"; later he adds: "The guitarist probed a deep introspection punctuated by bursts of notes that suggested desperate thoughts, while Smith was baldly emotional."[19]

Interesting: during both performance and playback, the guitarist discerned none of the emotional content identified by Schieber. A critical question arises—not inevitable but reasonable—as to whether Schieber's interpretive observations are correct. He hears melancholy in Smith's rendering of "And the Willow Weeps"; the guitarist does not. Content expressionism countenances a fact of the matter here, about which either of them might be wrong. The reality of emotional-expressive properties provides certain musical perceptions with a *justificatory*

[17] Len Lyons, *The 101 Best Jazz Albums* (New York: William Morrow and Company, 1980), 376.
[18] Ibid. 373–4.
[19] Curtis Schieber, "Smith, Monaco Offer 2 Takes on Organ's Place in Jazz," *The Columbus Dispatch*, 8 Nov. 2004. The guitarist described in the review is me.

ground: hearing the music as melancholy is warranted only if the melancholy is, in some sense, really there.[20]

Thus we confront questions about correct musical perception, appropriate reaction, and the like. Recall McDowell's observation that an important kind of understanding requires consideration of how experience and behavior are proper or improper, merited or unjustified, or otherwise "fitting" to the circumstances. Here we have a straightforward application of McDowell's observation: in confronting normative questions about our engagement with music, we are led to reflect upon the justificatory role, if any, played by emotional-expressive properties.

Normative considerations are certainly endemic to the artworld. But an assumption looms in the background concerning the separability of normative claims—claims about merit, appropriateness, and fit—from descriptive claims about explanations and causes. McDowell's observation falls comfortably into a tradition that militantly contrasts causes with reasons, 'is' with 'ought,' explanation with justification, descriptive with evaluative discourse, and facts with values. Wilfrid Sellars—a major influence in McDowell's work—bases much of his indictment against the "Myth of the Given" upon empiricists' failure to distinguish mechanistic explanation from justification.[21] There is thus a rich philosophical precedent for the contrast noted by McDowell: and surely the contrast is undeniable. Questions about the appropriateness of musical experience, for example, are *prima facie* distinct from questions about causes; and this contrast engenders a sense that there are two possible routes to ontological citizenship of properties: the way of explanation and the way of justification. This, in turn, leads to curiosity about whether the contested emotional-expressive properties of music might establish their citizenship via the latter route.

[20] It is undeniable—if one consults actual artworld practice and discourse—that artistic experience is susceptible to assessments of appropriateness. A critic might experience the music incorrectly; an accompanist, failing to hear the soloist's lapse into a non-standard metric pattern, can play sequences that do not fit; a club-owner might destroy audience ambience by selecting background music that she or he should have perceived as inappropriate. For further discussion see my "Perceiving the Music Correctly," in Michael Krausz (ed.), *The Interpretation of Music* (Oxford: Clarendon Press, 1993), 103–18.
[21] Wilfrid Sellars, *Empiricism and the Philosophy of Mind* (Cambridge, Mass.: Harvard University Press, 1997); a helpful discussion of Sellars's reliance upon the explanation/justification contrast is found in Richard Rorty, *Philosophy and the Mirror of Nature* (Princeton: Princeton University Press, 1979), esp. ch. 3, sect. 2 ("Locke's Confusion of Explanation with Justification").

A profound metaphysical assumption lurks here: viz. that a property might function as a justifier even if it plays no role as an explainer. This is a mistake. To see that this is a mistake, one need only reflect upon how properties come to play a justificatory role in the first place. Suppose that Karl occupies a sensory-perceptual state of the sort typically associated with the presence of barns; on the basis of this state he claims a barn to be in the vicinity. His evidence is experiential: his claim is justified, in part, by phenomenal properties of his perceptual field. Such phenomenal evidence is of course defeasible; but it is nonetheless evidence, insofar as the presence of that particular perceptual state-type makes probable the presence of a barn. This probabilistic connection, in turn, could not obtain unless the "of a barn" phenomenal properties were causally correlated with barns, thus providing reliable indication of their presence; and such correlation could not hold unless the phenomenal properties stood in causal-explanatory relations: barns typically cause "of a barn" phenomenal properties under normal conditions. Therefore the warrant-providing status of the phenomenal properties—i.e. their normative role—presupposes that those properties enter into the causal-explanatory order. Properties that lack causal efficacy could not have justificatory force.

Or consider Tom's anxiety at the approach of his departmental Chair, who displays a characteristic frown as he nears Tom in the corridor. Frowns of that sort do not bode well for Tom's career. During subsequent reflection Tom assesses his anxiety—prompted by the Chair's approach—to have been appropriate: a fitting response to the situation. So far as Tom is concerned, that frown packs justificatory force. But note that it would not pack such force unless it were correlated with other properties: for example, the Chair's tendency to drag Tom into his office for humiliating reprimands. Thus there exists a correlation between that characteristic frown and that humiliating behavior. This correlation, in turn, could not obtain unless the frown entered into the causal-explanatory order—perhaps as yet another effect of the beliefs and desires that generate the Chair's unpleasant behavior.

The point is not that justification is causal explanation, or that questions about appropriateness, merit, and fit collapse into questions about explanation and causation. The point is rather that any property that plays a justificatory role must be caught up in causal relations, and therefore cannot be explanatorily eliminable. Put another way: any property that is explanatorily inert is normatively inert. This

blocks the possibility that emotional-expressive properties, though not causal-explanatory, nonetheless pack normative power.

An annoyingly quick argument, given the stakes. But the argument suffices for present purposes, if only to generate skepticism about the touted normative role of emotional-expressive properties of music. Recall the idea was that such properties, even if acknowledged to be causal-explanatorily idle, might play a role in matters of justification, appropriateness, fit, and other notions essential to our engagement with music, thereby earning them ontological citizenship because of their place within the normative order. If the argument sketched here is correct, properties that lack causal-explanatory power also lack justificatory power. Thus McDowell-inspired considerations of merit, warrant, and fit provide no basis for rejecting Stravinsky's anti-expressionism. If emotional-expressive properties are non-explanatory, they are non-justificatory as well.

VII

This leaves a substantial puzzle concerning the realities of customary thought and talk about music. Whatever the ontological status of emotional-expressive properties, they appear to be countenanced in common music-critical discourse: Al DiMeola's exuberant arpeggios do not fit well with Chick Corea's languorous accompaniment; ZZ Top's "Tush" is too boisterous for the austerity of a funeral; "Days of Wine and Roses" is maudlin and thus suitable accompaniment to a story about the tragedies of alcoholism; Rimsky-Korsakov's edit of Mussorgsky's *A Night on Bald Mountain* alters the emotional tone of the original but preserves the terror and torment associated with winged spirits of the night. And so on. Such descriptions are commonplace; any adequate account of artistic practice should explain why they are commonplace. Arguments against the justificatory or explanatory power of emotional-expressive properties thus fly in the face of artworld realities, insofar as expressionism appears to be implicit in ordinary music-critical practice.

It is undeniable that emotion concepts are frequently applied to musical events; the critical question concerns the role that such concepts play in such applications, and whether expressionism can be "read off" customary discourse about music. Having rejected content expressionism, the anti-expressionist must address the forces sustaining expressionism

within the artworld: the fact that so many people find music emotionally expressive must be explained.

There are several possible strategies.

One possibility is that the emotions aroused in some listeners by some musical events are in turn "projected" onto the music: perceived as embodied in the music itself. This is a complex and controversial explanatory strategy, inspired by Hume's recognition of the "gilding or staining all natural objects with the colours borrowed from internal sentiment, [thereby raising] in a manner a new creation."[22] Here the "objects" in question are pitch–time events, the "colours borrowed from internal sentiment" are musical emotions. Such an explanatory strategy—analogous to "projectivist" and "anti-realist" accounts of moral practice—purports to explain the realities of music-critical discourse without endorsing an ontology that the discourse appears, at first blush, to require.[23] There are, strictly speaking, no emotional-expressive properties in the music: the process of "projection" makes it sound otherwise.

Yet another strategy is to construe emotional-expressive properties as "response-dependent": the despondency of a funeral march, for example, is constituted by the disposition of the music to arouse despondency—or some feeling sufficiently like despondency—within members of a certain listening population under normal conditions. Response-dependent properties are *real*: if the despondency of the funeral march consists of that music's tendency to prompt despondency in a specified class of listeners, then the reality of emotional-expressive properties is, *pace* Stravinsky, assured, insofar as such tendencies are real. Here the obvious analogy is with Lockean secondary-property accounts of color: colors are real properties, exemplified where they appear to be exemplified; but they consist of dispositions to bring forth specified sensory-perceptual responses within the relevant population. Granted, despondent music often leaves some listeners unmoved to despondency, and moves others only rarely; but this poses no conceptual problem,

[22] David Hume, Appendix 1 of the *Enquiry Concerning the Principles of Morals*.
[23] A good introduction to the aspirations and complexities of projectivist explanation is Simon Blackburn, *Spreading the Word* (Oxford: Clarendon Press, 1984), esp. ch. 5 and 6. On the subtleties of response-dependence see, e.g., Mark Johnston, "Objectivity Refigured: Pragmatism without Verificationism," in J. Haldane and C. Wright (eds.), *Reality, Representation and Projection* (New York: Oxford University Press, 1993), 85–132; Philip Pettit, "Realism and Response-Dependence," *Mind*, 100 (1991), 587–626.

any more than does the fact that red objects do not appear red to all viewers on all occasions, or that poisonous substances occasionally do not kill those who ingest them. Puzzles associated with the metaphysics of dispositions and response-dependence are obviously relevant here.

Response-dependence (hereafter 'RD') and projectivism appear to be substantially different metaphysical strategies. A response-dependent analysis of property P specifies the *nature* of P: response-dependent properties are *real*, and located in the objects and events to which they are ascribed; attributions of such properties are *truth-evaluable*. Projectivism, in contrast, is a nondescriptivist semantic strategy: a denial that certain predicates express properties—thereby precluding the need for further metaphysical analysis of the contested properties—and a denial of the truth-evaluability of sentences within the contested region of discourse. Such contrasts make a difference.

Perhaps. But note that such contrasts rest upon more basic metaphysical and semantic notions: what it *is* for a property to be real, what it *is* for a predicate to express a property, and what it *is* for a sentence to be true (rather than merely "assertible"); pending further discussion of such notions, it is not clear how deep the contrast between RD and projectivism goes. Consider: if some property P (e.g. melancholy) is customarily "projected" onto a musical stimulus S, then S obviously possesses the disposition D to prompt that projective process. D is itself *a real property of S*; the projective process is a *response* to S. One might undertake the Lockean strategy of seeking to identify *musical melancholy* with D; thus the contrast between projectivism and RD might, in the long run, be difficult to sustain.

Put such subtleties aside.[24] Suppose the path is clear to construing emotional-expressive properties as reifications of the power of music to arouse emotion in some listeners. It is important to see that this strategy—if ultimately workable—represents no concession to expressionism: the metaphysical gap between this response-dependent model of emotional-expressive properties and content expressionism is profound. Expressionism grounds music's power to arouse emotion in the causal-explanatory efficacy of emotional-expressive properties; RD, in contrast, finds no role for emotional-expressive properties in the

[24] At least for the present. Discussions with Paul Boghossian and Christopher Peacocke convinced me of the need to flag such contrasts, if only to dismiss them as not immediately relevant to the task at hand.

causal-explanatory order—at least, given certain assumptions about the causal powers of dispositions. This is a difference that makes a difference. Response-dependent properties are constituted by elaborate dispositions to arouse specified responses within the "relevant population" under "normal" circumstances. Thus RD appears not to give Stravinsky what he wants: for the analysis countenances such properties as *real* (insofar as dispositions are real), whereas Stravinsky insists that they are "only an illusion and not a reality." But the thrust of Stravinsky's claim—as interpreted by the content expressionist—is that emotional-expressive properties lack causal-explanatory power; the question is whether RD has this consequence.

Grant, for example, that *funniness* is a response-dependent property, constituted by dispositions to induce humor experiences, provoke laughter, and bring forth among standard viewers (?) a sufficient number of experiential/behavioral responses deemed relevant in specifying "what it is for something to be funny." It is a matter of some controversy whether the funniness—thus construed—of Seinfeld's monologues plays any role in the best explanation of why most members of the audience *find* the monologues funny; more generally—and more controversially—it is questionable whether response-dependent properties do any causal-explanatory work.[25] Caution is required here: not all explanation is causal explanation; moreover, the explanatory potency (if any) of a response-dependent property is not to be conflated with the explanatory potency of its categorical base. Delicate analytic labor is thus required to show that *RD portrays emotional-expressive properties of music as explanatorily idle*, thereby giving Stravinsky what he wants. The question is whether emotional-expressive properties, construed as response-dependent, are thereby portrayed as no "inherent property of music," but "simply an additional attribute which . . . we have . . . thrust upon it."

Recall that the initial challenge was to address the forces sustaining expressionism within the artworld: the fact that so many people *find* music emotionally expressive must be explained. RD provides such an explanation: some listeners' emotional responses to music are reified and "heard in the music," and the music's disposition to prompt such reactions constitutes properties of the music itself. Note that RD offers an exciting additional benefit: it illuminates the

[25] For a recent overview of the latter issue see Bradley Rives, "Why Dispositions are (Still) Distinct from Their Bases and Causally Impotent," *American Philosophical Quarterly*, 42 (Jan. 2005), 19–31.

impasse between expressionist and anti-expressionist. Attributions of response-dependent properties are implicitly relativized to populations; distinct populations often respond differently to the same musical stimuli; RD thus predicts disagreement across populations about the emotional-expressive properties of music.

This latter point is important. It is quite remarkable—to some—that any listeners deny the obvious truth that music expresses emotion; it is equally remarkable—to some—that any listeners deny the obvious truth that music does not express emotion. This contrast is itself noteworthy: expressionists and anti-expressionists have difficulty taking each other seriously. Dismissive laughter, marginalization, and communication breakdowns often emerge when the task at hand is to make sense of our complex relationship to music. This divide—between those who hear emotion in the music and those who do not—is itself a datum to be explained. RD provides resources to do so: different syndromes of response to music are sustained within different communities. RD might explain, for example, why working musicians and "mere theorists" occasionally have profound difficulty agreeing upon the data to be explained.

The reality of emotional-expressive properties in music is often assumed to be obvious: a non-inferentially observed "Moorian fact" requiring no postulation or theoretical justification. This assumption points toward misunderstanding of the metaphysical challenge. It is not disputed that some listeners experience music as embodying emotions: they "hear emotions in the music." The dispute concerns whether those experiences are explainable and/or justifiable in terms of purely structural descriptions of musical stimuli; if so, there is basis for treating the contested emotional-expressive properties as explanatorily and normatively idle and thus nonexistent. The musical-ontological dispute is thus reconfigured as one about explanatory adequacy and one about justificatory practice. These are profoundly complicated philosophical issues; but the discovery that the plausibility of musical expressionism rests upon them is itself progress. It remains to be seen whether the resources provided by the austere, structural conception of musical events suffice for the explanation and/or justification of the behavioral and phenomenological data. Until final returns are in, listeners such as Stravinsky can remain confident, in good metaphysical and musical conscience, that the reason they do not hear emotion in the music—except as symptomatic of a player's or composer's psychology—is that it isn't there.

VIII

It is undeniable that some music possesses features that some listeners do not hear. Performing musicians frequently suffer unresponsive and nondiscerning audiences: listeners deaf to metric structure, melodic contours, collaborative invention among players, tensions and resolutions, and other vital features of the music. We might speculate (with assistance from psychologists and music educators) about the conditions that produce such lamentable deafness: inadequate exposure to the genre, inadequate neural/computational resources for tonal and rhythmic processing, failure to develop proper habits of selective aesthetic attention, and so on. Whatever the explanation, it is undeniable that some people do not perceive the music correctly. The present question—concerning the existence of emotional-expressive properties—bears upon the larger question of what it would *be* to perceive the music correctly. We cannot answer that until we know what attributes the music really has, but securing agreement on that front is no easy task.

It is noteworthy that in confronting this question we get little help from many who reflect upon the general issues. Thus Malcolm Budd:

> The third movement of Beethoven's first *Rasoumovsky* string quartet is an expression of sadness of extraordinary depth and sincerity; Elgar's *Sospiri* expresses profound sorrow and a feeling of irrecoverable loss; the opening of Mendelssohn's *Italian* Symphony is imbued with *joie de vivre*; the adagio introduction to the finale of Mozart's string quintet in G minor expresses ultimate despair; the Prelude to Wagner's *Tristan und Isolde* is suffused with yearning. Each piece of music can be said to possess a particular emotional quality or to be expressive of the emotional condition it reveals.[26]

No *arguments* are provided for these characterizations. The background assumption is that no arguments are needed: any sensitive listener will hear the emotions in the music, just as any standard observer with properly functioning visual apparatus will, under normal conditions, discern the colors of objects. No argument is required for the claim that a given object is green: just look and see; no argument is required for the claim that Mozart's composition expresses ultimate despair: just listen and hear.

[26] Malcolm Budd, *Music and the Emotions* (London: Routledge & Kegan Paul, 1985), 18.

The problem is that some listeners—some of whom possess substantial musical credentials—do not hear the alleged emotional-expressive properties. Are such listeners to be excluded from the discussion? Or does their existence suggest a need for further metaphysical inquiry? Wilson Coker, reflecting upon disputes about whether music expresses affective states, cites Stravinsky, Hanslick, and others "on the negative side," and Liszt, Wagner, Copland, Mozart, Tchaikovsky, and others on the positive side. Coker concludes

The "ayes" have it, if any weight is given to sources available. . . . But although a positive majority opinion affords a certain comfort, it is elsewhere that we find cause to believe in the extrageneric meaning of music. It is our own experience that leads to belief (or doubt), and the theories of philosophers and composers that help us to gain understanding.[27]

It is something of a relief that the ontological matter is not to be settled with questionnaires: despite the preponderance of positive testimony, emotional-expressive properties of music should (according to Coker) be countenanced not on the basis of majority opinion but rather on the basis of "our own experience." But *whose* experience? The experiences of the majority? (If so, questionnaires once again become appropriate.) The experiences of experts? Who are the experts? Stravinsky is no less an expert than Mozart; must we engage in invidious rankings?

Mark Wilson offers an intriguing discussion that provides yet another case in point. Speaking of "the older fiddle tunes that were once common in the hills of eastern Kentucky," Wilson says, "To me the sadness inherent in many of these tunes seems every bit as palpable as that found in classical music"; and laments that certain listeners simply cannot hear it. More generally, he acknowledges that "this same problem of deafness with respect to emotive mood occur[s] with other forms of music as well," and tentatively endorses the sentiment that

". . . a score can be played badly, in which case the sadness may drop out of it, but once the music is executed correctly, the melancholy *has to be in there*, despite the fact that some ill-starred auditors cannot respond to it. Indeed . . . the Mozart can't be what it properly *is* unless it displays the sorrow. What the sadness-deprived folk experience is merely an impoverished surrogate for the true Mozart, lacking many of its core attributes. They are like color-blind

[27] Wilson Coker, *Music and Meaning* (New York: The Free Press, 1972), 146.

individuals who can only discriminate the shapes of things and not their hues." The proper content of the Mozart, we insist, requires a certain degree of intrinsic melancholy.[28]

Indeed, Wilson suggests that "*expresses sadness musically* seems as if it qualifies as a wholly *essential characteristic* of certain portions of the score." Perhaps he is right about this. But emotion-deaf members of the audience remain skeptical; Wilson gestures toward a consideration that might address the skepticism:

> Certainly, if the fuller property *adequately realizing the music of the* Symphony in G Minor could be internally divested of its sadness, the music itself would lose its capacity to cheer us on the couch. However the "true music" of the Mozart would be properly conceived, it must be thought of as something that can carry the attributes of melancholy, for such modality seems essential to the music's greatness.[29]

This is a *causal-explanatory* consideration: a claim that the capacity of the music "to cheer us on the couch" depends causally upon the presence of specified emotional-expressive attributes; but precisely this causal-explanatory claim is disputed by the anti-expressionist. Thus the metaphysical problem remains.

As noted earlier, there is a rich, ongoing literature devoted to exploring the complexities and subtleties of the connection(s) between music and the emotions. Stephen Davies notes the frequent observation that emotions are felt and necessarily involve propositionally contentful thoughts, and moreover that

> Even if music has a dynamic character resembling that of human action, at best music can present movement, not behavior. Music just does not seem the sort of thing that could possess emotional properties.[30]

The upshot of such considerations, Davies points out, is either of two possible responses:

> (i) Accepting as incontrovertible the evidence of our experience of music's expressiveness, it might be suggested that the emotions expressed in music are of a distinctive type, in that they are not felt, lack emotional objects, and are not expressed through action.

[28] Mark Wilson, *Wandering Significance: An Essay on Conceptual Behavior* (New York: Oxford University Press, 2006), 49.
[29] Ibid.
[30] Stephen Davies, *Musical Meaning and Expression* (Ithaca, NY, and London: Cornell University Press, 1994), 201–2.

(ii) Accepting as incontrovertible the argument suggesting that music is incapable of containing emotion, it might be suggested—and has been by Eduard Hanslick—that emotions are not expressed in music. To the extent that music is beautiful and significant, its beauty and significance is purely formal, since music cannot directly embody the world of human experience. Moreover, if music invites understanding and appreciation, a concern with emotions has no part to play in (indeed, is a hindrance to) the enjoyment of music.[31]

Davies finds each such viewpoint unsatisfactory; his arguments merit careful study. But the present strategy corresponds to neither of the above: rather, it accepts as incontrovertible—or, more accurately, as a datum to be respected and accommodated—the evidence of some listeners' experience of the music as *not* expressive of emotion, and seeks to articulate the epistemological, metaphysical, and semantic work required to put such experience in proper context.

Such disputes find correlates elsewhere in philosophy. Consider a theist who discerns—or claims to discern—expression of God's Love in the objects and events around him. He offers no *argument* that the natural world expresses God's Love, nor does he believe such argument to be required: it is, he claims, an undeniable fact of phenomenological life that the world presents itself as theistically expressive. Armed with such data, he might seek a theoretical account of the relation (perhaps causal, perhaps teleological, perhaps other) between God's Love and the natural order.

But some people do not discern the alleged theistic properties; John Calvin offers a possible explanation:

Indeed, the perversity of the impious, who though they struggle furiously are unable to extricate themselves from the fear of God, is abundant testimony that his conviction, namely, that there is some God, is naturally inborn in all, and is fixed deep within, as it were in the very marrow From this we conclude that it is not a doctrine that must first be learned in school, but one of which each of us is master from his mother's womb and which nature itself permits no man to forget.[32]

Alvin Plantinga glosses Calvin's position thus: "one who does not believe in God is in an epistemically defective position—rather like someone

[31] Stephen Davies, *Musical Meaning and Expression* (Ithaca, NY, and London: Cornell University Press, 1994), 202.
[32] John Calvin, *Institutes of the Christian Religion*, trans. Ford Lewis Battles (Philadelphia: Westminster Press, 1960), 1. 3 (pp. 43–4); cited by Alvin Plantinga in his "Theism, Atheism, and Rationality," available online at www.leaderu.com/truth/3truth02.html

who does not believe that his wife exists, or thinks that she is a cleverly constructed robot that has no thoughts, feelings, or consciousness."[33]

And so it goes, perhaps, with emotional-expressive properties of music. Listeners who do not discern such properties suffer an epistemic defect: perhaps the result of preoccupation with music's technical complexities, or unfamiliarity with relevant artistic/cultural conventions, or years of touring with high-decibel rock bands. Many roads lead to epistemic disadvantage, and often—lamentably—to inability to hear the music for what it is. On the other hand, despite the prevalence of the tendency to regard (some) music as emotionally expressive, such a tendency might be grounded in an incorrect explanatory and/or justificatory theory. If so, Hanslick, Stravinsky, and others who fail to hear emotions in the music are not missing anything that is there.[34]

[33] Plantinga, "Theism, Atheism, and Rationality.".

[34] This chapter originated as a rejoinder to Jenefer Robinson's "Listening with Emotion: How Our Emotions Help Us to Understand Music," presented at the Annual Meetings of the Ohio Philosophical Association (University of Cincinnati, 9 April 2005); subsequent versions were presented at Columbia University (March 2006) and St. Louis University (July 2006). I am grateful to Robinson, Ryan Jordan, and Tim Fuller for comments on earlier drafts; and to Justin D'Arms, Cristina Moisa, Christopher Gauker, Kendall Walton, Lawrence Jost, Ramon Satyendra, Jonathan Neufeld, and Ian Matthew Kraut for valuable discussion and correspondence. Special thanks to Henry Pratt for extensive, detailed comments on the penultimate draft.

5

Interpretation and the Ontology of Art

> "The question is," said Humpty Dumpty, "which is to be master—that's all."
>
> Lewis Carroll, *Through the Looking Glass*

Duane Hanson's *House Painter* (1988) is an eerily realistic, life-sized sculpture of a house-painter applying paint to an interior wall. The painter is replicated in polyvinyl and autobody filler, but the accompanying accessories are real: paint roller affixed to extension handle, work garb (including cap and white tee-shirt splattered with pink paint), and other paraphernalia appropriate to the painter's task. Part of the visually presented scene—several feet below the point at which roller meets wall—is an AC receptacle equipped with plastic outlet cover.

Is the outlet cover part of the artwork?

Perhaps not. Perhaps it is merely an artifact of the installation, forced upon the scene by the humdrum fact that museum walls, like most other interior walls, contain AC receptacles, and safety requires covering them with standard plastic covers.

The question matters. If the cover is a feature of Hanson's artwork, then any adequate artistic interpretation must accommodate it. After all, competent painters remove such covers—or, at least, protect them with masking tape—prior to working on the surrounding wall. If the cover is part of the artwork, then a full interpretation of *House Painter* must portray this painter as inept, or driven by fatigue to ignore obvious job requirements, or—perhaps—so skilled that painting around the cover without smearing paint on it is a live possibility. Whatever the explanation, if the outlet cover is part of the artwork—rather than part of the installation—then a proper interpretation must address it, insofar as artistic interpretation seeks to accommodate all features of an artwork and explain their interconnections.

Perhaps Hanson formed an intention—conscious or otherwise—to include the outlet cover as a feature of *House Painter*; or perhaps some other aspect of his behavior and/or mental life determines the boundaries of the work; or perhaps Hanson himself has no privileged authority, and the operative factor involves audience response and/or critics' sense of explanatory coherence. However the relevant features of the work are determined, on this approach the art object comes first, thereby providing material for the interpretive process: interpretation may be construed as a function that takes artworks as inputs and yields meanings, interpretations, and/or explanations as outputs. Thus construed, interpretation presupposes ontology; no wonder it is so critical to specify the features of the work.

Turn to another example. Christopher Ries's *Lotus* is a monumental sculpture of carved lead crystal: glass of such optical purity that it is 99.8 percent transparent. The piece is displayed under intense illumination, thereby producing a dazzling spectral result on the adjacent wall.

Are the spectral colors on the wall part of the artwork?

Perhaps not. Perhaps they are merely an artifact of the installation, forced upon the scene by humdrum facts about electromagnetic wavelength, optical density, incidence, dispersion, and refraction.

The question matters. If the refracted colors are no part of *Lotus*—but merely part of the installation—they can be safely ignored: proper interpretation and/or aesthetic perception of the work need not address them. If, however, the refracted spectral colors are a feature of Ries's artwork, then any adequate artistic interpretation must accommodate them: proper experience of the work will demand not only discerning the images that dance within the glass, but also the relationship between internal prismatic features and contingent contextual forces such as illumination, relative position, and the very relation between "interior" and "exterior."

Such examples are easily multiplied, and occur across genres. Even if, as Whistler suggested, "the picture ends where the frame begins," it is often unclear where the frame begins.

I

Individuative conundrums are familiar on the philosophical scene: one wants to know whether a certain wooden plank belongs to the Ship of Theseus, or a certain water molecule partially constitutes the river

Caÿster, or a certain statue ceases to exist when a portion of its clay is removed, or a certain temporary conscious episode belongs to the ongoing psychological history of Mr. Jones, or a certain inscription belongs to the compliance class of a specified lexical type. Artworld variants of such puzzles include familiar questions about the amount of restoration (if any) a sculpture, building, or painting can endure while remaining the same artwork, or how many improvisational liberties a musician can take while nonetheless performing a specified piece. Often—not always—something of importance hinges upon such conundrums and their resolution: questions about spatiotemporal spread, identity, and endurance bear upon matters of causation, legal and moral liability, personal survival, and conceptual content. In the artistic setting—where the issue is how much of the passing show constitutes a given artwork—the stakes are high: artistic interpretation and/or aesthetic perception aspires to accommodate all features of an artwork; thus it is vital to understand the procedure by which the class of such features is delineated.

We can learn something about the ontology of art—and about what we are doing when we ponder the ontology of art—by reflecting upon a parallel problem in the philosophy of mathematics. Just as we wish to know what *House Painter* is—what features it does and does not possess—we might wish to know what the number seven is—what properties it does and does not possess. We might consult the Dedekind–Peano axioms to determine whether, for example, the number seven is a set, or whether it is abstract, or whether it is identical with Julius Caesar. But this strategy assumes that the axioms tell the whole story about numbers: that the only properties of numbers are those structural features by virtue of which they form a recursive progression. Perhaps this is a mistake: perhaps numbers have properties that are not disclosed in the axioms. Perhaps some important features of numbers are non-structural, and thus cannot be inferred on the basis of the axioms alone.

This question—about what features the number seven does and does not possess—seems far removed from individuative questions about artworld objects; but there is a deep and illuminating connection. The nature of natural numbers has *something* to do with the way people think about numbers: perhaps natural numbers are those objects—whatever they may be—the features of which provide the best explanation of arithmetical intuitions and ordinary mathematical practice. But whose intuitions are relevant? Perhaps only the mathematicians matter: after

all, they are the "experts." But non-mathematicians have views about numbers as well, and it is hardly clear that such views should be ignored. If some population enjoys privileged status in specifying the properties of natural numbers, which population is that, and why? Analogously, it is not clear who gets to decide the constitutive features of artworks. Is Duane Hanson the final arbiter in determining the boundaries of his *House Painter*? Might the artworld public be consulted? The public is a mixed lot, ranging from the artistically savvy to unsophisticated philistines; surely not all aesthetic judgments and responses merit equal consideration.[1] Perhaps there exists a decision procedure for dignifying some members of the audience as authoritative on individuative issues; perhaps that procedure determines who the Humean experts are, and thus who gets to fix the standard of taste.[2] If some population enjoys privileged status in determining the relevant features of artworks, which population is that, and why?

It is useful to consider in greater detail the dispute about natural numbers: specifically, whether certain properties are legitimately invoked in ruling out certain interpretations of formal number theory as inadequate. Initially it appears that *ad hoc* social decisions—regarding whose intuitions matter and whose don't—play a constitutive role in determining the ontology of number. But a deeper look suggests that *explanatory power*, rather than social-institutional status, is the operative force in determining the plausibility of a given mathematical ontology. Against this backdrop, artworld individuative puzzles emerge in a fascinating light: prompting questions about what sort of explanation an ontology of artworks should provide, and how to adjudicate among competing ontologies.

II

A coherent story about the metaphysics of mathematics should illuminate puzzling aspects of mathematical practice. Mathematical truths

[1] This is not uncontroversial. Occasionally I am accused of endorsing a "repressive semantics" for various musical events and compositions, insofar as I seek an account of *appropriate aesthetic response*, one consequence of which is that many listeners do not experience the music properly. But such accusations of "elitism" and "aesthetic coercion" rest upon the misguided egalitarian assumption that all responses to artworks are equally legitimate.

[2] Henry Pratt made this connection clear to me.

are knowable *a priori*: knowable through exercise of reason alone, without recourse to empirical experience. Mathematical truths are *necessary* truths, subject to a special kind of certainty. Mathematical truths are about *abstract objects*: entities somehow removed from the physical world of matter and causal connections. Mathematical truths are applicable to the physical world: numbers can be used to count things. Mathematics is about an *objective, mind-independent* reality: the mathematician is engaged in discovery, not invention. These facts—or alleged facts—about the epistemology, modality, applicability, and subject matter of mathematics merit explanation. A proper understanding of "what numbers are" should facilitate such explanation.

How do we determine what numbers are? We might begin by codifying our intuitive understanding of number, noting all significant features: each number has a unique successor, no two numbers have the same successor, some number is the successor of no number, and so on. Armed with such a list—likely to resemble the Dedekind–Peano axioms—we might seek to develop number theory, and to explain the puzzling aspects of mathematical practice noted above.

Familiar problems loom. Various non-equivalent structures satisfy the axioms; if the only features of numbers are those specified in the axioms, it is unclear how one interpretive model might be privileged as "correct" and thus as "really being the natural numbers." Perhaps there is no determinate fact as to which structure is really the natural numbers, and thus no fact (beyond structural facts about positions in recursive sequences) as to what features numbers really possess. But this conclusion is disturbing: natural numbers—*qua* existent entities—surely have a determinate ontological nature, whether or not our resources enable us to discover it. Thus one wonders whether the properties reflected in the Dedekind–Peano axioms tell the whole story: perhaps the number seventeen has the property of *not being identical with any set*, despite the axioms being mute on this point. Perhaps essential properties of the natural numbers have somehow been ignored, or disenfranchised, by this entire methodology.

So says Jerrold J. Katz.[3] In assessing Paul Benacerraf's celebrated argument in "What Numbers Could Not Be," Katz notes a curious

[3] Jerrold J. Katz, "Skepticism about Numbers and Indeterminacy Arguments," in Adam Morton and Stephen P. Stich (eds.), *Benacerraf and his Critics* (Oxford: Blackwell

background assumption: viz. that the Dedekind–Peano axioms exhaust the relevant features of numbers.[4] The basic issue, it appears, is "who gets to say" which properties are essential to numbers and thus relevant to questions about indeterminacy and intended models. It is well known that, as Geoffrey Hellman puts it, "first-order renditions of defining conditions will inevitably fail to characterize certain of the most central structures in all of mathematics, including the natural-number structure."[5] Such observations are frequently taken to demonstrate the need for second-order resources in the foundations of mathematics. But this is not Katz's point. Katz insists, against Benacerraf, that there is *more* to numbers than what mathematicians—*qua* mathematicians—say about them, even given higher-order logical machinery. There are properties essential to natural numbers that are not expressed within formal arithmetic theories (first-order or otherwise); Katz's point is that such properties may legitimately be invoked in distinguishing numbers from other things:

> It is essential to seventeen that it has no spatial or temporal location, that it is causally inert, that it is not mind dependent, and so on, but these are not structural properties. . . . [A]lthough some essential properties of numbers—perhaps even those that matter most for most purposes—derive from the relations they bear to one another in virtue of being arranged in a progression, others derive from the relations numbers bear to one another, sets, propositions, sentences, etc. in virtue of all of them being abstract objects.[6]

Waive, for the moment, concerns about Katz's evidence for these claims. There is, according to him, more to our knowledge of the natural numbers than what is expressed in formal number theory; but—according to Katz—Benacerraf's argument discriminates against such informal knowledge: it depends upon a curiously imperialist assumption that *only* those properties expressed in mathematical discourse are relevant to the philosophical endeavor of specifying what numbers are. Thus Benacerraf's error consists in ignoring important properties of numbers; this, in turn, results from disenfranchising the interests and intuitions sustained

Publishers, 1996), 119–39; *idem*, *Realistic Rationalism* (Cambridge, Mass.: MIT Press, 1998), ch. 4.

[4] Paul Benacerraf, "What Numbers Could Not Be," *Philosophical Review*, 74 (1965), 47–73.
[5] Geoffrey Hellman, "Structuralism without Structures," *Philosophia Mathematica*, (2) 4 (1996), 101.
[6] Katz, *Realistic Rationalism*, 109.

elsewhere in the community, outside mathematicians' narrow structural interests. Numbers are not the exclusive property of mathematicians:

> Numbers are, as it were, communal property. . . . The mathematician's special interest in numbers is their arithmetic structure; the philosopher's is with their ontology and epistemology. From the standpoint of the inherent selectiveness of formalization and theory construction, the assumption of Benacerraf's argument that we know nothing about the numbers except what is in number theory seems truly bizarre.[7]

If this is right, then the perplexities posed by rival set-theoretic interpretations of first-order arithmetic can be addressed by augmenting Benacerraf's conditions on *what it is to be a natural number*. The vexed question of whether to accept Zermelo's scheme or Von Neumann's scheme for translating number theory into set theory does not arise: *neither* scheme is acceptable, for the simple reason (ignored by Benacerraf) that numbers are not sets.

And so on. Note that a social-institutional dimension has emerged: according to Katz, portions of the community have been disenfranchised, and therefore relevant intuitions about numbers have been ignored. In assuming that "mathematicians tell us whatever there is to know about numbers," Benacerraf has implicitly treated numbers as "the property of mathematicians," whereas in fact they are (as it were) "communal property." The features cited in specifying the natural numbers have been unduly restricted to structural features; but there is no metaphysical or epistemological justification for such restriction.

This dialectic has a clear echo in the artworld. Although paintings, sculptures, fugues, and other artworks are—unlike numbers—created by people, there is nonetheless a need to determine "who gets to specify" vital properties relevant to interpretation. Perhaps art historians and/or critics tell us "whatever there is to know" about artworks; or perhaps final authority lies with the artist; or perhaps artworks are (as it were) "communal property." The curious thing about this quandary is that it isn't clear how to proceed. Were the ontological question already settled, we could determine who is best situated with respect to artworks—who the "experts" are—and thus whose verdicts are most likely true. But we cannot appeal to an ontology of art in determining whose practices, intuitions, and testimony concerning artworks deserve to be taken seriously, because we do not yet know where

[7] Katz, *Realistic Rationalism*, 111.

the artwork begins and ends, and thus where responsible authority begins and ends. The problem is that we are treating ontology as somehow implicit in practice, but it is not clear which practice is relevant, and why.

The way out of this quandary is to realize that Katz's allegation, though intriguing, is misguided. It is true that Peano arithmetic says nothing about whether numbers are spatially located, have members, or have syntactic properties. And it is true that there might nonetheless *be* such facts—perhaps known by reason alone, and not explicit in the customary axioms, and intuitively grasped by ordinary, reflective people engaged in mathematical activity. But caution is required, lest too many intuitions be permitted to play a role in determining the properties of numbers. Having warned about the perils of disenfranchising portions of the community (and thus disenfranchising relevant properties of numbers), Katz fails to provide any principled mechanism for determining whose intuitions matter, and why. Even if numbers are "communal property," it hardly follows that *all* number-theoretic intuitions deserve equal billing when the task at hand is ontology.

Consider: some ideologically driven community might sustain the strong intuition that numbers are ideas in the Mind of God; it seems odd—pending further directives—to dignify that intuition by treating that theological property as metaphysically constitutive of number. Egalitarianism can be carried too far: perhaps numbers lack that theological property, despite widespread intuitions to the contrary. But refusal to add such properties to those specified in the Dedekind–Peano axioms is no concession to *a priori* atheism; such refusal is grounded, rather, in the (defeasible) conviction that theological properties do no explanatory work. The correct ontology of numbers is the ontology that best explains—when conjoined with auxiliary information about human practices, computational procedures, cognitive capacities, institutional norms, and all the rest—why people think about numbers the way they do. If, perchance, nominalist resources suffice to explain the prevalence and strength of platonist intuitions, then the mere existence of those intuitions provides no refutation of nominalism. Thus the issue does not, after all, rest upon (possibly arbitrary) decisions about "property rights," institutional marginalization, and/or bias toward experts. The issue rests, rather, upon matters of explanatory power, and upon which notion of number packs maximal explanatory punch.

Intuitions are data to be explained. Ontology is part of the explanation. Intuitions should not be ignored; nor should they be automatically

certified (given their source) as accurate.[8] Katz wishes to valorize the widespread intuition that numbers are abstract; but perhaps that intuition can be accommodated—by *explaining* it—without treating it as correct. The point is that numbers have those properties which facilitate the most robust and ramifying explanation of mathematical practice and informal mathematical intuition; adjudication of rival ontological theories turns upon comparisons of explanatory power. And so it goes in the artworld: the correct ontology of Hanson's *House Painter* is that which facilitates the richest, most robust explanation of artworld phenomena. But what phenomena are to be explained?

III

The Katz–Benacerraf dispute is a valuable case study in ontology. We wished to know the nature of a certain object—in this case, natural number. We consulted various intuitions, attempting to construct a list of constitutive features: the resulting list took the form of the Dedekind–Peano axioms. Subsequently we were reprimanded for violation of property rights ("numbers are . . . communal property"): accused of ignoring relevant intuitions and thus failing to acknowledge important constitutive features. Katz's allegations prompted fear that our ontological method smacked of elitism and social marginalization: privileging the "experts" and downplaying others. But we were exonerated: ontology is in the business of explanation, and nothing in the earlier methodology ruled out anyone's intuitions as undeserving of explanation.

There remains the task of applying these methodological morals to artworld cases. The Hanson and Ries examples—easily multiplied across

[8] Thomas Nagel and other "intuitive realists" maintain that intuitions have a privileged, inviolable status: any theory that fails to accommodate ("do justice to," "capture," etc.) them comes up short. Richard Rorty, in contrast, regards intuitions as artifacts of a language-game: traces of a discourse within which we have learned to make non-inferential reports. Given that intuitions are spontaneous judgments, and judgments are things we learn to make in some vocabulary or other, the pragmatist idea is not to ignore intuitions, but only to refuse to grant them primacy. *Qua* mental realities, intuitions deserve to be explained, but their status as intuitions is no guarantor of truth; and we might, under pressure of theory, wish to jettison or revise them. A helpful discussion of the Nagel/Rorty tension concerning intuitions can be found in the Introduction to Richard Rorty's *Consequences of Pragmatism* (Minneapolis: University of Minnesota Press, 1982), esp. pp. xxxv–xxxvii. See also my "Varieties of Pragmatism," *Mind*, 99 (Apr. 1990), 157–83.

artistic genres—dramatize the need to address ontological problems that arise in the context of art criticism and interpretation. It matters whether the outlet cover is part of *House Painter*, whether the spectral pattern on the wall is part of *Lotus*, whether a certain "restoration" results in elimination of a cherished sculpture, and whether the audience response is part of a theatrical performance or a distracting intrusion upon it. These ontological questions matter because they bear upon issues of interpretation and/or proper aesthetic perception; what is not yet clear is how to go about resolving them.

The natural first inclination is to consult the artist: surely Hanson is best situated to determine the boundaries and constituents of his own artistic creation. But an analogy with semantic interpretation tells against such an approach.

Suppose we wish to understand Emily as a speaker of natural language. We wish to interpret her linguistic behavior; this requires, given the holism of interpretation, that we know how much of her behavior qualifies as linguistic. Suppose a reidentifiable grimace (discernible to sensitive observers) routinely accompanies certain utterances; it is unclear whether that grimace packs semantic significance. Two interpreters might disagree: one insisting upon the semantic relevance of the grimace (perhaps it functions as a negation operator, or a device that hedges endorsement), the other wishing to exclude it from semantic evaluation. How might such disagreement be resolved?

Perhaps Emily's *intentions* are the ultimate tribunal: her intentions fix the semantic significance—if any—of her grimace: it matters not whether those intentions are epistemically accessible to the interpreter, or even to Emily. Her grimace is semantically evaluable if and only if she intends it to be.

Not plausible. Emily might lack the self-awareness assumed in granting her such authority: the best interpretation of her linguistic behavior might ride roughshod over her intentions (and beliefs about her intentions) concerning syntax, semantics, or—in this case—lexicon. If the goal is to understand Emily as a speaker, we had better not treat her *self*-understanding as the ideal to which we aspire: Emily might—like most people—fail to see herself and her behavior clearly, and might thus be a poor judge as to which of her behavior qualifies as linguistic. Her intentions do not determine the boundaries of her utterances.

And so it goes in the artworld. If the analogy between semantically evaluable constituents of utterances and interpretable constituents of artworks is viable, then Hanson is not, after all, the final arbiter

of the boundaries of his own artistic creation: he might be mistaken about the constituents of his artwork. His intentions are surely relevant data points: any adequate interpretation of *House Painter* ought to accommodate his artistic goals. But Hanson's mental life—artistic intentions included—is only part of the data to be accommodated by successful interpretation; in artistic behavior, as in linguistic behavior, intentions might be overridden in light of other interpretive demands.[9]

Such considerations are complicated by the fact that we do not know what an interpretation is supposed to do, or what makes one interpretation superior to another; the very idea of *good interpretation*—semantic or artistic—has yet to be explicated. But this much is clear: we cannot say that the superior interpretation is that which accommodates more features of the situation; for this assumes that we know which features of the situation merit accommodation, but that is precisely the problem we are trying to solve.

A familiar analogy arises in epistemology: we cannot say that the superior theory is that which, *ceteris paribus*, explains the most data, because what count as data worthy of explanation depends upon the theory in terms of which the situation is perceived and described. What qualify as data to be explained—like what qualify as data to be semantically or artistically interpreted—cannot be assumed at the outset.

Not that "best explanation" is especially clear. It is far from obvious what constitutes an explanation (as opposed to an idle redescription of the data), or when one explanation trumps another, or whether there are different *kinds* of explanation (perhaps the notions of *explanation* deployed in psychology, economics, particle theory, and literary criticism are importantly different). Perhaps explanation consists in the postulation of underlying causal mechanisms, or the development of

[9] Thus I reject Sherri Irvin's approach to these issues. She suggests that artists fix the features and boundaries of their artworks not only through making and presenting objects, but also through various actions (e.g. correspondence with museum curators) that serve to authorize certain installations and treatments of their work. Irvin stresses that such *artists' sanctions* are not identical to artists' *intentions*—actual or hypothetical—and that in some cases the features sanctioned by the artist might conflict with those she intended. Irvin's discussion illuminates an important aspect of artworld practice; but even if (as she insists) her view contrasts with standard intentionalist approaches, it grants the artist too much special authority in determining the features of her own artwork. See Sherri Irvin, "The Artist's Sanction in Contemporary Art," *Journal of Aesthetics and Art Criticism*, 63 (2005), 315–26.

models that provide unification and/or systematic codification of the data, or the explicit formulation of *justificatory* underpinnings that show certain practices to be rational. Until we know what explanation and interpretation are supposed to do, efforts to think about relations between interpretation, explanation, and ontology—both in and out of the artworld—require caution. Nevertheless, it is becoming clear how we might approach our artworld individuative problems.

IV

Something went wrong in the initial formulation of the problem. Artistic interpretation, it was alleged, presupposes determinate artistic objects (or events) as input; it was assumed that interpretation requires a prior answer to the ontological question about where the artwork begins and ends. This might be a mistake. Perhaps artistic interpretation is *assumed* in solving the ontological problem. Instead of treating interpretation as presupposing artistic objects as input, perhaps we do better to treat ontology and interpretation as sustaining one another, via mechanisms of correction and recalibration, up to reflective equilibrium.

To see how this works, note that a certain interpretive strategy—perhaps plausible in light of other work by the same artist—might be deployed in the very process of delimiting the artwork. Here is one critic's take on Hanson's work:

> The subjects are often surrounded by banal consumer goods. Implied in this juxtaposition is the question of humanity's relationship to industry. Implied in that is a critique of hegemony as deployed through capitalist products. Hanson quietly queries the import of these goods, and their influence on peoples' psychologies.
>
> The inanimate objects (football helmet, lawnmower, etc.) are not replicas; they are real; the flesh is replicated. So, what are usually considered fake (consumer goods) become the most real elements in a Hanson piece. Thus, Hanson's work implies a critique of our notions of reality in a capitalist consumer society.[10]

Whatever the virtues of this perspective, plastic outlet covers surely qualify as "banal consumer goods"; the critic's interpretive stance thereby lends plausibility (however slight) to treating the cover as part of the

[10] The critic is David Shapiro; I am unable to locate the original text.

artwork. Thus, in this case, interpretation drives ontology. Individuative boundaries around *House Painter* are fixed by interpretive and/or explanatory considerations; the outlet cover is part of the work if and only if the best interpretation treats it as part of the work. Notwithstanding strong *caveats* about the nature of—and relations between—explanation and interpretation, the ontological question is thereby illuminated.

Earlier analogies with semantic interpretation prove helpful. Even a jungle linguist, engaged in the task of translating native informants' words, cannot begin with a simple list of items to be translated. Interpretive conjectures drive the linguist to notice aspects of behavior that might previously have been missed, and to entertain the hypothesis that certain (hitherto ignored) gesture-types are fitting candidates for semantic interpretation. Intonation, pitch, and other parameters might be semantically irrelevant in some linguistic environments but urgently relevant in others. A linguist following a procedural checklist of the form "First figure out the lexicon and syntax; then do semantics" will not succeed. Tentative translations invite reassessments of *what it is that deserves to be translated*.

And so it goes in the artworld. We erred in assuming that the status of the outlet cover in Hanson's *House Painter* and the spectral patterns on the wall in Ries's *Lotus* could be determined prior to embarking upon interpretive questions. If interpretive benefits flow from treating the outlet cover as part of the artwork, then the outlet cover is part of the artwork.

Interpretive benefits?

It is not clear what constitutes an interpretive benefit. Moreover, if ontological issues turn on matters of interpretive superiority, there are relativistic risks. Plausibility of interpretation depends upon interests, goals, ideological orientation, and other factors, and often appears to be in the eye of the beholder. Freudian and feminist interpretations of texts, for example, might diverge radically: it is not clear that some more comprehensive interpretation—yet to be articulated—satisfies both factions. If interpretation is interest- and goal-relative, and if ontology is fixed by matters of interpretation, then inclusion of the outlet cover in Hanson's work is itself relative to interpretive perspective. Thus the inclusion of a problematized feature in a given artwork (e.g. the spectral projections in Ries's *Lotus*) varies with interests, explanatory goals, and interpretative orientation: we are left with an ontological pluralism, a relativization of ontology to a plurality of interpretations.

Such relativity should be resisted. Either the outlet cover is part of Duane Hanson's *House Painter* or it is not. An artwork is a determinate whole, difficult though it may be to discover its boundaries. There is a fact of the matter about its features: notwithstanding pluralism of interpretive perspective, ontological determinacy must be restored.

That's one view. Another is that we have no business trying to draw determinate boundaries around certain artworks, and efforts to ensure determinacy are misguided. Ambiguity and irony are part of the work: indeterminacy of constitution is built into its very content.[11] To understand Hanson's piece is, among other things, to experience individuative crises and uncertainties about its boundaries. If the task is to explain critical and interpretive artworld realities, we had best acknowledge that the work is ontologically indeterminate: there is no fact of the matter about whether the outlet cover belongs to *House Painter*.

Perhaps. I do not know whether the best interpretation of Hanson's work attributes such ironies. But despite the postmodern attractions of indeterminacy and uncertainty, this hypothesis is curiously self-defeating: requiring that the outlet cover be an essential feature embedded in such a way as to prompt viewers to wonder whether it is an essential feature. Irony indeed: insofar as the task of ontology is explanation, this "indeterministic" strategy dictates that the artwork be treated as having a determinate constitution, features of which explain the very indeterminacy and uncertainty touted as part of its interpretive content.

Thus it is worth returning to the earlier hypothesis that *House Painter* is a determinate whole, the constitution of which is yet to be determined: if such an ontology provides the best explanation of the interpretive irony and ambiguity broached above, so much the better.

The Katz–Benacerraf controversy points the way. Note that we *might* have said—though we felt no inclination to do so—that natural numbers are abstract relative to those with strong intuitions of their abstractness, and concrete relative to those of nominalist bent. We might have said that the features of natural numbers are interest-relative, and in the eyes of the beholder. But we did not say that: such relativity is implausible. Natural numbers are determinate realities, and either they are abstract or they are not. If they are, the nominalists are massively mistaken; if they are not, Katz and his fellow platonists are massively

[11] I owe this suggestion to Cristina Moisa.

mistaken. Either way, someone is mistaken: an ontological relativism that suggests otherwise must be rejected. The way to block such relativism in the mathematical case appeals to a notion of *natural number* sufficiently robust to explain various perspectives. The mere fact—if it is a fact—that large segments of the philosophical community intuit ("by reason alone") the abstractness of numbers does not compel acknowledgment that "numbers are abstract relative to that community." Not at all. An alternative strategy is to attempt an explanation of such intuitions without necessarily acknowledging their correctness: attempt to provide, for example, a nominalistically acceptable explanation of platonist intuitions. Only when such efforts fail—when it appears that the best explanation of abstractist intuitions requires reference to numbers construed as abstract entities—does a conception of numbers as abstract appear compelling. An obvious methodological analogy involves efforts to explain theistic intuitions in terms of purely secular resources, and conceding theism only when such efforts fail.

V

I do not know whether there exists a "best interpretation" of Hanson's *House Painter*; if such an interpretation exists, I do not know why it qualifies as best: perhaps it provides the most comprehensive story about that artwork in the context of Hanson's biography, or in relation to pieces of the "hyperrealist" genre, or human sculptures rendered in polyvinyl, or the history of art in general, or artists who graduated in 1946 from Macalester College, or all of these, or yet others. Artworld interpretation is a heavily contested phenomenon, and it is far from clear what a "best interpretation" is supposed to do and what questions it is supposed to answer. Efforts to define the ontological boundaries of artworks in terms of "best interpretation" are risky. Here the problems echo those connected with pragmatist efforts to define 'truth' in terms of best scientific theory and the "end of inquiry"; thus Quine:

> Peirce was tempted to define truth outright in terms of scientific method, as the ideal theory which is approached as a limit when the (supposed) canons of scientific methods are used unceasingly on continuing experience. But there is a lot wrong with Peirce's notion, besides its assumption of a final organon of scientific method and its appeal to an infinite process. There is a faulty use of numerical analogy in speaking of a limit of theories, since the notion of limit

depends on that of "nearer than," which is defined for numbers and not for theories. And even if we by-pass such troubles by identifying truth somewhat fancifully with the ideal result of applying scientific method outright to the whole future totality of surface irritations, still there is trouble in the imputation of uniqueness ("*the* ideal result"). For... we have no reason to suppose that man's surface irritations even unto eternity admit of any one systematization that is scientifically better or simpler than all possible others. It seems likelier, if only on account of symmetries or dualities, that countless alternative theories would be tied for first place.[12]

These *caveats* apply equally to current efforts to define artworld ontology in terms of best interpretation—even if we resist assimilating interpretation to explanation. Lacking a clear notion of a "limit interpretation," and lacking a reason to anticipate a unique best result (artistically better or simpler than all possible others) emerging from the interpretive process, we are left with the possibility of "countless alternative interpretations tied for first place," thereby resulting in countless solutions to artworld ontological puzzles. Not good.

Perhaps such pluralism can be resisted.

Two kinds of features are associated with Hanson's *House Painter*: *core* features (the tip of the painter's nose, paint splattered tee-shirt, etc.) are those treated as non-controversial constituents of the artwork; *problematized* features (outlet cover, floor tiles contiguous with the painter's feet, etc.) are those treated as problematic and contested. What qualifies as core, and what as problematized, doubtless rests upon artworld contingencies and critical traditions, and thus varies with discursive context. Nevertheless, the contrast is sufficiently clear in individual cases: unless core features are present, the puzzles that prompt this art-ontological discussion would not arise. Perhaps we can say that superior interpretations are those which, *ceteris paribus*, accommodate more core features of the artwork; and that such interpretations, in turn, determine the ontological fate of problematized features.

Return to critic David Shapiro's interpretation, according to which Hanson's work is about "humanity's relationship to industry" and the influence of inanimate consumer goods upon people's psychologies. Suppose this interpretation provides the best explanation—whatever that means—of the core features of *House Painter*, the core features of other Hanson sculptures, and aspects of the historical situation deemed worthy of accommodating. If these conditions are satisfied,

[12] W. V. Quine, *Word and Object* (Cambridge, Mass.: MIT Press, 1960), 23.

then the outlet cover is part of the work. This ontological verdict is fully consistent with the fact—if it is a fact—that other art-interpretive communities offer different verdicts: the question is whether the Shapiro interpretation—and the ensuing Shapiro-inspired ontology—provides sufficient resources for explaining such alternative verdicts.

Here the mathematical analogy is telling: the nominalist's task is not to concede defeat in the face of platonist intuitions, but rather to explain the existence and prevalence of such intuitions, thereby accommodating them without necessarily treating them as correct. We seek the best explanation of the way most people—mathematicians and non-mathematicians included—think about natural numbers. And, analogously, we seek the best explanation of the way most people—experts and non-experts alike—think about Hanson's work. If construing the cover as part of the artwork furthers that explanatory aim, the ontological question is thereby resolved. Once the boundaries of the artwork are fixed, a foothold is provided for *normative* claims: there is a *correct* way to experience Hanson's work—or, at the very least, an *in*correct way to experience it, by ignoring constitutive properties—given what it is. A viewer who ignores the outlet cover in experiencing and/or interpreting *House Painter* is making a mistake.

Having conveniently sidestepped complexities associated with *best interpretation* and *best explanation*, ontology falls neatly into place: the correct ontology of individual artworks and performances is that which provides maximal explanatory power. It might be helpful to explore the general strategy in other artistic domains: music performance, for example, prompts individuative questions about constitution and boundaries, and such questions are susceptible to similar treatment.

VI

Consider a typical jazz audience. It contains listeners responsive to rhythmic complexities, harmonic subtleties, melodic continuities, musical interplay among musicians, and other relevant parameters. These listeners understand the genre. In some important way—yet to be specified—they are participants in the performance: a musician has a strong sense of working collaboratively with them. Perhaps an adequate metaphysics of jazz should reflect this intimate tie between players and audience: it is a special tie, different from that which occurs in most other musical genres.

Unfortunately, typical jazz audiences also contain people engaged in conversation and generally oblivious to the performance. They do not listen; most of them do not know how to listen. Often they are loud and intrusive, obscuring dynamic subtleties with their chatter. Some are tone-deaf; some treat live music performance as a resource intended to facilitate conversation and pair bonding. Unfortunately, working players have little choice but to deal with such patrons: they are part of the audience. They too are participants in the performance, insofar as their behavior stands in complex feedback relations to what is produced on the bandstand.

This is the plight of the public venue. Any artform—painting, ballet, slam poetry, sculpture, performance theater, film, classical music, etc.—is likely to attract some visitors capable of selective aesthetic attention and others who are not.

Is (some of) the audience part of the performance?

The question seems idiosyncratic—perhaps silly—to those removed from the realities of live music (although R. G. Collingwood, speaking of artforms other than music, insisted upon the artist–audience relation as "collaborative".)[13] But actively engaged participants in the music world have decisions to make—aesthetic decisions—about where to focus their attention. If the audience consists not of "mere observers" but itself constitutes part of the performance, then proper aesthetic perception requires attending not only to John Scofield's improvised melodic contours, for example, but also to their impact upon the audience and the audience's impact upon his improvisations. The ontological question thus bears upon questions of selective aesthetic attention: perhaps, in the world of jazz, to "bracket" the audience is to ignore an important constituent of the artwork.

Perhaps. It is undeniable that feedback between performers and audience—and causal relations between performers and other contextual factors—exist in all performance situations: even a classical musician is affected by audience response. But it is a matter of degree: in some genres audience participation assumes greater significance. Perhaps the audience is a constituent of jazz performances by Jimmy Smith at the Club Baby Grand, but not of classical performances by the New York Philharmonic at Lincoln Center; perhaps understanding a genre requires knowing, among other things, where to define

[13] R. G. Collingwood, *The Principles of Art* (Oxford: Oxford University Press, 1938), 311–24.

the "cut" between artistic performance and observer. And important contrasts exist even *within* genres: Glenn Gould sought to hermetically isolate himself from live audiences, finding them distracting and conducive to artistic compromise, whereas Rubinstein sought close rapport with his audiences. Even *within* a genre (in this case, concert piano performance) the aesthetic significance of the audience may vary.

Grant that *core* features of an improvised jazz performance consist of melodic phrases, chord sequences, modulations, metrical pulse, rhythmic figures, instrument timbre, and other events constituted by the elements of tonal music. There is room for speculation about the constitutive significance of *problematized* features: amplifier distortion, musicians' body language and position on the bandstand, attire, lighting, density of cigarette smoke, inebriation level of sound crew, color of background wall, depth and chemical structure of substances coating the stage, and visible extent of players' interpersonal rapport. The issue is which of these features (if any) constitute the performance and which belong to "extraneous" embedding conditions: in a phrase, how much is picture and how much is frame. More specifically: the present question is whether the audience—a problematized feature—is constitutive of the jazz performance.

The answer depends upon the individual case: as with the Gould–Rubinstein example, there is variation within the genre. Some players "feed off" the audience: their performance is closely linked to listener response. Other players are more distant: their behavior during live performance differs little from that in studio conditions. Some players aim to replicate, in their public appearances, playing dynamics achieved under isolated practice conditions; others revel in vulnerability to audience contributions. Rahsaan Roland Kirk was of the latter sort: an unresponsive and/or hostile audience could drag down his playing considerably; an enthusiastic and supportive audience could move him to extraordinary musical pinnacles. Bill Evans, in contrast, was more isolated: relatively aloof from his audience, providing lyrically rich musical explorations that appeared to flow primarily from his soul construed as an isolated system. These characterizations are subject to dispute, but bear upon the question at hand: Rahsaan's audiences, unlike Evans's, are part of the performance. To ignore the audience at a Roland Kirk performance is to ignore an aesthetically relevant aspect of what is going on. Miles Davis famously turned his back on his audience, working to filter out their reactions so as to facilitate greater

concentration; insofar as he succeeded, he provides yet another instance of performance of which audience is no part.

The audience (a problematized feature) is a constituent of the performance when perception of audience response bears essentially upon proper perception of core features. Some cases are reasonably clear: Evans's harmonic transformations are not illuminated by the behavior of listeners seated near the bandstand, whereas organist Tony Monaco's climbing onto a Hammond B-3 during "Caravan" cannot be understood in isolation from the frenzied and hysterical reactions of his audience. The constitutive ontological relation in question is *normative*: a matter of how one *ought* to perceive the music and the elements around it. That normative relation holds when certain causal dependencies hold: if the core features depend counterfactually upon problematized features, the latter features belong to the artwork.

This can't be right. It allows far too many features to be constitutive. Recall the earlier suggestion (see Chapter 3) that a musician's emotional life might be a causal-explanatory antecedent of a performance without thereby being an aesthetically relevant constituent of that performance. The contrast between cause and content is vital; but here that contrast is threatened. Pat Martino's harmonic substitutions in "El Hombre" are—*qua* human actions—results of countless factors, most of them aesthetically irrelevant: food intake, ambient temperature, alcohol consumption, a recent stroke, and the like. Obviously not all causal forces sustaining core features are aesthetically relevant. What is needed is a principled basis for ruling Martino's audience—but not his dinner—part of the artwork, despite the causal efficacy of both.

The challenge is to screen off causally sustaining but aesthetically irrelevant features. This is a difficult problem—going far beyond aesthetic theory—that presents itself whenever causation plays a constitutive role in the specification of content.[14]

Consider an oversimplified case involving causal factors relevant to natural-language interpretation: candid utterances of 'gavagai' are typically caused by rabbits looming in the speaker's vicinity, thereby suggesting 'rabbit' as the most plausible translation; but countless other features enter into the causal chain between distal stimulus and utterance

[14] A helpful overview of this problem in the context of semantic theory and mental content attribution is Brian McLaughlin, "What is Wrong with Correlational Psychosemantics?," *Synthese*, 70 (1987), 271–86; see also Jerry Fodor, "Semantics, Wisconsin Style," *Synthese*, 59 (1984), 231–50.

event, and it is unclear which of these intermediaries, if any, belong to the semantic content of the expression. 'Gavagai' utterances are triggered by local rabbits only under certain neurochemical conditions: yet those conditions are no part of the meaning of 'gavagai'. Perhaps any analysis of content in terms of cause is doomed to failure; or perhaps there exists a principled procedure for distinguishing semantically relevant features of the causal chain from those that figure merely as background conditions.

Radical translation notwithstanding, the issue here does not—in any straightforward way—concern the *content* of a musical performance: it is even doubtful whether any familiar notion of *content* is applicable to musical events. The issue concerns, rather, the aesthetically relevant aspects of music performance: those features of the situation to which a comprehending listener should attend. The point of the above remarks is to highlight a tempting analogy with the semantically relevant aspects of linguistic performance: those features of the situation to which a comprehending conversationalist should attend. Proper understanding of Emily's utterances might or might not require attention to her occasional grimaces; proper understanding of Duane Hanson's *House Painter* might or might not require attention to the outlet cover; proper understanding of Pat Martino's performances might or might not require attention to his listening audience. And so on.

The notion of *proper understanding* of an artwork obviously bears tremendous theoretical burden here. But the above analogies—between *understanding linguistic behavior* and *understanding artistic performances*—might be misleading: music performance is not linguistic utterance; semantic comprehension is not aesthetic comprehension. Nevertheless, such analogies are perennially tempting. For the present we appeal to some inchoate notion of *understanding artworks and artistic performances* that permits resolution of the problem at hand.

The phenomenology of music performance is relevant here. Many performers see themselves as essentially *en rapport* with audience members, connecting with them in a way that rivals their connections with other players; this might be illusory, but it might not be. And audience members often feel themselves part of the band, insofar as they perceive the efficacy of their own behavior in determining energy dynamics, choice of material, and other aspects of musicians' performance behavior; this might be illusory, but it might not be. Phenomenology is, I have insisted, no infallible indicator of truth; but it is a factor that merits explanation. Under the circumstances there is no obvious objection to

the bold ontological hypothesis that the audience is, indeed, part of the performance. Such a hypothesis serves to explain the phenomenology, and provides a ground for the sense that selective attention to the audience is essential to proper experience of certain musical events. Ontology is in the service of explanation. Pending a careful specification of precisely what is supposed to be explained, what constitutes an explanation, and when an explanation surpasses another, this leaves us in the precarious position of not knowing what constitutes a plausible ontology, or when one solution to an artwork constitution problem surpasses another.

But more than explanation is at stake: much of the above discussion is dominated by concern with *interpretation* and *proper aesthetic perception*. The artworld is saturated with *norms*: norms of production, presentation, perception, reaction, criticism, interpretation, and all the rest. Proper response to an artwork—whether sculpture, painting, poem, or music performance—depends upon *what that artwork is* and *what features it possesses*. Ontology is thus also in the service of justification: warranting certain reactions to artworks as correct and delegitimizing others as mistaken. If treating the outlet cover as part of Hanson's *House Painter* is part and parcel of the best interpretation (whatever this might mean) of that work, and if treating Thelonious Monk's audience as part of the session (enshrined in *Live at the Village Vanguard*) leads to the most comprehending grasp (whatever this might mean) of Monk's playing, then the ontological perplexities are thereby resolved.

Humpty Dumpty's wisdom—it depends on "which is to be master"—is thus applicable on several fronts. Perhaps ontology is master of interpretation: after all, interpretation is something people *do*, and interpretive behavior would not occur unless ontology were already in place. There must be a domain of determinate objects, properties, and events serving as prompting stimuli. Ontology thus precedes and guides interpretation: ontology is presupposed if there is to be anything to interpret. But if the foregoing considerations are correct, perhaps interpretation is master of ontology: the constitution of artworld objects and performances is determined by interpretive constraints. Interpretation thus precedes and guides ontology: without interpretive endeavors there would be no principled way to draw boundaries around artworld objects. Concerning ontology and interpretation, it is not clear which is to be master.

Then there is the issue of who gets to decide the boundaries of artistic objects and performances. Perhaps Hanson himself determines

the constitution of his sculpture—by explicit intention or otherwise. Or perhaps other forces make that determination, and Hanson—like a parent sending his child out into the world—loses authoritative control, leaving artworld ontological facts to be fixed by others. Concerning artist, critic, and audience, it is not clear which is to be master.

Despite these conundrums, there is progress. There is a clearer sense of what we are doing in confronting ontological questions, and a clearer sense of the standards relevant to adjudicating among rival ontological hypotheses. Artworld individuative puzzles resolve into puzzles about best interpretation and best explanation. Further investigation into these latter notions is obviously in order.

6
Pluralism and Understanding

Barnett Newman's *Adam* (1952) is an oil-on-canvas painting consisting of vertical bands of intense color over a darker field. The majority of Newman's later works—usually categorized as "Abstract Expressionist"—consist of areas of color separated by lines ("zips"). These artworks present the viewer with formidable interpretive puzzles: despite their apparent simplicity, Newman's paintings are often treated as "among the most challenging works of art of the twentieth century."[1] The following anecdote—which dramatizes the interpretive complexities of Newman's work—describes a confrontation between a disgruntled art collector and two of Newman's fellow Abstract Expressionist painters:

Franz Kline and Elaine de Kooning were sitting at the Cedar Bar when a collector Franz knew came up to them in a state of fury. He had just come from Newman's first one-man show. "How simple can an artist be and get away with it?" he sputtered. "There was nothing, absolutely nothing there!"

"Nothing?" asked Franz, beaming. "How many canvases were in the show?"

"Oh, maybe ten or twelve—but all exactly the same—just one stripe down the center, that's all!"

"All the same size?" Franz asked.

"Well, no; there were different sizes; you know, from about three to seven feet."

"Oh, three to seven feet, I see; and all the same color?" Franz went on.

"No, different colors, you know; red and yellow and green . . . but each picture painted one flat color—you know, like a house painter would do it, and then this stripe down the center."

"All the stripes the same color?"

"No."

"Were they the same width?"

[1] From the online commentary provided for a Barnett Newman exhibition at the Philadelphia Museum of Art; see www.philamuseum.org/exhibitions/exhibits/newman/index.html

The man began to think a little. "Let's see. No. I guess not. Some were maybe an inch wide and some maybe four inches, and some in between."
"And all upright pictures?"
"Oh, no; there were some horizontals."
"With vertical stripes?"
"Uh, no, I think there were some horizontal stripes, maybe."
"And were the stripes darker or lighter than the background?"
"Well, I guess they were darker, but there was one white stripe, or maybe more..."
"Was the stripe painted on top of the background color or was the background color painted around the stripe?"
The man began to get a bit uneasy. "I'm not sure," he said, "I think it might have been done either way, or both ways maybe..."
"Well, I don't know," said Franz. "It all sounds damned complicated to me."[2]

This remarkable anecdote raises questions about artistic understanding and attributions of artistic content.

I

Kline did more than highlight physical features of Newman's paintings that the collector had overlooked; any person, however ignorant of art history and/or Newman's work, might have done that. Kline purported to highlight *aesthetically relevant* features: aspects of the paintings (allegedly) essential to their meaning or significance. Kline's questions aimed to undermine the collector's sense that there was "nothing there": there was (according to Kline) plenty there, but the collector failed to discern it. Kline's observations thus resemble those that a skilled translator might offer to a non-comprehending listener convinced that an acoustic stimulus is "mere noise": the sounds are not mere noise, but discerning their content requires identifying and tracking semantically relevant features.

The operative assumption is that aspects of Newman's paintings highlighted by Kline (e.g. the relation between color of field and width of zips) are genuinely relevant to the meaning or significance of the work, and that the collector, having overlooked such features, thereby failed to understand what was going on. But it is not clear that the features

[2] Thomas B. Hess, *Barnett Newman* (Greenwich, Conn.:New York Graphic Society Ltd., 1971), 89.

Pluralism and Understanding 123

highlighted by Kline are genuinely relevant, or—if they are—what makes them so.

Suppose some rival critic had highlighted aspects of the work *other* than those identified by Kline; might that rival critic have been mistaken? Might Kline, for all his cleverness and knowledge of the genre, have been mistaken? Is there something here to be mistaken about? Perhaps certain features of Newman's work are genuinely relevant to its meaning, and thus to its proper interpretation, whereas other features can be safely ignored. Or perhaps not: there might be "no fact of the matter" about which features of the work have greater interpretive significance than others, in which case Kline cannot claim triumph over the collector. Perhaps the collector was right after all: there is "nothing there" (over and above unnoticed physical attributes of physical objects) despite Kline's gallant efforts to show otherwise.

Such questions point toward issues broached earlier. We did not know whether the outlet cover is relevant to proper interpretation of Duane Hanson's *House Painter*, or whether the audience is part of the jazz performance and thus a factor that must be tracked by comprehending listeners; we do not know whether the width of zips in Newman's *Adam* is a feature to which a comprehending viewer must attend, or, if so, why.

The collector's goal, we might suppose, is to *understand* Newman's work: perhaps this consists of his having a correct interpretation, or—depending upon the role assigned to interpretation in our interactions with artworks—of his seeing, experiencing, and responding to the work properly. The basic assumption behind Kline's dialectic is that there is such a thing as "getting it right"—or, at least, as "not getting it": the collector didn't get it, and Kline tried to help. Perhaps there is only one way to get it right: call this the *monist* option; or perhaps there are many ways to get it right: call this the *pluralist* option.

Pluralism is intimately related to *tolerance*: a tenet of liberal democratic orthodoxy is that Tolerance is a Good Thing. But not all forms of tolerance should be tolerated. Fashionable relativisms and postmodern rhetoric notwithstanding, there is a way the world is: there is a way to get it right, many ways to approximate it, and many ways to get it wrong. There are, for example, determinate facts about the electrostatic properties of copper; no "plurality of equally correct but incompatible" characterizations of such facts should be countenanced. Perhaps this is irrelevant: scientific description might be importantly *different* from artworld-interpretation. Although Ptolemy and Copernicus could not

both have been correct about planetary trajectories, Franz Kline and his rivals might all be correct about the aesthetically relevant features of Newman's work, despite genuine disagreement amongst themselves about which features qualify. Perhaps there is no single, unique interpretation and/or experience requisite for artistic understanding: if there is a way to get an artwork right, then there are many.

Once the pluralistic rhetoric is put aside, it is difficult to see what any of this might mean. Genuinely incompatible theories—artworld-interpretive or otherwise—surely cannot both be correct (unless the pluralist gives 'correct' a non-standard interpretation). The challenge—beautifully described by Davidson in a related context—is to improve intelligibility while retaining the excitement.[3]

II

Critical Pluralism is the thesis that artworks admit of alternative, equally acceptable ("correct") interpretations, some of which are incompatible with others; it asserts that if there is a way to get an artwork right, then there are many ways. Thus construed, Critical Pluralism (hereafter 'CP') contrasts with *Critical Monism* ("There is a single correct, complete interpretation of an artwork"), and with *Critical Anarchism* ("All interpretations of an artwork are equally acceptable"). CP is an exciting thesis: it entails that two critics could lay equal claim to understanding the same artistic phenomenon despite serious interpretive disagreements with one another. It promises *rival interpretations*: complete interpretations, each of which accounts for all the artwork's features—yet all equally correct, and genuinely incompatible. CP is thus puzzling: it strains at our ordinary concepts of *correctness, completeness, disagreement,* and *incompatibility*. In what sense are the touted "rival" interpretations genuinely incompatible? Does one interpretation really affirm what another denies? In what sense are they "equally correct"? (Does 'correct' here mean 'true'?) In what sense do they account for all of the artwork's features? What would it *be* to "account for an artwork's features"?

Problems of coherence and intelligibility aside, two immediate questions arise: one concerns the importance of CP, the other concerns the reasons, if any, for accepting it. Although Critical Monism is not

[3] Donald Davidson, "On the Very Idea of a Conceptual Scheme," in *Inquiries into Truth and Interpretation* (Oxford: Clarendon Press, 1984), 183.

without adherents,[4] pluralism is the dominant sentiment within the artworld. Terry Barrett, for example, claims as a basic principle of interpretation that "Artworks attract multiple interpretations and it is not the goal of interpretation to arrive at single, grand, unified, composite interpretations."[5] Despite his acknowledgment that some interpretations are more coherent, reasonable, convincing, and informative than others—thereby rejecting what I call "Critical Anarchism"—Barrett nonetheless insists that "there is a range of interpretations any artwork will allow."[6] It is not clear, however, what sorts of arguments support his pluralistic preferences.

In adjudicating between monism and pluralism, it would be helpful if we had a better sense of what it is to *understand* an artwork, insofar as these doctrines bear upon the number of routes to artistic understanding. We know, for example, that Franz Kline regarded the irate collector as failing to understand Newman's work: according to Kline, the collector didn't get it. But we do not know precisely what it *is* to "get it": we do not know what *artistic understanding* consists of. We do not know how such understanding relates, for example, to the forms of understanding at work when a native speaker (or translator) understands a grammatical sentence, or when a scientist understands the data, or when a person understands another person's actions and/or mental states. Nor do we know how artistic meaning—that which is specified in artistic interpretation—relates to linguistic content, or to the meaning of socially significant non-linguistic gestures, or to the content of psychological states, or to other interpretable phenomena. We need a better understanding of interpretation and understanding, artistic and otherwise.

A *caveat*: "pluralism" is said in many ways. Some views roughly characterizable as "pluralistic" are not targeted in what follows. Consider a possible analogy between interpreting artworks and describing persons. Any effort to tell "the whole story" about Robin, for example, involves a plurality of complex descriptions: facts about her life as Nurse Practitioner, art enthusiast, parent, spouse, friend, daughter, and community activist must all be accommodated. Perhaps any effort to pin down a "single, grand, unified, composite" story about her is misguided (except

[4] See, e.g., Alexander Nehamas, "The Postulated Author: Critical Monism as a Regulative Ideal," *Critical Inquiry*, 8 (1981), 133–49.
[5] Terry Barrett, *Interpreting Art: Reflecting, Wondering, and Responding* (New York: McGraw-Hill, 2003), 198.
[6] Ibid.

in the trivial sense that the set-theoretic union of this plurality of stories is constructible, thereby resulting in a single story). Understanding Robin's intricate life requires attention to a variety of stories, each of which is potentially infinite; this looks vaguely "pluralistic." Perhaps some analogue of this situation obtains in the realm of artworld interpretation. But note that the alleged pluralities involved in characterizing Robin's complex life flow from an underlying explanatory ground: persons are unified entities, and the properties manifest throughout her plurality of roles flow from some personal essence—her character. Her patience and compassion, for example, explain *both* her professional *and* her parental temperament; her cleverness and deftness of mind explain both her problem-solving skills in hospital settings and in dealing with friends' crises. And so on. If there is indeed such an underlying essence from which her multifarious properties flow, and there is a story that best explains features exemplified throughout her plurality of roles, there is, after all, a "single, correct story" about Robin. Monism vindicated. Postmodern gestures toward the "fragmentation of the self" notwithstanding, understanding Robin requires understanding *why* she exhibits the features she does throughout her various involvements. Note that the notion of *explanation* again moves to the forefront, this time in its unifying capacity.

Work is required to rigorously formulate the sense(s) of "pluralism" at issue here, and to vindicate present assumptions about the existence of an underlying "explanatory essence" that serves to unify a person's life. But perhaps some rough analogue obtains in the artworld: a plurality of informative stories—cast in incommensurable vocabularies—each of which is important to understanding a given artwork, but—in contrast to the personal case—not susceptible to explanation in terms of some unified, underlying essence. That would be a pluralism worth taking seriously. Or perhaps there exists an artworld correlate of Davidson's "anomalous monism": different classes of predicates "not made for one another" yet applicable to the same artwork and relevant to its interpretation.[7] Such art-interpretive pluralisms would be interesting, were they to obtain; but pending arguments in their favor they do not merit refutation.

Several strategies in support of Critical Pluralism suggest themselves; it will emerge that none is convincing: the Critical Monist will have a

[7] Donald Davidson, "Mental Events," in L. Foster and J. W. Swanson (eds.), *Experience and Theory* (Amherst, Mass.: University of Massachusetts Press, 1970), 79–101.

ready, if labored, response to each. Obviously this does not demonstrate the falsity of CP; but in light of other plausible assumptions about interpretation—discussed below—it provides sufficient basis for skepticism. Given the prevalence of pluralistic sentiments within the artworld, this result is non-trivial.

III

One way to approach the issue is to explore parallel puzzles concerning the metaphysics of linguistic meaning: in the wake of Quine's arguments for the indeterminacy of translation, there is ongoing dispute about the existence of "mutually incompatible but equally correct" translations of sentences in natural language. Quine's results are pluralistic: if there is one correct translation scheme from an alien language to our own, then there are many such schemes. Perhaps Quine's arguments are applicable to artworld interpretation: there might be enough points of contact between artworld interpretation and natural-language translation to render such explorations useful. If Quine is right—if there is "no fact of the matter" (beyond correlations between stimulatory input and linguistic behavior) about sentence meaning and the reference of singular terms—perhaps similar considerations apply to the artworld, thereby providing support for interpretive pluralism. If so, it is ill-advised to seek the "proper interpretation" of an artwork: there are many, incompatible interpretations; and it is, likewise, ill-advised to seek those features of Newman's paintings relevant to their proper interpretation: different interpretive strategies—all of them equally correct—identify different classes of such features.

Exploring such "parallels" might do more harm than good: artistic genres are not natural languages. Artworld interpretation might diverge sufficiently from natural language translation to render arguments within linguistic theory completely irrelevant; but even a clear articulation of such divergences would itself represent progress.

Quine claims that natural-language meaning is *indeterminate*: for any given language L, it is possible in principle to construct incompatible translations of L ("rival translation manuals"), all of which are equally correct. As Quine puts it,

manuals for translating one language into another can be set up in divergent ways, all compatible with the totality of speech dispositions, yet incompatible

with one another. In countless places they will diverge in giving, as their respective translations of a sentence of one language, sentences of the other language which stand to each other in no plausible sort of equivalence however loose.[8]

The argument turns on specifying the constraints on "proper translation" and noting that various non-equivalent functions from one language to another satisfy those constraints equally well.

The heart of Quine's argument for the indeterminacy of translation (hereafter 'IT') involves the specification of conditions that (allegedly) implicitly define *correct translation*. A function f is claimed to be a *correct translation* of L into L' if and only if certain conditions are met: f is a recursive function that pairs observation sentences in L with stimulus-meaning equivalent observation sentences in L'; f commutes with truth functions; f pairs stimulus-analytic (stimulus-contradictory) sentences in L with stimulus-analytic (stimulus-contradictory) sentences in L'; and so on. Explanation and rationale for these conditions require considerable background discussion, insofar as they draw upon elaborate behavioristic machinery developed by Quine in Chapter Two of *Word and Object*. But the intuitive idea is clear enough: according to Quine, a correct translation is any mapping from L to L' that meets these conditions.

The argument is, to say the least, controversial. Opponents claim that it assumes an indefensible bifurcation of translation and natural science: that the analytical hypotheses demanded by translation are, *pace* Quine, genuine hypotheses, ontologically on a par with the theoretical hypotheses of mathematical physics. There are other familiar criticisms: that Quine's arguments rest upon indefensible forms of behaviorism; that the bifurcation of semantic discourse and scientific discourse is incompatible with Quine's own scientific realism; that the bifurcation stems from prejudice in favor of elementary particles and against intensional entities; that IT promises full-blown rival translation manuals but fails to deliver; that first-person access to intentional contents of our own utterances provides immediate disconfirmation of IT; that the thesis is self-refuting; or that the thesis is unintelligible.[9] There is little agreement

[8] W. V. Quine, *Word and Object* (Cambridge, Mass.: MIT Press, 1960), 27.
[9] The literature in this connection is enormous. See, e.g., Donald J. Hockney, "The Bifurcation of Scientific Theories and Indeterminacy of Translation," *Philosophy of Science*, 42 (1975), 411–27; Noam Chomsky, "Quine's Empirical Assumptions," in D. Davidson and J. Hintikka (eds.), *Words and Objections: Essays on the Work of*

about the correctness of IT, the cogency of Quine's arguments for it, or its precise consequences. But *prima facie* the thesis is profound: it says that if there is a way to get the natives' discourse right, then there are many ways.

One is inclined to ask how Quine came up with the specific list of conditions that implicitly define 'correct translation,' and whether he might inadvertently have omitted important conditions from the list. Hilary Putnam notes that

[i]f the adoption of one system of analytical hypotheses rather than another permits a great simplification of such sciences as neurophysiology, psychology, anthropology, etc., then why should we not say that what we mean by 'translation' is *translation according to the manuals that have this property*?[10]

One way to put Putnam's criticism is that the alleged plurality of "correct translations" is an illusion wrought by inadequate specification of *what it is for a function to be a correct translation*. Crudely: IT is a trivial consequence of too minimal a set of constraints on translation.

Artworld analogues of natural-language translation—and of indeterminacy—come to mind.

Peter Kivy, in a discussion of musical formalism, offers the following:

Now in music of the Middle Ages and Early Renaissance, there are musical events that sound to *us*, because we live in the historical period of the major–minor tonal system, exactly like the dominant tonic cadential figure: the moving from tension to rest. But in the syntax of that historical period, they perform an entirely different function: in particular, they perform a continuing function rather than a cadential one from tension to rest. So, if a musical composition is continuing rather than coming to rest at a certain point, then it possesses, quite literally, a different form, a different formal structure from a piece, *making exactly the same sounds*, that is coming to rest there.[11]

Kivy invokes this example as illustrative of the *historical contingency of musical form*: a listener hears certain medieval tonal events incorrectly

W. V. *Quine* (Dordrecht: D. Reidel, 1969), 53–68; Richard Rorty, "Indeterminacy of Translation and of Truth," *Synthese*, 23 (1972), 443–62; Hartry H. Field, "Conventionalism and Instrumentalism in Semantics," *Nous*, 9 (1975), 375–405; John Searle, "Indeterminacy, Empiricism, and the First Person," *Journal of Philosophy*, 84 (Mar. 1987), 123–46; Jerrold Katz, "The Refutation of Indeterminacy," *Journal of Philosophy*, 85 (May 1988), 227–52.

[10] Hilary Putnam, "The Refutation of Conventionalism," *Nous*, 8 (1974), 38.

[11] Peter Kivy, *Introduction to a Philosophy of Music* (Oxford: Oxford University Press, 2002), 103–4.

if contemporary listening habits are deployed. There is a correct way to hear a given musical passage; the standard of correctness is dictated by historical context. Insofar as there is a "fact of the matter" as to whether a given tonal event constitutes a piece of medieval music, there is a fact of the matter concerning its musical formal structure. No indeterminacy here.

But indeterminacy lurks in the vicinity. There could be a contemporary composer, deeply influenced by medieval music, whose work prompts genuine puzzles among informed listeners about proper perception of certain passages—whether, for example, a given sequence of tones should be heard as an instance of continuity or as a dominant–tonic resolution. In such cases, I suggest, there is foothold for attributing indeterminacy (this suggestion is no part of Kivy's agenda).

Related examples can be found elsewhere in the artworld. Kendall Walton argues that the kinds of experiences requisite for proper perception of an artwork are determined by the *category* to which the work belongs, and he offers a set of conditions that determine, in most cases, the artistic category in which a given artwork is properly perceived. But sometimes it happens that one cannot specify criteria for correct aesthetic perception, because the stated conditions determine no unique category. In discussing situations of this kind, Walton considers a possible critical dispute about Giacometti's thin metal sculptures:

> To a critic who sees them simply as sculptures, or sculptures of people, they look frail, emaciated, wispy, or wiry. But that is not how they would strike a critic who sees them in the category of thin metal sculptures of that sort (just as stick figures do not strike us as wispy or emaciated). He would be impressed not by the thinness of the sculptures, but by the expressive nature of the positions of their limbs, and so forth, and so no doubt would attribute very different aesthetic properties to them. Which of the two ways of seeing these works is correct is, I suspect, undecidable... So perhaps the dispute between the two critics is essentially unresolvable. The most that we can do is to point out just what sort of a difference of perception underlies the dispute, and why it is unresolvable.[12]

Such "unresolvabilities" are, I submit, instances of indeterminacy.

These examples are problematic: if no indeterminacy infects genre-type or artistic category membership, then such cases provide no instances of interpretive pluralism; compelling artistic examples must be

[12] Kendall L. Walton, "Categories of Art," *Philosophical Review*, 79 (1970), 362.

sought elsewhere. But most claims of indeterminacy prompt controversy, and (alleged) artworld examples are no exception.

If the pluralist seeks to appropriate arguments for CP modeled on those provided by Quine in support of IT, and if Quine's arguments deploy too sparse a set of defining conditions on 'correct translation,' then pluralism gains no support: the touted multiplicity of "incompatible but equally correct interpretations" is an unexciting consequence of an inadequate characterization of *interpretative correctness*.

If that is so, then CP is an artifact of faulty methodology: a trivial consequence of too minimal a set of constraints on proper artwork interpretation. Unfortunately, such constraints (in contrast to Quine's constraints on correct translation) are not likely to be made explicit, given the customary methodology of aesthetic theory; thus it is difficult to show that this "Quinean" route to CP is unsuccessful. But the opponent of CP can shift the onus: demand that the pluralist specify precisely what he or she takes "correct interpretation" to *be*, and, in light of the pluralist's response, insist that the specification omits vital conditions—conditions which, once added, rule out touted "rival interpretations" as inadequate. Indeed, the monist can throw down the gauntlet: treat the existence of "incompatible but equally correct" interpretations of an artwork as itself a *reductio ad absurdum* on any set of conditions that allows such a result. This has the effect of rendering the pluralist's position doomed from the outset: no characterization of "correct interpretation" which admits of pluralistic results will be deemed acceptable by the monist. But extreme situations call for extreme measures.

This "extreme measure"—which essentially involves building the falsity of critical pluralism into the very notion of 'correct interpretation'—is less outlandish than might first appear. David Lewis provides a beautiful statement of the underlying rationale:

Could indeterminacy of beliefs, desires, and truth conditions also arise because two different solutions both fit all the constraints perfectly? Here is the place to hold the line. This sort of indeterminacy has not been shown by convincing examples, and neither could it be shown—to me—by proof. *Credo*: if ever you prove to me that all the constraints we have yet found could admit two perfect solutions... then you will have proved that we have not yet found all the constraints.[13]

[13] David Lewis, "Radical Interpretation," in *Philosophical Papers, Vol. I* (New York: Oxford University Press, 1983), 118.

Lewis is not here addressing art-interpretive considerations of the sort that concern us; but his methodological "Credo" is surely relevant, and leads to a fascinating line of inquiry. Earlier we wondered whether such properties as *being abstract* or *not being identical with any set* belong among the defining conditions for 'natural number'—and, if so, why. This generated puzzles about how implicit definitions are to be crafted: whose intuitions deserve to be represented in such definitions, and why. In the present context, the goal is to codify prevalent intuitions about "correct artworld translation," thereby resulting in a set of conditions—not unlike the Dedekind–Peano axioms for natural number, or Quine's constraints on translation—and then see whether "all the constraints . . . could admit two perfect solutions": if so, CP is thereby validated.

But suppose the view is prevalent among art critics, aesthetic theorists, and artists themselves that critical pluralism is true. In that case—pending further directives—we must designate as a constituent feature of *correct interpretation* that it is never unique. In other words: *I* qualifies as a "correct interpretation" of Newman's *Adam* (for example) only if there exists some interpretation *I'* distinct from *I* such that *I'* is also a correct interpretation of Newman's *Adam*. To be a correct interpretation is, *inter alia*, to be one of a bunch: it is stipulated from the outset that artworld interpretations travel in pluralistic packs. A suspiciously quick and simple route into pluralism! (Compare Katz's methodology, which provides a suspiciously quick and simple route into platonism.) But this strategy rekindles some familiar questions: How are we to determine the conditions that implicitly define 'correct interpretation'? What would a correct characterization of "correct interpretation" *be*? Why?

In light of such complexities, arguments for Critical Pluralism modeled on Quinean arguments for the indeterminacy of translation are not likely to be convincing.[14] Perhaps other justificatory strategies are available to the pluralist.

IV

There is a venerable but controversial view about a methodological contrast between natural science and "interpretive" inquiries such as

[14] William Lycan (private communication) suggests yet another reason to be skeptical here: "In the case of translation, Quine thinks there *must* always be competing translation manuals, because he has algorithms for generating them. There aren't, at least not obviously, such algorithms for artistic interpretation."

psychology, linguistics, social anthropology, and art criticism. Jürgen Habermas, for example, stresses a distinction between "empirical-analytic" sciences, which seek to discover microstructural explanations and covariances among observable events, and "historico-hermeneutic" sciences, which seek to discover meaning or semantic content; the former inquiries aim at prediction and control, the latter aim at facilitating dialogical interaction. Such a methodological bifurcation might provide ground for Critical Pluralism. Although paintings, music performances, and other artworld phenomena are susceptible to study from a "naturalistic" perspective, there is *another* standpoint from which the artworld might be surveyed: a perspective that involves interpretation rather than causal explanation. Perhaps pluralism is endemic—for reasons yet to be discovered—to this "hermeneutic" standpoint.

Habermas says:

> Hermeneutic knowledge is always mediated through this pre-understanding which is derived from the interpreter's initial situation. The world of traditional meaning discloses itself to the interpreter only to the extent that his own world becomes clarified at the same time. The subject of understanding establishes communication between both worlds. He comprehends the substantive context of tradition by applying tradition to himself and his situation.[15]

Think of this observation in the context of radical translation. The "pre-understanding which is derived from the interpreter's initial situation" is the linguist's capacity to use her own language. She reflects upon herself as a language-user, and the multiplicity of complex ways her words relate to one another, to sensory stimulation, and to action. She notes the roles played by individual expressions in the context of gathering evidence, theorizing, communicating, deliberating, and countless other activities. She notes relationships between individual word-types and perceptual evidence, appropriate behavior, and inferential transformations. She asks—if sufficiently perverse—about the patterns of sensory irritation which prompt assent, *ceteris paribus*, to certain kinds of utterances ("occasion sentences"). She asks about the conditions under which her sentences are true, and about the commitments undertaken in endorsing certain claims rather than others. And so on. In doing all this—in specifying the complex roles played by artifacts of her own background framework—she is thereby "clarifying her own

[15] Jürgen Habermas, *Knowledge and Human Interests* (Boston: Beacon Press, 1971), 309–10.

world." Thus equipped, she then seeks a pairing of native expressions with expressions in her own idiolect: her goal is to find, for each native expression-type, an expression-type in her own background framework that plays a similar role. Such correlations require idealization, approximation, counterfactual hypotheses, appeals to normalcy and *ceteris paribus* conditions, and other familiar aspects of theory construction.

A source of pluralism might be this: translation, and interpretation generally, is *holistic*. Social practices—linguistic and otherwise—are what they are by virtue of relations to one another. Perhaps such holism is itself a source of indeterminacy: if functional specification of institutional practices somehow leaves room for "incompatible but equally correct" specifications, then there is no unique correct description of a given practice. Perhaps any functional specification invoked by the interpreter can be replaced by another, "equally correct" but incompatible specification, so long as compensatory adjustments are made elsewhere in the theory.

But this is no argument for pluralism; it is a statement of a methodological prejudice. Even if hermeneutic interpretation involves the dynamics sketched above, there is little reason to countenance the existence of a plurality of non-equivalent but "equally correct" specifications of the "functional roles" identified and exploited by the interpreter. Functional roles—for example, the inferential roles occupied by truth-functional connectives—are determinate positions in a complex causal and/or normative network. There are *facts* about those positions: facts about the causal, normative, and counterfactual properties that linguistic items must possess in order to qualify as occupying them. Those facts, like any other facts, can be approximated in various ways: but there is a way to get them right and many ways to get them wrong. The interpreter—we are supposing—seeks to discover and specify such "functional" facts, and to achieve interpretation by mapping them onto relevantly similar facts within her own repertoire: she seeks, in short, to correlate items in one institutional system with items in another institutional system that possess relevantly similar functional properties. Such are the dynamics of interpretation. It might happen that her background framework is somehow inadequate: perhaps she cannot locate functional correlates to some of the items located in the framework under study. Approximations are required: she seeks only an *approximate match* of functional roles; such approximations can be achieved in various ways. But that is no source of pluralism; at most it is a source of ineffability.

Here is another way to put this. We might suppose that social practices—linguistic, artistic, or otherwise—and the objects and events produced by such practices are partially constituted by relations to other social practices; familiar holistic juggling is required to characterize social-institutional systems and their constituents. The pluralist may wish to argue from the holistic character of social-institutional phenomena to the existence of "incompatible but equally correct" characterizations of those phenomena; but no such argument has been provided, and it is unclear how such an argument might go. The holistic character of interpretation constitutes no ground for CP.

V

Yet another argument for the existence of "equally correct but incompatible" artworld interpretations is suggested by Habermas's insistence that interpretation "establishes communication between both worlds": for example, the world of the artist and that of the critic. If the very nature of interpretive correlations between one such "world" and another ensures non-uniqueness, perhaps Critical Pluralism is still in the running.

To see how this might go, imagine two interpreters immersed in radically different initial situations: different interests and explanatory goals, different senses of what is or is not important, different ideological commitments. These differences in their "initial situations" that constitute their "worlds" give rise to different interpretations of the same phenomena.

But there is little reason to regard these different interpretations as in any interesting sense *incompatible* or *rival*, or to allow that, if they are, they both have equal claim to correctness.

Different linguists might translate the same object language into distinct background languages; different interpreters might understand a given set of social practices in terms of different ideological commitments; different art critics might deploy different background assumptions and methodological preferences in confronting the same artworks. Some interpreters will doubtless do better than others (though we have yet to determine what this means). Given familiar facts about the methodology of theory construction, there will likely exist (relative to any chosen "background interpretive framework") a plurality of theoretical explanations, equally plausible in light of the linguistic, artistic,

and/or psychological data. Upon the availability of additional evidence, some of the "rival" candidate interpretations are knocked out of the running. That the interpretive process ultimately converges on a single theory is precisely what the pluralist denies.

But note that no *argument* for interpretive pluralism is derivable from these methodological considerations. All we find thus far is the underdetermination of theory by data: our familiar epistemic predicament grounded in the fact that there is more than one way to construct a smooth curve through finitely many data points. It is a commonplace of theory construction that a plurality of interpretations will, in many cases, appear equally plausible in light of available evidence. Additional data—combined with methodological preferences for simplicity, economy, and unifying power—can be expected to knock many of the rival candidates out of the running. These desiderata on theory construction are notoriously controversial: why believe that the correct theory is the simplest? Why believe that the world is unified? Nevertheless, the burden on the pluralist is to establish that no single interpretive theory is correct to the exclusion of all others; the present point is that reflection upon the epistemics of theory construction is insufficient to establish this result.

I said that the burden of proof is on the pluralist; I have treated interpretive monism as the default position. Perhaps herein lies the rub: the preference for monism might be guided by an inchoate sense that interpretation is intimately related to explanation, conjoined with a strong conviction that no plurality of "mutually incompatible but equally correct" explanations of objects and events in the world is forthcoming. Such "metaphysical realism"—the idea that the world is a determinate reality about which there is one way to be right and many ways to be wrong—is itself a frequent target of attack. If explanation is interest-relative, for example, then the very idea of "the correct explanation" of an event—artistic or otherwise—is untenable: there will be as many correct explanations as there are interests. But pending further inquiry into the subtle complexities of explanation, there is no reason to suspect that such interest relativity engenders any *incompatibility* among proffered explanatory theories. Marxists might favor different explanations than Freudians, given the divergence of interests; but once it is established—if it is—that those explanations cannot be consistently conjoined, one wants to know who has provided the more plausible account of what is going on.

If the Critical Pluralist wishes to base views about artworld interpretation upon rejections of both explanatory monism and metaphysical realism, considerable metaphysical and epistemological work is required: work not customarily undertaken by writers in aesthetic theory. Perhaps the best we can do, at present, is to articulate connections among views about explanation, artworld interpretation, and the metaphysics of a world about which explanatory theories can be right or wrong.

VI

Interpretive pluralism in the arts—the idea that a given artwork is susceptible to a multiplicity of incompatible but equally correct interpretations—has yet to be given a firm foundation. Unless the pluralist wishes to claim that pluralism is self-evident, intuitively obvious, or not in need of justification, an argument must be found elsewhere.

The social dimension of meaning might shoulder the burden here. Wilfrid Sellars advocates a "social behaviorist" theory, stressing the dependence of semantic content upon communally upheld linguistic norms that constrain a speaker.[16] More recently, Hilary Putnam urges that word meaning depends upon a "division of linguistic labor" throughout a population;[17] and Tyler Burge dramatizes the relation between attributions of propositional attitude content and the linguistic norms operative in an agent's community.[18] Such views, which foreground social-institutional factors, might provide Critical Pluralism with the sought-after foundation. The idea would be that interpretation—as opposed to causal explanation—cannot proceed unless the phenomenon to be interpreted is regarded as located within a system of social practices. Artistic behavior, insofar as it is meaningful, somehow involves

[16] See, e.g., Wilfrid Sellars, *Science, Perception and Reality* (London: Routledge & Kegan Paul, 1967), "Chisholm–Sellars Correspondence on Intentionality," in H. Feigl, M. Scriven, and G. Maxwell (eds.), *Minnesota Studies in the Philosophy of Science*, (Minneapolis: University of Minnesota Press, 1957), ii. 507–39; Wilfrid Sellars, "Language as Thought and as Communication," in his *Essays in Philosophy and its History* (Dordrecht: D. Reidel, 1974), 93–117.

[17] See Hilary Putnam, "The Meaning of 'Meaning'," in his *Mind, Language, and Reality; Philosophical Papers, Vol. II* (London: Cambridge University Press, 1975); see also *idem, Meaning and the Moral Sciences* (London: Routledge & Kegan Paul, 1979).

[18] Tyler Burge, "Individualism and the Mental," in P. French, T. Uehling, and H. Wettstein (eds.), *Midwest Studies in Philosophy, Vol. IV* (Minneapolis: University of Minnesota Press, 1979), 73–121.

the artist's responsibility to shared communal norms. Attributions of artistic meaning thus depend—in ways that must be made clear—upon relativization to a community. Crudely: artworks are artifacts, and thus cannot be understood in isolation from the communal norms that spawn and sustain them.

But once an artwork is construed as an artifact, a decision must be made about the social-communal system to which it belongs. Consider Barnett Newman's work: to what artworld community does it belong? Who are the artists and critics, shared practices among whom constitute the relevant interpretive context for Newman's paintings? Newman's contemporaries? Only Abstract Expressionists? Newman's predecessors? Is there a principled basis for answering this question? The Critical Pluralist may suggest that there is no determinate answer: such a suggestion, coupled with arguments connecting art-interpretive content to communal norms, might serve to support CP.

Linguistic communities play an essential role in the constitution of semantic content: it is the word's use within *this* group of speakers that constitutes its meaning. Art communities play a corresponding role in the constitution of artistic content. In fact the analogies are striking. The Artworld is constituted by a vast network of partially disjoint communal structures; each such structure is defined in terms of recognition and deference relations among its members. Each such structure, moreover, sustains norms and conventions definitive of a given genre and style. Picasso, for example, deferred to Braque, responding to his criticisms and ignoring most others'; Cézanne's reactions would have mattered more than those of Matisse. The Futurist painter Severini had similar ties with Boccioni and Balla; and so on. These are not inessential biographical facts about these artists: the very meaning and significance of their work is partially constituted by such facts. Recall the anecdote involving Franz Kline and Barnett Newman's paintings: we wondered whether Kline might have been wrong about the aesthetically relevant features. On the present view, line-width is significant insofar as Kline *recognizes* it as significant and Newman *recognizes* Kline as worth taking seriously. *To be a significant feature of the artwork is to be treated as significant by those who matter.*

The operative principle here is that Newman's work cannot be treated as an artwork—and as susceptible to interpretation—unless it is construed as occupying a place within an institutional, normatively constrained context: an artworld. This was Arthur Danto's fundamental

insight decades ago.¹⁹ But Danto failed to note that there are *many* such artworlds—just as there are many distinct natural languages. The act of interpretation thus requires specification of a cultural frame of reference: in interpreting a given work, shall we mobilize the canons sustained among Impressionists? Cubists? Surrealists?

The answer—one would think—is obvious: the *genuinely relevant* canons should be mobilized. But locating an artist's work within a style or genre—thereby facilitating a determination of what is important in the work—is often difficult: not because we do not know enough, but because the facts underdetermine the classification. It is here that pluralism might gain a foothold. Example: suppose a recognized art historian prefers to view Monet as a "Cubist before his time"; perhaps this historian believes that Monet's paintings "make more sense" when interpreted and evaluated relative to the artistic norms sustained among the Cubists (i.e. interpretive and explanatory benefits accrue from viewing the work relative to that frame of reference). It would be odd to object that such interpretive strategies are ruled out by the fact that Monet wasn't *really* a Cubist: for this critic's point is that regarding Monet as a Cubist yields interpretive advantages.

Interpretive advantages?

Folk wisdom—informed by traditional art history texts—dictates that Barnett Newman's paintings are best studied alongside those of Jackson Pollock, Marc Rothko, and other "Abstract Expressionists." If the goal is to *understand* Newman's work, it is vital to view it as an artifact of the appropriate community: it must be placed in the proper context. But it is difficult to specify a procedure for circumscribing communities. Communities are unified (and differentiated) in terms of shared interests, cooperative upholding of norms, dispositions to defer to the same authorities, and patterns of mutual recognition. But often it is unclear where one community or interest group ends and the next begins; this is equally true of artworld communities. Critical Pluralism might be grounded in the idea that corresponding to a given artwork there exists *no unique community of which that work is an artifact*; there is, rather, a plurality of distinct but relevant artistic communities, and different important features of the work become evident when the work is viewed against the backdrop of each such community. This, in turn, leads to a plurality of equally legitimate interpretations.

¹⁹ Arthur Danto, "The Artworld," *Journal of Philosophy*, 61 (1964), 571–84.

The pluralist thus invokes a multiplicity of distinct but "equally relevant" artworlds; herein lies, I think, the most promising argument in defense of CP. If a speaker of natural language belongs simultaneously to several "linguistic communities," there is basis for assigning different semantic contents to his or her utterances depending upon the linguistic community relative to which those utterances are interpreted. This would provide a basis for an interesting sort of "translational pluralism": construe Jones as speaking English, and his utterance is best translated one way; construe him as speaking Ghetto English—a derivative and closely related but nonetheless distinct language—and his utterance is best translated another way. Jones, as a contingent matter of fact, keeps company with both groups: he has close friends all around the city. Thus there is no principled basis for regarding one interpretation of his words as correct to the exclusion of the other.

Perhaps this situation has a counterpart in the artworld. The mechanisms that enable linguists to identify specific utterances as belonging to one language rather than another might have counterparts in the realm of artworks; some artist might arguably belong to a plurality of artistic communities, each of which sustains different norms and standards of significance. The work of such an artist would present an interpretive quandary: different critics might construe a given work as an artifact of different communities, thereby resulting in a plurality of interpretations—each of which is surely as correct as the next. Perhaps Critical Pluralism results from dwelling upon precisely such quandaries, and stressing their frequency in the artworld.

Let's review the argument. The Critical Pluralist here draws upon the insight that an artwork is essentially a cultural artifact, and thus is what it is by virtue of the communal artistic norms that bear upon it. But for any specification of such norms, and for any specification of the community to which that artwork "belongs" as an artifact, there exists another, incompatible but equally correct specification. Example: one may view the work of Kasimir Malevich in the context of work by Picasso, Braque, Léger, and other Cubists, thereby highlighting certain of its features; or one may pursue another interpretive gambit, placing it in the context of Russian Suprematism, thereby highlighting other features. Thus Malevich's artistic achievements are viewed now as artifacts of one community, now as artifacts of another. These classifications are equally "correct": each yields—we may suppose—considerable critical-explanatory dividends. Many artworks—perhaps most artworks—provide instances of such pluralism. Therefore CP is vindicated.

Art historians can hopefully provide compelling examples of this "multiple citizenship" phenomenon. But as an argument for CP it is unsound, despite its focus upon fascinating aspects of the artworld. Like most artists, Malevich obviously stood in a plurality of relations to a plurality of groups. There need be no "incompatibilities" among these groups; but even if there are, CP is no consequence. *The proper interpretation of the artist's work would take into account the tensions and ambiguities engendered by such disparate allegiances.* Any interpretation based upon the norms sustained in only one of the many groups to which he belongs would *not* be, *pace* the pluralist, "one of several equally correct interpretations"; it would, rather, be an *incomplete* interpretation, one that fails to account for all the features of Malevich's work.

These considerations about pluralities of relevant artworld communities thus provide no sound argument for CP. They do, however, foreground subtle and important aspects of the way we think about art in relation to language. Consider again natural-language translation. The norms reflected in correct translation are norms upheld in a population: we say "It is the word's usage in *this* population that constitutes its meaning." A speaker's overt verbal behavior involves the use of utterance-types which are, so to speak, communal property: the property of that group with which the speaker engages in fluid dialogue. Word-types are public property; semantic interpretation takes this into account by attempting to discover the role played by a speaker's utterance-types relative to that class of speakers by whose semantic norms the speaker is constrained. Circumscribing this class is often difficult, depending as it does upon distinguishing semantic differences from differences in collateral information. But we make whatever assumptions and idealizations are required to oil the wheels of smooth translation. None of this tells against the determinacy of semantic content. Likewise, the normative and communal character of the artworld provides no basis for Critical Pluralism.

VII

Art critic Leo Steinberg provides a fascinating documentation of his efforts to confront and understand Jasper Johns's artworks; those efforts involve a variety of successive interpretations, some of which he deems (after careful consideration) to be inadequate. After ruminating about nonsense and anti-art, banality of subject-matter, sensuous surface,

random and gratuitous desecration of the human body, spatial inversion, and a sense of waiting, Steinberg says

> In the end, these pictures by Jasper Johns came to impress me as a dead city might—but a dead city of terrible familiarity. Only objects are left—man made signs which, in the absence of men, have become objects. And Johns has anticipated their dereliction.[20]

This is a remarkably sensitive interpretation: one that—Steinberg thinks—makes maximal sense of Johns's work and best accommodates the salient features that merit interpretative explanation. Steinberg, however—more self-reflective than most art critics—raises a profound question about the status of his own interpretation: "What I have said—was it found in the pictures or read into them?"[21]

Steinberg's reflective question—whether the attributed interpretive content is "found in the pictures or read into them"—points toward another possible basis for pluralism.

There are two interestingly different ways to understand Steinberg's question. On one reading, he wishes to know whether his interpretation unearthed properties *intrinsic* to Johns's paintings, or *contextual* properties—constituted by relations between the artworks and features external to them—which he then treated as features of the artworks themselves. Perhaps if the properties ascribed via art-interpretive discourse are contextual—properties that relate an artwork to its causal ancestry, for example, or to its appropriate effects upon members of some specified community—then support is thereby provided for CP.

Doubtful. It is difficult to see how the (alleged) contextual/relational status of properties such as "being about the dereliction of man-made signs which . . . have become objects" provides basis for pluralism. Relational properties, like monadic properties, are real: either they are instantiated or they are not. Correct interpretation attributes these properties correctly; there is no room for pluralisms here.

Nevertheless: if such art-interpretive properties are indeed contextual/relational (and surely they are), an embarrassing explanation for the perennial attraction of pluralism is thereby available. Consider: if one overhears a conversation between two navigators, one urging that

[20] Leo Steinberg, "Contemporary Art and the Plight of its Public," in *Other Criteria* (New York: Oxford University Press, 1972), 15.
[21] Ibid.

Dubrovnik is to the east, the other that Dubrovnik is to the west, one might infer—given the obvious success of both navigators—that there exists a "plurality of equally correct but incompatible specifications of position." But this would be wrong. The specifications are not incompatible: Dubrovnik is both to the east (of Italy) and to the west (of Bulgaria). Relationality can engender an appearance of pluralism if some of the relata are not explicitly mentioned. But the contextual/relational character of properties ascribed *via* art-interpretive discourse provides no ground for CP.

Another reading of Steinberg's question is far more interesting: it involves not relationality, but subjectivity. Perhaps artworld interpretation is not an "objective" matter, in which case there might well be a plurality of "equally correct" (whatever this means) interpretive stories about an artwork. Recall the initial challenge to the intelligibility of the pluralist's thesis: we could not understand how genuinely rival interpretations of artworks might be both *complete* and *equally correct*. Pressure exerted by such challenges may lead the pluralist to suggest that there are "no objective facts of the matter" about the proper interpretation of paintings or the proper way to experience and/or respond to music. Perhaps, according to this view, the interpreter is not in the business of discovering determinate facts about the meanings of artworks, or the interpretive significance of artwork features, or the correct way to experience and/or respond to artworks. There are no such facts. Therefore, artworld interpretation aims not at the discovery of facts about artistic meaning (because there are no such facts); art-interpretive claims rather serve to express attitudes, manifest stances, or incur commitments. Such "anti-realism" about art-interpretive discourse might provide a ground for pluralistic claims.

There is precedent for such an approach. As noted in Chapter 1, Arnold Isenberg regards *reasons* provided in art criticism as serving not to call attention to relevant facts, but rather to induce a way of apprehending an artwork: directing the audience's attention to qualities that might have been missed.[22] On this view, it is hardly clear that critical reasons are truth-evaluable; and if they are, Isenberg alleges that they add no weight to an evaluative verdict.

Metaphysical realism and explanation once again come to the forefront. To better understand the costs and benefits related to this reading

[22] Arnold Isenberg, "Critical Communication," *Philosophical Review*, 58 (1949), 330–44.

Steinberg's reflective question, a bit of philosophical background is helpful.

There is a tendency in certain philosophical quarters to countenance a distinction between fact-stating and non-fact-stating indicative discourse.[23] Think here of Humean theories of causation, expressive theories of morality, deflationist theories of truth, and Kripke's Wittgenstein on rule-following: the root idea is that certain declarative sentences, though meaningful, are not in the business of stating facts or ascribing real properties; their role is to express non-cognitive attitudes, explicitly formulate commitments, deem and dignify, or perform some other non-descriptive task. Nondescriptivist strategies do not impugn the existence of objectively real facts and properties; they do, however, exploit the possibility that a specified region of declarative discourse serves not to represent such facts and properties but rather to do something else.

Such strategies are controversial: the requisite distinctions between predicates which express real properties and those which do not, or between fact-stating and expressive indicatives, are difficult to explicate.[24] But nondescriptivist strategies are attractive because they provide alternatives to reductive accounts of properties or concepts which, for whatever reason, generate puzzles.

Grant—for the sake of argument—that the art-interpretive statement "Jasper Johns's artworks anticipate the dereliction of man-made signs" is not a truth-evaluable (and thus possibly false) statement of some objective fact, but rather the expression or manifestation of Steinberg's sentiments in response to Johns's work. Thus construed, it is probably well-advised to allow that other critics will experience other sentiments in response to the same works, thereby resulting in quite different interpretive claims. Since there is no basis for singling out one particular set of art-interpretive sentiments as correct—alternative sentiments are equally acceptable—Critical Pluralism is thereby vindicated.

[23] A good introduction to anti-realist methodology and the (alleged) contrast between "descriptive" and "projective" discourse is Simon Blackburn's *Spreading the Word* (Oxford: Clarendon Press, 1984), esp. chs. 5–7; see also my "Varieties of Pragmatism," *Mind*, 99 (Apr. 1990), 157–83.

[24] A substantial critical literature targets various nondescriptivist strategies and the assumptions required to sustain them. Peter Geach, e.g. alleges "a radical flaw in this whole pattern of philosophizing," insofar as it confuses predication and assertion and provides inadequate accounts of conditional embeddings; see P. T. Geach, "Ascriptivism," *Philosophical Review*, 69 (Apr. 1960), 221–5.

This is confused. First, the sort of "subjectivism" entertained here about art-interpretive discourse leaves little room for literal talk of "correctness": thus no basis is provided for regarding the "incompatable interpretations" as "equally correct": 'correct' usually means 'true', but on the present proposal art-interpretive claims possess no truth values. This humble observation spills over into the alleged "incompatability": theory T is incompatible with theory T′ only if they cannot be true together. But on the present proposal, talk of truth is inappropriate; thus it is unclear what all the rhetoric about "incompatibility" comes to. These are rudimentary points, and discerning them requires no philosophical rocket science. The deeper point concerns the extent to which art interpretation involves discovery of "objective facts" about meaning, aesthetically relevant properties, and the like. Scientific inquiry aims at objectivity; does art-interpretive inquiry aim at objectivity? That depends upon precisely *what it would be* to aim at objectivity. And here the metaphysics is profoundly difficult. 'Objective' and cognate expressions do various jobs in various contexts; often it is difficult to see what talk about 'objective facts of the matter' really amounts to. Perhaps *objectivity* has something to do with *explanation*: there are objective facts of kind K if and only if such facts enter into the explanatory order. But we still have no clear sense about what constitutes an explanation; moreover, it seems unduly restrictive to tie objective matter-of-factuality to explanatory endeavors: couldn't there be facts which, despite objective status, play no essential role as explainers?

VIII

It is important to review our position in the dialectic. The pluralist here alleges that anti-realism ("expressivism," "projectivism," "non-descriptivism") about art-interpretive discourse allows for a coherent formulation of CP. The careful pluralist claims that the "incompatibility" of rival interpretations is *not* a truth-functional matter consisting in disagreement about the facts; it is more like the incompatibility between a "boo" stance and a "hooray" stance taken toward the same state of affairs. Such incompatibility might be grounded in disagreement about facts, but is not equivalent to any such disagreement. If the Critical Pluralist can develop a convincing analogy with expressivist theories of moral discourse (and moral disagreement), and if she can provide a convincing anti-factualist account of the correctness of an artistic interpretation,

she will thereby have earned the right to persist in her pluralist claim. Critical Pluralism is true insofar as different critics occupy incompatible but equally acceptable (whatever this means) interpretive stances. But the anti-factualist strategy, even if workable, is risky: it threatens to ramify. Art-interpretive discourse is, *prima facie*, remarkably similar to the discourse of psychological interpretation, linguistic interpretation, and semantic content ascription generally. There seems little plausibility in the claim that "Paul's utterance was about the exhibition" is a fact-stating, descriptive sentence, whereas "Cézanne's paintings represent objects viewed from several perspectives simultaneously" is not. Perhaps the contrast could be rendered plausible: perhaps artworld interpretation is so different from other instances of content-attributing discourse that anti-realism about the former need not entail anti-realism about the others. Pending such an argument, however, it seems that across-the-board anti-realism about content attribution is too high a price to pay for the intelligibility of Critical Pluralism. Better to give up CP and preserve our realist intuitions about meaning, reference, and the content of propositional attitudes.

I think we have reached a point at which a helpful diagnosis of the monism–pluralism dispute(s) is available.

Imagine an art historian who insists that Barnett Newman's peers— his artistically savvy peers—constitute the "reference population" for proper interpretation of Newman's work. Our historian is dogmatic: he insists upon a distinction between *correct* and *incorrect* interpretations of an artwork. And now the key: this historian urges that an interpretation, to be correct, *must be constrained by the artistic norms and practices operative in the community that produced the work*. This historian acknowledges that many artists work in relative isolation, and many *avant-garde* artists break away from extant systems of norms. No matter; our historian insists upon interpreting the artworks with an eye on precisely those norms and traditions from which the artists and their works break away. He is convinced that there is a *unique population* against the backdrop of which an artwork must be interpreted; only in this way, he argues, can an interpretation be found which *genuinely explains all of the artwork's features*. He knows that different viewers—individually or in organized groups—are likely to interpret a piece in different ways, or to regard different features as significant. But this, he says, hardly legitimizes those viewers as *understanding* the piece; perhaps they are getting it wrong, and reinforcing one another's interpretive errors.

What are we to make of this historian's insistence upon the existence of a unique correct interpretation of an artwork? Here the anti-realist strategy broached above might be illuminating. We may construe this historian's monistic rantings as the expression of a *commitment*: to the essential explanatory role of that population responsible for the artwork. This historian believes that the artistic perceptions and standards of significance operative among the artist's immediate artworld community provide the constraints on correct interpretation. Our monistic historian believes that only in terms of such perceptions and standards can various important aspects of the work be best explained. His artwork interpretations—and insistence that there exists only one correct interpretation—manifest a commitment to the norms upheld in a particular population. Thus this historian is committed to seeing himself as "one of them" when experiencing, interpreting, and responding to the work, and to the necessity of adopting this standpoint if he is to "genuinely understand" the work. The significance of an artwork, he urges, is as much an artifact of social-institutional forces as is the meaning of an utterance; his insistence upon the uniqueness of that significance manifests an unwillingness to divorce the artifact from the very population that constitutes it.

The pluralist is unimpressed by such considerations. He admits, should the question explicitly arise, that the explanatory significance of that particular population and norms sustained therein is precisely as the historian portrays it. But, in contrast to the historian, the pluralist lacks any urgent motive to provide the kinds of *explanations* sought by the historian; he is content to immerse himself in the work and tingle with aesthetic rapture, whatever form that rapture might take. The suggestion that some modes of rapture are "more appropriate" than others, given the meaning of the work, strikes him as inimical to the spirit of art. Consequently, the population that the historian elevates to privileged status has, for the pluralist, a far less privileged status: it is simply one community among many, one interest group among many, one set of norms among many. He is willing to cut the artwork loose from its causal-historical ancestry and let a thousand equally legitimate reference classes bloom. In defense of this pluralistic strategy, he insists that art is *just the sort of thing from which people should derive whatever experiences they can*—none being any more or less "correct" than any other (such sentiments correspond to Critical Anarchism): explanation be damned in the artworld. Less extremely: this pluralist might insist that art is just the sort of thing which warrants flights of interpretive

fancy, the only constraint being that the interpretation "makes sense" of the intrinsic features of the work. The monist, repulsed by this sentiment (the word 'philistine' gets much play here) does not even agree with the pluralist about *what it would be* to 'make sense' of an artistic feature. He grants the relativity of artistic significance to population; but resists the inference from such relativity to pluralism. This he can do because he has already cast his lot with a quite specific population—it is, for him, the only population "relevant" to a correct understanding of the work. We might fault him for this, depending upon our own interests, explanatory goals, and conceptions of how art ought to be treated. But if he wishes his interpretations to be constrained by the norms of that community alone, and he believes that such constraints are enjoined by the very nature of artworks, then so be it. It seems perverse to accuse our monist of having made some factual error.

But nor has our pluralist made a factual error. He, like the monist, might acknowledge the population relativity of artistic meaning; but he is impressed with the multiplicity of populations in relation to which interpretation can be imposed. Unlike the monist, he refuses to cast his lot with one particular such population, even if doing so maximizes explanatory power.

So ironically the monist and pluralist are, on this construal of their dispute, not in disagreement about some matter of fact; rather, they have clashing sentiments about how art should be approached, about what sorts of considerations should constrain one's artistic experiences.

So far, so good. But what of the pluralist's claim that the various artistic interpretations are, in addition to being equally correct, somehow *incompatible* with one another? If the goal is to account for most aspects of the monism/pluralism dispute, the pluralist's insistence that the rival interpretations are genuine rivals—that is, that they are incompatible—had better be illuminated.

It is. Consider a simple analogy: one interest group sees a diagram as a duck; another sees it as a rabbit. Insofar as these ways of seeing are operative in distinct communities—and explicable in terms of the interests and goals operative in those communities—no explicit "incompatibility" infects the situation. No pronouncement of the form "It is correct to see it as a duck and it is not correct to see it as a duck," uttered in a tone which heralds victory for pluralism, is warranted. Nevertheless, 'incompatibility' is said in many ways: there is more to incompatibility than logical inconsistency. The impossibility of seeing the diagram simultaneously as a duck and as a rabbit, though perhaps

ultimately explicable in terms of logical constraints on the computational mechanisms of perception, is *prima facie* not a logical impossibility. It is *some other kind of incompatibility*: the kind, perhaps, which grounds the inability to think of oneself simultaneously as a member of certain disparate interest groups.

Some person, we might suppose, cannot think of himself concurrently as both an autonomous moral agent and as a soldier; perhaps there is a way to do it, but he cannot. He cannot make anything of *what it would be like* to see the world from both standpoints simultaneously. Similarly, some art enthusiast might think of himself as unable to approach Jasper Johns's work from the standpoints of Marxist, Freudian, and Structuralist constraints at the same time. He might believe, given pluralist persuasions, that one standpoint is as legitimate as the other for purposes of artistic interpretation; but he is so overwhelmed with the psychological incompatibility of these diverse standpoints—the differences in interest, explanatory goal, ideology, and perhaps even patterns of argumentation—that his sense of that incompatibility rises to the surface in the form of an insistence upon Critical Pluralism.

Thus the monism/pluralism dispute is portrayed as a clash of sentiments and commitments, rather than a disagreement about some fact: one side dignifies a particular population as the tribunal against which to measure the correctness of an artistic interpretation, and insists that doing so leads to unique interpretation. The pluralist will have none of this.[25]

[25] Such nondescriptivism at the level of philosophical reflection is likely to puzzle and/or disappoint: surely there is a fact of the matter as to whether a given discourse is fact-stating or expressive, yet the suggested resolution to the monism/pluralism debate portrays the semantic contrast in expressivist terms. This strategy is not unprecedented: Allan Gibbard entertains (in a different setting) a related approach:

Couldn't the fact–norm distinction itself just be a normative distinction? Perhaps when I call a statement factual or call it normative, I'm saying what we ought to do with it. To call it factual is to say to do one thing with it, and to call it normative is to say to do another. If so, the fact–norm distinction might remain perfectly intelligible, as a distinction of what to do with various statements. (The Hempel Lectures, delivered at Princeton University, 1992)

Gibbard thus suggests a metatheory of meaning "with its sharp factual/normative gap formulated as a normative thesis." See Allan Gibbard, "Meaning and Normativity," in Enrique Villanueva (ed.), *Philosophical Issues 5: Truth and Rationality* (Atascadero, Calif.: Ridgeview Publishing Co., 1994), 95–115. The plausibility (and coherence) of an expressivist theory of the factual/expressive contrast is discussed in my "Robust Deflationism," *Philosophical Review*, 102 (Apr. 1993), 247–63. Thanks to William Lycan for stressing the need to address this point.

We thus end on an intriguing note: neither monism nor pluralism emerges as the unqualified victor. But in evaluating the monist's and pluralist's claims, we are led to inquire into the purposes served by insisting upon uniqueness of correct interpretation, and whether those purposes are worth achieving. We are led to ask whether artworld interpretation is a mode of explanation—if so, what kind—and whether unique explanations of artworld data are forthcoming. We are led to ask whether there are objective "facts of the matter" that serve as truthmakers for art-interpretive claims—and, more profoundly, *what it would be* for there to be such facts. Critical Monism is the default position if one views artworks as cultural artifacts about the significance of which one might be correct or mistaken. This might not be the best way to view artworks; but it is the best way to view them if the overall goal is explanation of artworld phenomena.[26]

[26] A distant ancestor of this chapter appeared as "On Pluralism and Indeterminacy," in P. French, T. Uehling, and H. Wettstein (eds.), *Midwest Studies in Philosophy, Volume XVI: Philosophy and the Arts* (Notre Dame, Ind.: University of Notre Dame Press, 1991), 209–25. Thanks to Mitch Flower for help with the original version, and to William Lycan for valuable suggestions and comments on the more recent version.

7
Objectivity, Ontology

A recurring theme in previous chapters is that ontology—artworld and otherwise—is in the business of explanation, and that an ontology of art which yields maximal explanatory benefits is therefore to be preferred. But explanation is only one of countless human endeavors: it is hardly clear that ontology marches in time to its demands. Perhaps ontology plays a normative role, serving not to *explain* but to *justify*: the restoration of certain artworks is to be condemned, for example, because of the *kinds* of things artworks *are* (cultural artifacts rather than instruments of pleasure). Frankly, it is not obvious what "an ontology of art" is supposed to do—or, more generally, what ontology is supposed to do.

Yet another theme involves the notion of *objectivity*: the idea that artworld interpretation aspires to discover objective facts (e.g. facts about artistic meaning and/or significance of artwork features). But it is not clear what notion of *objectivity* is at issue here, or what it would *be* for artworld interpretation to get at objective facts, or why it might matter.

These themes spring from a common source. *Ontology* is the study of what there is, and of the basic categories in terms of which we confront the world and ourselves in the world. *Objectivity* is the feature that marks the contrast between what is in the world and what is not. Something is thus gained in treating these topics together. They are large topics—reaching far beyond the bounds of aesthetic theory—but inquiries into artworld practice prompt such concerns in the first place; it is appropriate to see where they might lead.

I

Artworld interpretation aims to discover *artworld meaning*, broadly construed: representational content, or syndromes of appropriate

experiences and responses associated with artworks. An interpreter might be right or wrong about matters of proper interpretation, proper experience, or proper response. A music critic can be mistaken about whether Mussorgsky's *A Night on Bald Mountain* expresses anxiety, or whether a piano performance by Cecil Taylor expresses Black Nationalist rage, or whether a guitarist's blues solo is "forthcoming with melancholy," or whether any music expresses any emotions at all (see Chapter 4). Franz Kline could have been mistaken about the importance of width and orientation of stripes to the understanding of Barnett Newman's paintings. Critic Leo Steinberg entertained, but then dismissed, interpretations of Jasper Johns's works as commentaries upon gratuitous desecration of the human body, or as studies in spatial inversion; but Steinberg's dismissals might have been mistaken (see Chapter 6). The fact that certain interpretations failed to satisfy him—given his interests, methodology, and art-critical goals—hardly shows them to be incorrect.

These ways of thinking about artworld situations assume that interpretive correctness and incorrectness are possible: there is something to be right or wrong about. When Steinberg ultimately construes Jasper Johns's works as concerned with the dereliction of man-made signs which, in the absence of people, "have become objects," he wonders—as do we—whether his interpretation was "found in the pictures or read into them."[1] He wonders whether he *discovered* "objective facts" about the artworks or merely *invented* a helpful (to him) story that he then projected back onto them; this distinction matters to him.

Despite fashionable subjectivisms and relativisms, one has a strong sense that artworld interpretation is beholden to standards of correctness: meaning is a determinate property there to be discovered. *Whatever* constitutes the facts at which artworld interpretation aims, they are objective facts, discovered rather than invented. Such a contrast obviously mattered to Steinberg, and it matters to other reflective critics who "want to get things right."

Unfortunately it is not clear what any of this means. Talk of "facts of the matter", "correctness," "objectivity," and even "truth" is often left unexplicated; considerable stretches of metaphysical dispute—artworld and otherwise—are thus riddled with puzzles and communication breakdowns. Here the issues go far beyond aesthetic theory.

[1] Leo Steinberg, "Contemporary Art and the Plight of its Public," in *Other Criteria* (New York: Oxford University Press, 1972), 15.

II

The concept of *objectivity* plays a fundamental role in a variety of philosophical disputes. Some examples: (1) Arguments persist among literary theorists about whether textual meaning is objective, and whether there is such a thing as "the correct interpretation of the text." This is the issue, explored earlier, of pluralism vs. monism in Critical Theory. (2) Arguments persist among philosophers, scientists, and psychophysicists about whether color is an objective feature of the external world or merely a subjective "creation of the mind" imposed upon external reality. This is the issue—fueled by Galileo, Newton, and Locke—of the metaphysical reality of color. (3) Arguments persist about the nature of morality: whether there are moral facts, and whether moral predicates express objective features of the world. This is the issue of "projectivism" vs. "realism" in the metaphysics of morality.

Similar arguments persist on other fronts: concerning the interpretation of scientific theories (realism vs. instrumentalism), discovery vs. invention in history (realism vs. social constructivism), and the objectivity of linguistic meaning (cf. Quine's claims about the status of analytical hypotheses of translation). In each case one side claims, and the other denies, that certain statements or regions of discourse get at "objective facts of the matter." But these disputes—despite their perennial hold upon us—are vexing because the root notion of *objectivity* is left unexplicated. Theorists generally assume that the concept is sufficiently clear. It is not. What would it *be* for there to exist—or not exist—objective facts about meaning or morality? What would it *be* for an artworld interpretation to be "correct"? What would it *be* for color or mathematical truth to exist as "mind-independent" realities? What would it *be* for a scientific theory to successfully "get at the facts," rather than simply providing a helpful instrument for predicting experiences and effectively dealing with the world? How are we to understand the metaphysical discourse about objectivity, facts of the matter, and real properties that underlies these venerable realist/irrealist disputes?

These are extraordinarily difficult questions: those working in metaphysics frequently ignore them. Carnap was an exception: he questioned the very ideas of *existence* and *reality* as wielded in traditional

metaphysical disputes; more recently, Michael Dummett has articulated a similar concern:

> We also face another and greater difficulty: to comprehend the content of the metaphysical doctrine. What does it mean to say that natural numbers are mental constructions, or that they are independently existing immutable and immaterial objects? What does it mean to ask whether or not past or future events are there? What does it mean to say, or deny, that material objects are logical constructions out of sense-data? In each case, we are presented with alternative *pictures*. The need to choose between these pictures seems very compelling; but the non-pictorial content of the pictures is unclear.[2]

In the present context, the issue is the *objectivity of artistic meaning*.

One way to approach the (alleged) contrast between *objective* and *non-objective*—the contrast between inquiries that aim to discover "matters of fact" and those that do something else—is to advocate its elimination. After all, some contrasts deserve to be dropped: some are artifacts of outmoded theories, or do social harm, or are essentially incoherent. Perhaps the contrast between objective and nonobjective is useless, or rests upon incorrect theories (like the contrast between phlogisticated and dephlogisticated air), or serves to implement the coercive agendas of Colonialism.

Perhaps. Another possibility is that the objective/nonobjective contrast plays a valuable role: it is a discursive mechanism that merits retention rather than elimination. If that is right, then we should undertake the tough analytical challenge of determining *what we are doing* when we speak of objectivity, facts of the matter, and correctness. We should work to understand such discourse, not delegitimize it. Richard Rorty pursues the eliminative strategy: suggesting that we do well to abandon the very idea of *objectivity* and substitute in its place the idea of *social consensus*.

Rorty's views are especially interesting in the present context. His form of "pragmatism" involves a culture holism that undercuts neoscientific "reductive" analyses and encourages "more respect for poetry than the Western philosophical tradition has usually allowed itself."[3] Once literature and the arts are given equal billing with the natural sciences, Western philosophy might—Rorty believes—"overcome the

[2] Michael Dummett, *The Logical Basis of Metaphysics* (Cambridge, Mass.: Harvard University Press, 1991), 10.

[3] Richard Rorty, "Non-Reductive Physicalism," in his *Objectivity, Relativism, and Truth* (Cambridge: Cambridge University Press, 1991), 125.

temptations to scientism" and move in more fruitful directions. But he is also convinced, with E. D. Hirsch, that "the much advertised cleavage between thinking in the sciences and the humanities does not exist," and that "philosophy of science and literary theory ought to carry over into each other."[4] It is fitting that an inquiry into the metaphysics of artworld practices critically engage Rorty's views.

I shall suggest that despite the laudable aspects of Rorty's pragmatism, his remarks about objectivity provide an instructive paradigm of how *not* to think about metaphysics, including those fragments of metaphysics relevant to the objectivity of artistic interpretation. I then pursue an alternative approach, suggesting that the notion of *objectivity* is intimately tied to that of *explanatory ineliminability*. This latter strategy is controversial in its privileging of *explanation*—a problematic notion that looms salient in previous chapters. But the strategy has the virtue of justifying continued deployment of a metaphysical distinction that seems vitally important: the distinction mobilized in Steinberg's "What I have said—was it found in the pictures or read into them?" Finally I turn to the purposes of ontology, artworld and otherwise.

III

Historian Peter Novick offers a remarkable contrast between philosophers and historians:

Philosophers, as a result of both training and inclination, can rarely resist engaging in systematic critical evaluation of the thought they discuss. We historians, as a result of our training and inclination, are professionally sensitized to the historicity of intellectual life: the extent to which the emergence of ideas and their reception are decisively shaped by surrounding cultural assumptions, social setting, and other elements of their total historical context. We are thus reflexively loath to apply implicitly timeless criteria in judging what we describe and, historically, explain.[5]

Novick's picture is this: Any theorist sensitive to sociocultural assumptions and other aspects of historical context will resist engaging in "systematic critical evaluation" of the historical thoughts identified and discussed. Such a sensitive theorist will not, for example, inquire into

[4] Richard Rorty, "Texts and Lumps," in *Objectivity, Relativism, and Truth*, 84.
[5] Peter Novick, *That Noble Dream: The "Objectivity Question" and the American Historical Profession* (Cambridge: Cambridge University Press, 1988), 6.

the correctness of Freud's explanations of human behavior, Plato's views about art, Chomsky's views about syntax, Thales' views about the *Urstoff* of the universe, or Derrida's views about meaning. Given a grasp of the dialectical situation, the historian will rest content with exploring the fabric of human ideas: speculating about the sources and consequences of various theories and discourses, without any (misguided) efforts to say which of them are true, or warranted in light of the data.

There is—supposedly—justification for refusing to undertake such critical assessment of theories situated in other cultural contexts. Any theorist who questions the truth of Freud's views about the unconscious, or Skinner's behaviorism, or Locke's empiricism, or Satanist theories of demonic possession, is (allegedly) applying "implicitly timeless criteria in judging what we describe." And this is misguided, because (as a matter of fact?) there are no such criteria: there are only contingent standards that we construct and temporarily endorse.

So Novick's working assumption is this: participation in "critical discourse" assumes commitment to the existence and applicability of "timeless criteria." But, according to Novick, the fact that the historian is located in social-institutional space—or the fact that canons of rational coherence are grounded in convention and historical contingency—undermines his or her right to engage in dialogue about what is correct, or disconfirmed, or sustained by fad and prejudice rather than relatively neutral observation. A contingently situated being cannot—without inexcusable transcendent arrogance—engage in such dialogue.

All of this is dreadfully confused. Even if the historian wields no "innocent eye"—even if evaluative discourse is itself shaped by sociocultural and political forces—there is nonetheless a vital distinction between how the world appears and how it really is: between those historical figures *who got things right* and those who did not. Granted: assessments of correctness are grounded in perspective, situation, and idealization; but this does not—pending further argumentation—undermine such assessments.

It is simply false that those who incline toward "systematic critical evaluation"—historians, for example, who are willing to talk about the correctness or incorrectness of past theories—doubt their own historical and sociocultural situatedness, or regard their own criteria of judgment as "implicitly timeless." Rather: such historians believe that criteria and standards of assessment need not be "timeless" (or "noncontingent") in order to be legitimately applicable.

Nevertheless, Novick's *caveats* are refreshing, and not totally without warrant. The history of thought is littered with embarrassing attempts to "ground" principles and practices in something transcendent and ahistorical: the Structure of the Mind, or Relations between Forms, or Natural Rights, or Culturally Unconditioned Biological Invariants, or the Inevitabilities of Class Struggle, or God's Will. Such "ahistorical" groundings—often enshrined in metaphysical theories—stem from the conviction that those trapped in historical contingency cannot—unless *en rapport* with something transcendent and noncontingent—legitimately engage in "systematic critical evaluation" of past or present practices.

But having become convinced that, as Richard Bernstein puts it, "there may be nothing—not God, reason, philosophy, science, or poetry—that answers to and satisfies our longing for ultimate constraints,"[6] a theorist can go too far in the opposing direction, and give up on the very idea of objectivity.

This extreme reaction—often associated with "pragmatism"—is of considerable interest. But it tends to be contaminated with slogans and overstatements. One can acknowledge that Kant's attempts to "ground" the universal validity of the Moral Law, or Plato's attempts to legitimize certain classificatory procedures, rest upon self-deceptive reifications of certain practices into "ahistorical tribunals" that are not really ahistorical at all. One can acknowledge, with Wittgenstein, Dewey, and Heidegger, that "investigations of the foundations of knowledge or morality or language or society may be simply apologetics, attempts to eternalize a certain contemporary language-game, social practice, or self-image."[7] But overreaction should be avoided: surely there is more to objectivity than what we all agree to, or more to knowledge than what we can get away with among our peers. Richard Rorty falls prey to such overreaction: intent upon acknowledging historical contingency, the parochiality of critical standards, and the ahistorical arrogance characteristic of much traditional philosophy, he embraces a pragmatism so extreme that it collapses into a form of social idealism—a theory as implausible as the transcendent metaphysics that prompts it.

[6] Richard J. Bernstein, *Beyond Objectivism and Relativism* (Philadelphia: University of Pennsylvania Press, 1983), 19.

[7] Richard Rorty, *Philosophy and the Mirror of Nature* (Princeton: Princeton University Press, 1979), 9–10.

IV

There is a peculiar intolerance—or inconsistency—involved in Rorty's strategy. We are offered the distinction between

(a) the search for truth (or "foundations")

and

(b) the creation of rich and accommodating metaphors and narratives.

Rorty recommends that we stop thinking of ourselves as involved in (a), and substitute a picture of ourselves as involved in (b). It is not clear that such a choice is required. The traditional "realist" story about truth, accuracy, incorrect description, correspondence to the facts, reliable evidence, and the like might itself be regarded as an elaborate narrative or metaphor: a rich and useful regulative device that enables communities to get on with their inquiries and work tenaciously through disputes until valuable consensus is achieved. Suppose that the way we depict our customary investigations—viz. as "aiming toward correct description"—is yet one more metaphor; it seems like a "rich and accommodating" metaphor. Why give it up?

Put this another way. Rorty wishes us to substitute an "aesthetic" for a "rational" ideal: we should evolve into thinking about ourselves—and our ongoing struggles to understand the world—as engaged in *invention* rather than *discovery*, *making* rather than *finding*, *narrative* rather than *description*. We should stop insisting that our inquiries, when successful, enable us to "find the real wall behind the painted ones, the real touchstones of truth as opposed to touchstones which are merely cultural artifacts."[8]

But why should we stop? What is *wrong* with the venerable attempt to find the real wall? Is there no difference between a real wall and a merely apparent wall? Perhaps the implicit argument is this: any inquiry is culturally situated, shaped by social, historical, economic, ethnic, gender, and countless other forces; therefore anything we take to be real is itself a cultural artifact, and the contrast between real and merely apparent walls is illusory (!).

[8] Richard Rorty, *Contingency, Irony, and Solidarity* (Cambridge: Cambridge University Press, 1989), 53.

A notoriously bad argument. Grant that the drive to posit neutrinos—or linguistic meanings, or the unconscious, or natural numbers, or God—stems from cultural and historical forces acting upon the theorist; how does it follow that the postulated items are *themselves* cultural artifacts—invented rather than discovered—or that questions of correctness have no purchase? There is a basic confusion here between aspects of the discovery process and aspects of the facts and objects discovered. Perhaps scientific inquiry into particle-pair annihilations is funded by the National Science Foundation; but the particle-pair annihilations themselves are not. Doubtless the inquiries are socially constrained; but neither muons nor mountains are social constructs: they would be "out there" even if there had been no society to discover them. Indeed: that is part of the narrative story we tell about the kinds of things that muons and mountains *are*.

V

Despite Rorty's insistence that he recommends no rejection of realistic folk wisdom about our position in the world, his formulations smack of a revisionist drive to jettison the very idea of an objective, mind-independent, language-transcendent reality: a world which is what it's like independent of local perspective, a world about which we can be correct or mistaken or ignorant, a realm of facts there to be "discovered" rather than "woven." But it is still not clear why we should jettison this idea.

Much of Rorty's work is dominated by this theme. Sometimes he claims that appeals to objectivity are vacuous or idle, devoid of explanatory or legitimizing power. Other times he suggests that the very concept of objectivity is philosophically tainted, and should be replaced with an uncontaminated successor concept. On still other occasions he urges that appeals to objectivity do more harm than good—social harm, rather than epistemic or metaphysical harm. Here his motives are sociopolitical. Unfortunately, he tends to run these criticisms together.

One way these themes play themselves out is in the sociocultural sphere. Consider those theorists who seek a "philosophical foundation" for a culture's way of doing things—a vindication of their social practices in something outside those practices—perhaps in the form of a theory of justice, or natural rights, or sociobiology. The anthropologist Clifford Geertz is, according to Rorty, a good example of someone who

seeks a philosophical foundation for our culture's tendency to enlarge its sympathies and adapt itself to what it encounters: Geertz is dissatisfied with the idea that our own bourgeois liberalism is "just one more example of cultural bias." Rorty despairs of such philosophical foundations: they don't accord with his obsessive desire to avoid the transcendent and the ahistorical. He denies that there are general principles—whether moral, epistemic, or metaphysical—or facts about what the world is like or what the culture ought to be like, that provide justification for our way of doing things and our way of condemning repressive cultures that do things differently.

But elsewhere he softens this: it isn't that such principles (e.g. principles about justice or natural rights) are "impossible" or "metaphysically dubious"; it's rather that, as a matter of contingent fact, such principles haven't helped the community expand in the ways prized by members of a liberal democratic society. When pursuing this latter theme, Rorty claims that he offers no "large philosophical view about the nature of culture"; rather, he simply wants members of the culture to stop aspiring to vindication in something outside of the culture.[9] He doesn't think it does any good.

But he also thinks that aspiring to such objective vindication—that is, justification that lies in something outside the culture—rests on a mistake: viz. the possibility of a "God's-eye view" of one's own culture, and of transcending that culture long enough to assess it in light of something non-cultural. Such appeals to objectivity, Rorty claims, assume the misguided philosophical picture that Putnam has dubbed "Metaphysical Realism."

Appeals to objectivity might or might not assume such pictures; and such pictures might or might not be misguided. But how *should* we talk about ourselves and our culture? According to Rorty, Western liberals should admit that their commitment to diversity is a cultural bias and that their commitment to human equality is a "mere cultural artifact," an "irrational" Western eccentricity. Such admission, Rorty insists, is refreshingly honest and non-self-congratulatory; moreover (he claims), it does not undermine our customary moral commitments. Indeed, we should acquiesce to ethnocentrism and drop the very distinction between rational judgment and cultural bias.[10]

[9] Richard Rorty, "On Ethnocentrism: A Reply to Clifford Geertz," in his *Objectivity, Relativism and Truth*, 207.
[10] Ibid. 207–8.

Granted, Rorty is not advocating ideological anarchism, or suggesting that we treat all possible social practices as equally acceptable. He is merely urging, with historicist humility, that liberals

> take with full seriousness the fact that the ideals of procedural justice and human equality are parochial, recent, eccentric cultural developments, and then to recognize that this does not mean they are any the less worth fighting for. It urges that ideals may be local and culture-bound, and nevertheless be the best hope of the species.[11]

But there is something peculiar about treating one's own ideals (whether of justice, equality, mathematical truth, or epistemic privilege) as "parochial," "eccentric," "local," and "culture-bound"—at least, while one is in their grip. One's own ideals ought to be dignified in some special way—and not simply with a footnote reminder that they are one's own. Otherwise they might lack the power to compel allegiance. Rorty, of course, would deride this sentiment as evidence that philosophical therapy is required. But perhaps it is he who needs therapy, in the form of a better interpretation of what goes on when cultures assess themselves and one another in terms of notions like *objectivity*, *rationality*, and *truth*.

VI

Most importantly, it is difficult to find Rorty's *arguments* in favor of his recommendations. What aspects of justification, truth, explanation, or representation mandate such radical revision in our ordinary ways of thinking? Why should we *stop* trying to describe ourselves "as standing in immediate relation to a nonhuman reality," and rest content with describing ourselves in relation to one another?[12] Why should we substitute solidarity for objectivity? It emerges, after one struggles to locate Rorty's arguments, that he has no "philosophical" arguments in mind at all. Rather,

> The best argument we partisans of solidarity have against the realistic partisans of objectivity is Nietzsche's argument that the traditional Western metaphysico-epistemological way of firming up our habits simply isn't working anymore. It isn't doing its job. It has become as transparent a device as the postulation

[11] Richard Rorty, "On Ethnocentrism: A Reply to Clifford Geertz," in his *Objectivity, Relativism and Truth*, 208.
[12] Richard Rorty, "Solidarity or Objectivity?," in *Objectivity, Relativism and Truth*, 21.

of deities who turn out, by a happy coincidence, to have chosen us as their people.[13] The claim is that certain metaphysical concepts either do no work at all, or do positive social-institutional damage. Drawing further upon Nietzsche, Rorty says

> the pragmatist suggestion that we . . . think of our sense of community as having no foundation except shared hope and the trust created by such sharing—is put forward on practical grounds. . . . It is a suggestion about how we might think of ourselves in order to avoid the kind of resentful belatedness—characteristic of the bad side of Nietzsche—which now characterizes much of high culture. This resentment arises from the realization . . . that the Enlightenment's search for objectivity has often gone sour.[14]

Call this the *Nietzschean* consideration. It is difficult to evaluate: I do not know what "resentful belatedness" is, or whether it is worth avoiding; nor (unfortunately) do I know much about "high culture".

There is, in Rorty's remarks, a laudable call for tolerance, humility, and solidarity: a heightened appreciation of the ideologies and historical contingencies that ground inquiry. But his sentiments embrace a disturbing cynicism, which might be characterized thus: "We have finally realized that much scientific and historical theorizing has been deeply ideological, so let's bite the bullet and recalibrate our self-concept—metaphysics and all—in light of it." Such cynicism must be monitored, lest it devolve into the irresponsible and self-refuting sentiment that truth, objectivity, warrant, logical coherence, and all the rest are simply devices used by certain populations to perpetuate hegemony over other populations.

Indeed, there is a discernible suggestion in Rorty's work that a certain concept of objectivity provides a basis for Fascist manipulation and Totalitarianism. Surely such a suggestion would be mistaken; besides, substituting 'solidarity' for 'objectivity' and 'warranted assent' for 'truth' leaves no *less* latitude for coercion and repression (manipulative scoundrels will continue to manipulate, whether their refrain is "Go with the Facts" or "Go with the Communal Flow"). But more importantly, one wants to shake this overreactive and slightly hysterical pragmatism by the shoulders: the prospects for dropping the distinction between *rational judgment* and *cultural bias*, or between *non-institutional fact* and

[13] Richard Rorty, "Solidarity or Objectivity?," in *Objectivity, Relativism and Truth*, 33.
[14] Ibid.

cultural artifact—are dim. Surely there are better ways to avoid political repression and self-congratulatory metaphysics.

Note, moreover, that if Rorty gets his utopian way—eliminating the concept of objectivity and substituting that of solidarity—much of contemporary discourse is undermined. Consider this remark by M. F. Peruts concerning Gerald Geison's book on Pasteur:

[T]he Second Law of Thermodynamics states that heat cannot be transferred from a cold to a warm body without performing work. This is neither an empirical claim, nor a social construction, nor a consensus by institutionalized science, but an inexorable law of nature based on the atomic constitution of matter. Scientific laws are different from social ones like "extreme poverty breeds crime," which may be called a consensus among liberal sociologists. I challenge Berger and Geison to quote a single law of physics or chemistry which can justifiably be described as a social construction.[15]

I admire the strength of sentiment expressed here; I take seriously Peruts's distinction between *social construction* and *inexorable law of nature*: the distinction matters. Whether or not we accept Peruts's claims about the status of scientific laws, it isn't clear that anything is gained by marginalizing his discourse and distinctions as outmoded or worthy of elimination; but the "objectivity as consensus" strategy would have precisely this result.

Despite Rorty's discourse of tolerance, there is a deeply troubling *in*tolerance, or anti-metaphysical imperialism, in his remarks. The message seems to be this: "Traditional metaphysics must be eliminated; it embraces a self-deceived appeal to the timeless, the ahistorical, the primacy of one's own practice. Throw the metaphysicians out." Rorty promulgates selective *in*tolerance in the name of liberal tolerance.

To feel the force of this, one need not embrace the Enlightenment hope that philosophy can "both justify liberal ideals and specify limits to liberal tolerance by an appeal to transcultural criteria of rationality." Nor need one embrace Dewey's commitment to the futility of such strategies. One can start with a clean slate, but be enough of a social holist to take seriously the way social practices tend to appraise and regulate themselves. In contrast to Rorty, we might not wish to pick and choose which parts of the culture are artifacts of vain philosophical theories (and thus ought to be discarded), and which parts are artifacts of culture's own attempts to retain stability and communal integrity

[15] *The New York Review of Books*, 4 Apr. 1996, 69.

(and thus ought to be tolerated). Given Rorty's commitment to cultural holism, there is something peculiar in his dismissals of certain venerable, culturally entrenched explanatory and justificatory strategies. Here is another way to put this. There is something odd in Rorty's suggestion that we should run the concept of objectivity out of town. His arguments for solidarity and against objectivity manifest a peculiar tendency to marginalize certain fragments of the culture: the venerable language-game sustained among reflective metaphysicians seeking to understand their place in the social and non-social universe is itself ostracized for the harm it does. There is thus a certain irony: although Rorty reprimands Quine for his physicalist imperialism—Quine's alleged willingness to selectively dignify scientific inquiry at the expense of other forms of life—Rorty is equally guilty of selective prejudice. For surely those metaphysicians who posit transcendent, nonhuman realities are themselves *part of the culture*; their explanations and justifications—though perhaps faulty—are *contributions to the conversation*. Rorty should, at the very least, be nervous about interpretations of metaphysical discourse that portray a vast majority of cultures as involved in something illegitimate and worthy of elimination.

The point is not that entrenched practices are unsusceptible to criticism; some concepts and distinctions—despite their prevalence—are surely dangerous (at least, by our lights) and ought to be jettisoned. But Rorty's revisionary desire to drop various distinctions (e.g. that between *scientific knowledge* and *cultural bias*) strains at his own culture holism: he should do more philosophical/interpretive work to understand the role played by such distinctions. The result would be a less radical, more conservative pragmatism.

Historian Peter Novick says that the "objectivity question" in history

is far from being "merely" a philosophical question. It is an enormously charged emotional issue: one in which the stakes are very high, much higher than in any disputes over substantive interpretations. For many, what has been at issue is nothing less than the meaning of the venture to which they have devoted their lives, and thus, to a very considerable extent, the meaning of their own lives.[16]

Novick is right: it matters whether we see ourselves as spinning rich narratives or discovering the way the world is. But it is not yet clear *why* it matters, because it is not yet clear what objectivity comes to. Here connections with ontology—artworld and otherwise—loom large.

[16] Novick, *That Noble Dream*, 11.

VII

Social consensus, when it obtains, is a condition susceptible to explanation; "shared hope and trust" within a community are, when they occur, real social-psychological conditions that occur for a reason. Often such conditions result from repressive political agendas, biased distribution of scarce resources, opportunistic editorial policies, and other mechanisms of social manipulation; but often they are grounded in agreement resulting from perceptual and cognitive uniformities among citizens. Communal solidarity concerning some banal matter—the height of a local mountain, for example—is best explained by adverting to the actual height of the mountain, conjoined with information about citizens' capacity to reliably form correct judgments about height. Occasionally it is necessary to remind pragmatists and postmoderns that there are mountains which are not social constructs: mountains with determinate properties, some of which are readily observable. Citizens with adequate perceptual and cognitive skills are able to form true beliefs about mountains. To deny these humble platitudes is to acquiesce into the lunatic fringe, and—more disturbingly—to flirt with social idealism.

Extreme or overreactive pragmatism is typified in John Murphy's observation:

> To be a pragmatist is to give up attempting to ground the solidarity we feel with our fellow inquirers in objectivity. It is to see that the craving to do so is a confusion: Objectivity is to be reduced to solidarity, and the only sense in which the natural sciences are exemplary of objectivity is that they are among our best models of human solidarity.[17]

If any "confusion" lurks here, it is not in efforts to "ground" solidarity in objectivity, but rather in touted attempts to "reduce" objectivity to solidarity: for any such "reduction" is impossible. There is more—and less—to the objectivity of a property than the possibility of consensus among inquirers regarding the presence of that property: objective properties might fail to command consensus, and consensus might be achieved about nonobjective phantasms. There is a "gap" between objectivity and solidarity.

Moreover—here is the earlier point about explaining social consensus—prospects for "explicating" objectivity in terms of solidarity

[17] John P. Murphy, *Pragmatism: From Peirce to Davidson* (Boulder, Colo.: Westview Press, 1990), 106–7.

are dim. Where communal solidarity obtains, it must be *explained*: often the best explanation mobilizes the concepts of mind independence and objectivity. If, for example, there is consensus about the location of City Hall it is because relative location is an objective property and citizens are equipped with sensory capacities, computational and discriminative skills that enable them to track such properties and share beliefs about them. Objectivity is, *inter alia*, an *explanatory* concept; communal solidarity is one of the phenomena it helps explain. Thus it is difficult to see how the former can be "reduced to," or replaced by, the latter.

And so it goes in the artworld. An adequate ontology of architecture, for example, must provide resources for explaining citizens' beliefs about the relative sizes of local buildings: buildings are the *sorts* of things to which normal observers have certain epistemic access. An adequate ontology should also explain why people sustain the architectural norms they do: if preservationists regard demolition of French Second Empire structures as immoral, that fact merits explanation; part of the explanation involves reference to the *kinds of things* that French Second Empire structures are (conjoined with information about citizens' beliefs and desires). Even where normativity is at issue, ontology appears to be in the business of explanation.

Such a theme is familiar elsewhere in philosophy: it is common to endorse ontological views on the basis of explanationist considerations. Allan Gibbard, for example, offers a metaphysics of normativity which, strictly speaking, has no room for certain sorts of normative facts (facts about what is rational, for example).[18] Here is Paul Horwich's description of Gibbard's ontological strategy:

Gibbard's line . . . is to characterize facts . . . as entities that have a role in the explanation of our beliefs about them. Therefore, facts of rationality do not exist, [Gibbard] argues, because the explanations of our beliefs about what is rational make reference merely to the evolutionary benefits of the coordination fostered by our having such beliefs; it is never because a thing is rational that we think it is. Hence there are no facts or truths about what is rational, and there is no property of rationality.[19]

Once again ontology marches in time to explanation. What it *is* for there to be no *K*-facts (facts about rationality, facts about heights

[18] Allan Gibbard, *Wise Choices, Apt Feelings: A Theory of Normative Judgment* (Cambridge, Mass.: Harvard University Press, 1990).
[19] Paul Horwich, "Gibbard's Theory of Norms," *Philosophy and Public Affairs*, 22, no. 1 (1993), 70–1.

of mountains, or facts about interpretive contents of artworks) is for best explanations of K-beliefs to make no reference to things' being K. If the best explanations of moral beliefs make reference only to nerve hits, evolutionary benefits, sentiments, and patterns of communal censure and commendation—but never to the rightness or wrongness of actions—then there are no facts or truths about what is right, and there is no property of rightness. Analogously: if the best explanations of theistic belief and practice mobilize reference to the deeds and powers of a Judeo-Christian God, then a theistic ontology is, *ceteris paribus*, thereby warranted. If the most plausible explanation of mathematical practice (including the phenomenology of mathematical engagement) deploys reference to a realm of *ante rem* abstract entities known by reason alone, then a platonistic ontology is thereby warranted. And so on.

The concept of objectivity is thus intimately connected with explanatory endeavors: objective facts are those that enter into best explanations. Moreover: existent entities and properties are those that earn their keep as explainers (recall Philo's refusal to countenance Cleanthes' God, insofar as the envisaged explanatory work can be done non-theistically). The best ontology of art—or mathematics, or morality, or linguistic content—is that which best serves the purposes of explanation. Of course there are venerable puzzles about what constitutes the data to be explained, what constitutes an explanation, what counts as a superior explanation, what counts as verification, and other conundrums about theory construction and assessment; but such puzzles do not speak against the current tendency to identify *explanation* as the key notion in terms of which objectivity and ontology are best understood. Insofar as explanation is a legitimate enterprise, the notion of objectivity is secure.

VIII

Despite Rorty's occasional overstatements, there is an intriguing construal of his indictments against the metaphysics of objectivity and his skepticism about ontology, a construal grounded in his ongoing commitments to pragmatism. A fundamental tenet of pragmatism involves distrust of metaphysics. Mark Johnston describes one possible basis for such distrust:

Let us say that metaphysics in the pejorative sense is a confused conception of what legitimates our practices; confused because metaphysics in this sense

is a series of pictures of the world as containing various independent demands for our practices, when the only real legitimation of those practices consists in showing their worthiness to survive on the testing ground of everyday life.... So defined, metaphysics is the proper object of that practical criticism which asks whether the apparently legitimating stories which help sustain our practices really do legitimate, and whether the real explanations of our practices allow us to justify them. There then ought to be a critical philosophy which not only corrals the developed manifestations of metaphysics within philosophy but also serves the ends of practical criticism. Such a critical philosophy would be the content of anything that deserved the name of a progressive Pragmatism.[20]

Perhaps the clearest example of "metaphysics in the pejorative sense" is a picture of the world as containing a Divine Being who makes demands on our conduct and practices. If our thinkings or doings run afoul of His wishes, they are somehow illegitimate; thus His very Nature packs considerable normative force. To do The Right Thing is, *inter alia*, to conform to His preferences. But He is independent of our practices: His existence and His demands do not depend upon our acknowledging them.

A less dramatic—though equally venerable—example concerns the existence and role of universals: though not themselves socially constructed, such entities allegedly provide touchstones for the correctness of our practices. Correct classification demands tracking real properties; correct assertion demands correspondence to actual patterns of property exemplification; and so on. Such examples provide (perhaps) a fix on what Johnston means by "metaphysics in this sense is a series of pictures of the world as containing various independent demands for our practices."

But slogans aside, what is *wrong* with such metaphysical pictures? Why the 'pejorative' in "metaphysics in the pejorative sense"? The world obviously makes "demands": if people do not acquiesce to the demands of radioactivity, for example, they will perish. But the sorts of theories impugned by Johnston (and, I believe, Rorty) are of another sort: they purport to provide "legitimation," not causal explanation; and this is (allegedly) misguided, because "the only real legitimation of those practices consists in showing their worthiness to survive on the testing ground of everyday life." Thus the root idea—which, I suspect, is a force

[20] Mark Johnston, "Objectivity Refigured: Pragmatism without Verificationism," in J. Haldane and C. Wright (eds.), *Realism and Reason* (New York: Oxford University Press, 1993), 85.

behind Rorty's indictments—is that any metaphysical theories which purport to be in the business of legitimating institutional practices are in principle misguided. Such theories are (for reasons yet unspecified) not up to the task.

Given the pragmatist's avowed concern with the realities of ordinary practice, these indictments are bizarre. After all, *ontology itself is part of ordinary practice*: our treatment of, and response to, paintings, musical compositions, sculptural installations, and literary works (to return to artworld examples) is regulated by ontological considerations. It is *because* of what artworks *are* that they should be treated in one way rather than another: certain patterns of audience attention are appropriate because of what a musical performance *is*; focus upon certain aspects of line and color is appropriate to understanding Barnett Newman's paintings because of what those paintings *are*; demolition of historic buildings is inappropriate because of architectural structures' essential links to our shared cultural past. And so on. Whatever else "an ontology of art" is supposed to do, it must be sufficiently robust to provide a *legitimizing ground* for the licenses and prohibitions—the norms—upheld within the artworld. It is because of what artworks *are* that we are justified in engaging them in one way rather than another. *Pace* pragmatist indictments, ontology appears to be a respectable aspect of ordinary practice.

Such justificatory power is hardly unique to artworld ontology: it is because of what natural numbers *are* that we are justified in treating them as constituting a countably infinite set; it is because of what persons *are* that we are justified in treating them as ends rather than means, or punishing them for evils they committed in the past; it is because of what I am—a self that endures through time—that I am justified in having greater concern for my future than that of my peers. And so on. Ontology provides the *legitimizing grounds* for our shared practices, artworld and otherwise. We treat things—artworks, numbers, persons—as they ought to be treated, given what they are; if we fail to do so, we have done something wrong.

Thus the pragmatist indictment against ontology is extremely puzzling. The metaphysics is *part of the practice*—not an artifact of some misguided philosophical attempt to survey the practice from an "outside" vantage point. Insofar as the practice contains an ontological story that serves to underwrite normative claims, understanding the practice requires accommodating the legitimating mechanisms sustained within it. What error, according to the pragmatist, is made here? Does

the ontology of art—and ontology generally—rest upon a mistake? What mistake?

The general issue is the relation between metaphysics and ordinary practical concerns: thus far the point is that ordinary practices, artworld and otherwise, have a certain amount of metaphysics woven into them. But there is, I think, a *picture* found objectionable by certain foes of metaphysics and ontology, and it is important to articulate that picture. The picture portrays people as moving within the space of reasons, groveling in the trenches of daily, normatively constrained life, while overbearing, authoritative transcendent objects loom over them, making demands about how to act, and threatening them with delegitimization if they go on one way rather than another. Grotesque imagery notwithstanding, these are "the superlative entities of the familiar metaphysical pictures"; and one kind of pragmatist philosopher—deemed "the Minimalist" by Johnston—claims that such entities—if they exist at all—"are not the crucial justifiers of our attitudes and practices."[21] Note that love of Desert Landscapes—that is, commitment to ontological parsimony—is *not* the driving force behind Minimalism: "metaphysical" entities might have respectable place in the order of explanation. Rather, the Minimalist is driven by views about the nature and locus of legitimacy, and denies that justification of a practice can be visited upon it "from the outside." But it is hardly clear that ontology—artworld and otherwise—involves any such errors.

Another observation by Johnston helps clarify the situation:

> [W]hat I have elsewhere labeled "Minimalism" [is] the view that metaphysical pictures of the justificatory undergirdings of our practices do not represent the crucial conditions of justification of those practices. The Minimalist has it that although ordinary practitioners may naturally be led to adopt metaphysical pictures as a result of their practices, and perhaps a little philosophical prompting, the practices are typically not dependent on the truth of the pictures. Practices that endure and spread are typically justifiable in nonmetaphysical terms. To this the Minimalist adds that we can do better in holding out against various sorts of skepticism and unwarranted revision when we correctly represent ordinary practice as having given no crucial hostages to metaphysical fortune.[22]

To be a Minimalist, then, is to favor a certain kind of account of the *justification* of our shared practices—or rather, to *reject* certain kinds of

[21] Mark Johnston, "Reasons and Reductionism," *Philosophical Review*, 101 (July 1992), 618.
[22] Ibid. 590.

account. It isn't that the Minimalist regards certain entities as intrinsically suspicious and undeserving of ontological recognition: abstract entities, for example, are not to be eschewed by mere virtue of their abstractness. Rather, Minimalism claims that the legitimacy of a practice is *not* to be found in the conformity of that practice to the demands made by items that somehow "stand above" the practice and demand compliance (it is hard to say what 'stand above' means here; but it prompts imagery that often moves pragmatists to despair). The enemy outside the Minimalist's gate is one who invokes certain "superlative" entities—whether meanings, universals, Cartesian Egos, values, or whatever—as *justifiers*. The Minimalist's enemy claims these entities to be the only things that would confer the required privilege on our practical concerns. Had the superlative entities existed, and stood in the right relation to the concerns in question [e.g. concern for our future self], then those concerns would have had an external point and anchor. They would not simply be consequences of our contingent and historically malleable interests.[23]

So we need to know what it would *be* for a practice or set of concerns to have "an external point and anchor": for the Minimalist claim is not only that our practices do not *require* such an external point and anchor, but that in fact they do not *have* one.

Granted, there are "external forces"—*causal* forces—that sustain institutional practices; but such forces do not *legitimate* those practices. The vital contrast here is that between *explanation* and *justification*. The pragmatist/Minimalist is concerned lest we seek justification for our practices in the wrong place.

Perhaps there is something to these indictments; perhaps certain traditional ontological theories run afoul of these *caveats* about practice and justification, and seek to "ground" the legitimacy of critical practices in a way that is somehow misguided. But in the present context there is no basis for skepticism about artworld ontology: for all the pragmatist and Minimalist have alleged, it is nonetheless acceptable to ask *what artworks are*, or whether music possesses, as a matter of metaphysical fact, emotional-expressive properties, or whether the ontology of architecture mandates certain historic restoration procedures rather than others.

The legitimacy of ontology—in light of present "pragmatist" indictments—can be clarified with an example drawn from yet another region of metaphysics.

[23] Mark Johnston, "Reasons and Reductionism," *Philosophical Review*, 101 (July 1992), 591.

Consider disputes about the metaphysical status of possible worlds. Two options are customarily available:

Option 1: Possible worlds (other than the actual world) exist. They differ from the actual world in various ways, foremost among which is that we do not inhabit them. Possible worlds and their denizens enjoy mind-independent reality: the truth or falsity of ordinary modal and counterfactual claims depends upon what goes on in possible worlds other than our own.

Option 2: The only possible world that exists is the actual world. Truth conditions for modal and counterfactual claims concern what goes on in *this* world (for this is the only world there is). Granted, possible-worlds semantics is a helpful tool for exploring and modeling the structure of modal discourse; but the ontologically bizarre entities spawned by such semantic theories should be treated with instrumentalist indifference.

More specifically: let *PW* be a standard Kripke-style semantics for a modal fragment of natural language. *PW* deploys familiar apparatus: possible worlds, accessibility relations and similarity orderings, domains of individuals associated with each world, mappings from worlds to extensions, denotation-at-a-world, truth-at-a-world, and the like. 'Necessarily P' is true at a world *w* iff P is true at all worlds accessible from *w*; 'If P were the case, then Q would have been the case' is true at a world *w* iff Q holds at all P worlds relevantly similar to *w*; and so on.

Here we have a *metaphysical picture*: possible worlds are spread out through Kripke space, like raisins in a pudding;[24] facts about those worlds are truthmakers for modal claims made in the actual world. We may argue about the correctness or coherence of this picture, insisting that the only existent entities are actual entities, or that modal claims made in this world have nothing to do with truths about other worlds, or that the very idea of a non-actual existent is unintelligible.

Option 2 denies that the metaphysical picture embedded in *PW* provides a "ground"—either a legitimizing foundation or a causal explanation—for our ordinary practices of endorsing or disputing modal claims. We can remain committed to the value of *PW* as a helpful mechanism for codifying aspects of modal discourse: clarifying modal intuitions, regimenting modal inferences, and recursively characterizing truth for modal assertions. *PW* might be regarded not as the

[24] The imagery derives from Larry Powers; see "Comments on Stalnaker, 'Propositions,'" in A. MacKay and D. Merrill (eds.), *Issues in the Philosophy of Language* (New Haven: Yale University Press, 1976), 95.

"metaphysical foundation" of our modal practice, or even as part of the "best explanation" of that practice, but rather as a clear and dramatic *representation of the norms implicit in that practice*. This should warm the pragmatist's heart. Thus interpreted, there is little in *PW* to arouse suspicion: the worlds do not *legitimize* or *explain* our modal practices; the worlds *represent* those practices. Thus *PW* need not provoke tiresome disputes about epistemic relations between actual beings and merely possible states of affairs. *PW* provides no "external point and anchor" for modal discourse, no "justificatory undergirdings" for the way we talk and think about possibility or counterfactuality. The worlds depicted in *PW* place no demands upon us; *the worlds depict the demands we place upon ourselves*.

Thus the metaphysical Minimalist can be comfortable with an ontology of possible worlds: but work is required to show that such a construal of *PW* is indeed acceptable. Technical labor is demanded: we need to show that *PW* is a *conservative extension* of ordinary modal discourse *D*, insofar as it "adds nothing to what was already there." Talk of "possible worlds" would thus be portrayed as picturesque redescription, equivalent to talk about what could have been the case; talk about "truth at all worlds" would be portrayed as equivalent to talk about necessity. And so on. On this interpretation, *PW* is neither more nor less than an algebraically tractable depiction of the descriptive and inferential norms that constitute modal discursive practices.

Any such demonstration of conservativeness requires that modal discourse be sufficiently regimented to allow precise determination of derivability and logical consequence: for the conservativeness claim is that anything derivable in $D + PW$ (in the vocabulary of *D*) is derivable in *D simpliciter*, and/or that all logical consequences of $D + PW$ formulas are consequences of *D* formulas. And there is basis for skepticism: after all, *PW* is sufficiently rich to allow for recursive characterization of truth-in-*D* (relative to a structure *M* and world *w*); unless *D* is semantically closed, there is reason to suppose that *PW*'s resources outrun those of *D*.[25]

The point here is that careful systematic efforts must be undertaken to determine whether *PW* "goes beyond" *D* in containing expressive/deductive/semantic resources that are not already present in *D*. But for all the pragmatist and metaphysical Minimalist have said about the pitfalls of ontology, there is little reason to eschew an ontology

[25] Thanks to Anil Gupta for helping me avoid a substantial error in formulation.

of possible worlds. The worlds are not in the business of legitimizing our modal practices; the worlds are simply a useful adjunct to those practices, rather like the record books wielded by public accountants. This digression into modal metaphysics provides an example of *ontology serving purposes other than the explanatory*: possible worlds play no role in *explaining* modal discourse, nor do they serve to *legitimize* modal discourse; they serve, rather, as convenient *codifications* of the norms sustained within that discourse. Like the dictionary discussed in Chapter 1, the ontology of possible worlds earns its keep by *summarizing* practices rather than entering into their best explanation. The worlds play no role in explaining the norms upheld in modal discourse; the worlds, rather, *codify* those norms. Perhaps the ontology of art can be understood in similar terms: George Dickie's "institutional" theory, for example, portrays artworld institutional practices as *constitutive* of artworld ontology rather than being *constrained* by it.[26]

There are thus two ways to think about the ontology of art and artworks. First, there are explanatory tasks: artworld institutional practices must be understood, and an ontology of art must be sufficiently rich to facilitate explanation of such practices. The better ontology is that which, *ceteris paribus*, does a better explanatory job. The lesson learned from our brief foray into modal metaphysics is that ontology often serves quite another purpose: that of codifying institutional norms and summarizing the principles sustained within our practices. Thus construed, the better ontology of art is that which comes closest to capturing our sense of how we ought to engage artworks: what features we should attend to, and what features are relevant to interpretation.

IX

An example brings the contrast into focus. Walter, a lover of fine art, discovers that his favorite Cubist painting—or, more precisely, a carefully crafted reproduction thereof—is easily obtainable from an online firm that specializes in replications of fine artworks. There is no hint of fraudulence or forgery: the company describes its reproductions

[26] See, e.g. George Dickie, *Art and the Aesthetic* (Ithaca, NY: Cornell University Press, 1974); *idem*, *Art and Value: Themes in the Philosophy of Art* (Oxford: Blackwell Publishers Ltd., 2001); *idem*, *The Art Circle: A Theory of Art* (New York: Haven Press, 1984).

as "custom made by request" and "hand painted in oils on canvas by highly skilled artists." Walter cannot afford Juan Gris's *Violin and Guitar*; but he can easily obtain an impressively accurate replica, a copy likely to satisfy most of his aesthetic needs.

That depends, of course, upon his aesthetic needs: something about such replicas disturbs Walter. He is no metaphysical slouch: he knows that artworks are historically situated, that their causal etiologies are essential to their identities, that Twin-Earth variants of persons and artworks are not identical to their Earthly counterparts, and so on. But he also enjoys photos of his children, poster advertisements for art exhibits, and recordings of his wife's voice; he is hard pressed to say how such enjoyment is consistent with his discomfort about the reproduced painting. He is disturbed—for reasons he cannot articulate—by the prospect of owning such a painting.

Ontology to the rescue: we might reflect upon the sort of thing a painting *is* and conclude that such replicas run afoul (or not) of some artworld norm or other. Perhaps owning such a replica is analogous to living with a functional doppelganger of a departed loved one: such a practice seems perverse—bordering on the macabre—and if we understand the sort of thing a person *is*, we will know why. But perhaps the analogy is misleading; after all, artworks are not persons.

If only we had a better sense of what paintings *are*, we would be better equipped to diagnose and evaluate Walter's discomfort: perhaps when he learns "the correct ontology of art" he will see that his attitude is inappropriate, and—once his sentiments catch up with his normative appraisals—he will comfortably order reproductions galore of his favorite artworks. Note that ontology here provides a *ground* for assessment of Walter's sentiments: it is because of *what works of art are* that various attitudes toward artworks and artwork replicas are deemed legitimate. Ontology here plays a justificatory role.

That is one view about ontology and how it earns its keep; the point of the earlier discussion of the metaphysics of possible worlds is that an alternative view is available. For there we saw that ontology—on one construal—is not in the business of providing a ground for assessing inferential norms, but is rather in the business of *codifying* such norms. Example: the discursive practice of iterating alethic necessity—of inferring, e.g., 'Necessarily necessarily P' from 'Necessarily P'—is *not* to be assessed in light of the "fact" that the accessibility relation defined over possible worlds is transitive. Rather: a transitive accessibility relation is

introduced into the model as a "picture" of the iterative inferential license sustained within the discourse. The purpose of the ontology is not to legitimize the inferential practice, but rather to provide a model of it.

Analogously: Walter's resistance to handcrafted replicas of his favorite artworks is not to be normatively assessed in light of ontological considerations. The ontology of art cannot shoulder that justificatory burden; the ontology provides a representation of the norms sustained within the artworld—much as a road map provides a model of the traffic engineer's handiwork—rather than a metaphysical construction to which those norms are beholden. Perhaps Walter's sentiments are illegitimate—there may be nothing wrong with such replicas—but that illegitimacy does *not* consist in the sentiments' straining at the realities of artworld ontology. An obvious analogy emerges from certain theories of semantic content: word meaning provides no independent tribunal against which to access correct communal usage, because word meaning is *constituted* by such usage. Similarly: the ontology of art provides no tribunal against which to assess the legitimacy of Walter's sentiments, because the ontology is merely a canonical representation of, among other things, the correctness (or incorrectness) of such sentiments. Questions of justification, though legitimate, are not resolved by consulting a practice-independent tribunal of artwork ontology: artworld ontology provides no such tribunal. It merely provides a codification of artworld practice, and thus—*inter alia*—of the justificatory status of sentiments sustained therein.

The goal of this chapter is to provide a better understanding of the concept of *objectivity* and what we are doing when we deploy it, and of the practice of ontology and what we are doing when we engage in it. The upshot is that the ontology of art and the quest for objectivity within the artworld do not rest upon mistakes.

8
Postscript: Language, Speaker, Artist

A salient theme in previous chapters concerns the assimilation of artistic genres to natural languages, or—less ambitiously—the tendency to regard analogies between artforms and linguistic structures as relevant and illuminating. More should be said about this.

Psychologist P. N. Johnson-Laird, writing on the computational mechanisms underlying jazz performance, offers the following:

> The psychological question about modern jazz is: how do musicians improvise? That is, what are the mental processes that underlie their performance? They themselves can articulate only a limited answer, because the underlying mental processes are largely unconscious. If you are not an improvising musician, then the best analogy to improvisation is your spontaneous speech. If you ask yourself how you are able to speak a sequence of English sentences that make sense, then you will find that you are consciously aware of only the tip of the process. That is why the discipline of psycholinguistics exists: psychologists need to answer this question too.[1]

Jazz improvisation is said to be "analogous" to spontaneous speech. It is not clear how far the analogy can be pushed: whether it can be generalized to other modes of music production, for example, or perhaps even to other artistic media. Is classical composition analogous to spontaneous speech? Is performance of Bach's compositions analogous to non-spontaneous speech, or direct quotation? Is Jackson Pollock's painterly activity analogous to slurred speech? Is sculpting like talking? How is it like talking? How close are the analogies?

In a chapter entitled "The Linguistic Analogy" architectural historian Peter Collins writes

> Language, after all, has one great advantage over the biological and mechanical analogies, in that neither of the latter tells us anything about human emotions or the way these emotions are experienced.... Language, on the other

[1] P. N. Johnson-Laird, "How Jazz Musicians Improvise," *Music Perception*, 19 (Spring 2002), 415–42.

hand, unlike biology and mechanical engineering, but like architecture, is both functional and emotional.[2]

Whatever the rationale, linguistic analogies play an ongoing role in theorizing about various artforms. Given Johnson-Laird's suggestion—which echoes themes developed in Chapters 1 and 3—it is clear why a theorist preoccupied with jazz improvisation would incline toward thinking about the arts in linguistic terms.

Work in other areas prompts similar speculation. Aniruddh Patel, a neuroscientist concerned with relationships between music and speech, uses neuroimaging data to locate convergence points between syntactic processing in language and music. Patel and fellow scientists suggest, for example, that music processing occurs in the same cortical areas as natural-language syntactic processing, and that Broca's aphasia is selective not only to language but influences music perception as well.[3] Here is a clear statement by Patel describing his recent work:

Two new empirical studies address the relationship between music and language. The first focuses on melody and uses research in phonetics to investigate the long-held notion that instrumental music reflects speech patterns in a composer's native language. The second focuses on syntax and addresses the relationship between musical and linguistic syntactic processing via the study of aphasia, an approach that has been explored very little. The results of these two studies add to a growing body of evidence linking music and language with regard to structural patterns and brain processing.[4]

Such results hardly confirm the bold hypothesis that "music is language" (Patel himself makes no such claims), but they surely encourage continued speculation along such lines.

[2] Peter Collins, *Changing Ideals in Modern Architecture* (Kingston and Montreal: McGill–Queen's University Press, 1965), 173–4.
[3] There is an enormous developing literature in the area. See, e.g., A. D. Patel, "Syntactic Processing in Language and Music: Different Cognitive Operations, Similar Neural Resources?," *Music Perception*, 16 (Fall 1998), 27–42; *idem*, "Language, Music, Syntax and the Brain," *Nature Neuroscience*, 6 (July 2003), 674–81; *idem* and Isabelle Peretz, "Is Music Autonomous from Language? A Neuropsychological Appraisal," in I. Deliège and J. Sloboda (eds.), *Perception and Cognition of Music* (London: Erlbaum Psychology Press, 1997), 191–215; *idem*, E. Gibson, J. Ratner, M. Besson, and P. J. Holcomb, "Processing Syntactic Relations in Language and Music: An Event-Related Potential Study," *Journal of Cognitive Neuroscience*, 10, no. 6 (1998), 717–33.
[4] Aniruddh D. Patel, "The Relationship of Music to the Melody of Speech and to Syntactic Processing Disorders in Aphasia," *Annals of the New York Academy of Science*, 1060 (2005), 1–12.

Postscript: Language, Speaker, Artist 179

Why does it matter? What is to be *gained* from the "art-as-language" hypothesis? Art is art; language is language. Doubtless there are points of similarity and points of divergence; why not leave it at that? We cannot leave it at that because our goal is to accommodate as much artworld data as possible: these include the customary ways in which artworld practitioners think and talk about their own practices and products. As noted in earlier chapters, there is a strong conviction among working jazz players that music is a linguistic form: such conviction rests primarily upon the phenomenology of music production. Playing music *feels* strikingly similar to speaking; ensemble performance *feels* strikingly similar to conversation; such phenomenological similarities demand explanation. Construing music as language is one possible explanation.

The plausibility of assimilating music to language depends, obviously, upon how one defines 'language' and thus upon the conditions ascribed in calling a mode of behavior B "linguistic". The following conditions come to mind, some more salient than others:

- B is rule-governed (i.e. B-behavior involves rule-following, not mere conformity to rules);
- B is representational;
- B involves the production of a potential infinity of well-formed behavior pattern-types, the set of which is recursive;
- meanings of complex B-performances are compositional functions of the meanings of constituent performances;
- B-performances stand in special relations (to be specified) to mental representations;
- complex B-behaviors have "intentional content" by virtue of certain properties (e.g. representational conventions) rather than others (e.g. nomological covariances);
- B consists of a finite stock of repeatable "basic behaviors" (corresponding to primitive vocabulary);
- production of complex B-behaviors is best explained *via* Chomskian generative mechanisms;
- comprehension of B-performances involves interpretation rather than causal explanation;
- B-behaviors are susceptible to a Tarski-style truth definition;

- *B*-behaviors "express information" by virtue of essential connections with causal-historical and/or social-institutional properties;
- norms of license and authorization hold among various possible *B*-moves; the significance of a given move depends primarily upon such "inferential connections."

And so on. Any such factors—and many others—might be salient in theorizing about relations between natural languages and artistic genres. The "art-as-language" advocate obviously thinks it important to locate some such features in artworld phenomena.

Garry Hagberg raises a relevant issue:

> Our fundamental concern here is with the view that the artist is in all essentials like a speaker of a language and that the meaning of an artwork is thus like the meaning of a word. The ways in which this analogy can be given details, however, differ considerably.[5]

Despite various obvious ways in which "this analogy can be given details"—note the possibilities offered above—there are risks (recognized by Hagberg) insofar as "a conception of meaning in art is [thereby] given shape by a prior, if implicitly held, conception of linguistic meaning."[6]

Hagberg is right about this, and one risk is especially salient. Suppose the art-as-language paradigm is conjoined with the thesis that semantic properties of linguistic items depend upon intentions of the speaker: one is thereby led to think of paintings, musical performances, and other artistic phenomena as having a meaning or significance that derives from artists' intentions which "lie behind" the production of those works. That is: insofar as semantic content is determined by psychological attitudes of the speaker, the art-as-language model fosters the idea that the purpose of artworld interpretation is to discover artists' intentions. One is thereby driven to a conception of artistic interpretation that might be out of sync with artworld realities: perhaps the meaning of an artwork goes beyond (or falls short of) anything the artist has in mind.

It is important to note that "mentalistic" theories of linguistic content are not inevitable.[7] Both W. V. Quine and Wilfrid Sellars, for example,

[5] Garry L. Hagberg, *Art as Language* (Ithaca, NY: Cornell University Press, 1995), 123–4.

[6] Ibid. 119.

[7] H. P. Grice and Stephen Schiffer provide paradigm instances of such "intention-based" semantic theories. See, e.g., H. P. Grice, "Meaning," *Philosophical Review*, 66

eschew theories according to which linguistic meaning is derivative from psychological representation; both resist the idea that natural-language interpretation is an effort to gain access to the intentions that underlie linguistic behavior. Quine offers an account of meaning and translation cast in terms of stimulus and behavioral response, and explicitly rejects any "pernicious mentalism" that construes "a man's semantics as somehow determinate in his mind beyond what might be implicit in his dispositions to verbal behavior."[8] Sellars offers an account of meaning and translation cast in terms of social-institutional norms and the "roles" played by bits of language within the framework of perception, inferential transformations, and action.[9] Quine foregrounds cause and effect; Sellars foregrounds license, entitlement, and authorization.[10] Both philosophers resist—in radically different ways—assimilation of semantics to psychology; both deny that correct translation turns on discovering mental events in which the meaning of overt verbal performances is grounded.

Such "non-mentalistic" accounts of semantic content might ultimately prove inadequate. The issues here—linguistic intentionality, mental representation, relations between psychological and semantic content—are notoriously complex and constitute the core of much work in the philosophy of language and the philosophy of mind. The present point is modest: there are alternatives to intention-based semantics—alternatives, that is, to construing linguistic meaning as determined by internal mental content.

(1957), 377–88; *idem*, "Utterer's Meaning and Intentions," *Philosophical Review*, 78 (1969), 147–77; Stephen Schiffer, *Meaning* (Oxford: Oxford University Press, 1972).

[8] W. V. Quine, "Ontological Relativity," in his *Ontological Relativity and Other Essays* (New York: Columbia University Press, 1969), 27; see also *idem*, *Word and Object* (Cambridge, Mass.: MIT Press, 1960), ch. 2.

[9] Wilfrid Sellars, *Science, Perception and Reality* (London: Routledge & Kegan Paul, 1967); "Chisholm–Sellars Correspondence on Intentionality," in H. Feigl, M. Scriven, and G. Maxwell (eds.), *Minnesota Studies in the Philosophy of Science* (Minneapolis: University of Minnesota Press, 1957), ii. 507–39; Wilfrid Sellars, "Language as Thought and as Communication," in his *Essays in Philosophy and its History* (Dordrecht: D. Reidel, 1974), 93–117.

[10] This contrast should not be overstated. As noted in Chapter 2, Quine is often portrayed—in contrast to Sellars—as having lost touch with normative dimensions of language use. This is a mistake. Quine's theories of linguistic behavior are saturated with references to "the critic, society's agent," the dynamics of "train[ing] the individual to say the socially proper thing" and "outward conformity to an outward standard." No lapse in normativity here. But Quine's stimulus–response view about what normativity *is* prompts some readers—especially those of Sellarsian extraction—to read Quine as having turned away from real normativity and substituted a behavioristic *ersatz*. Not so.

It is an open question whether there is, in the long run, more to be gained than lost by treating artforms as languages. But the tendency to invoke semantic models of artforms carries no commitment to treating the mind of the artist as the ultimate arbiter of meaning and interpretation in the artworld.

Index

aesthetic theory
 and artworld practice 1-24
 and linguistic theory 8-9, 15-17, 18-19, 57-65, 107-8
 marginalization of 1-2, 23-4
Alexander, Christopher 64 n. 35
Ali, Rashid 46
Alperson, Philip 65 n.
Amaral, Pedro 24 n., 65 n.
anti-realism 143-7; *see also* realism
art
 about art 12-15
 and language 18-19, 49 n. 9, 57-65, 107-8, 118, 137-41, 177-82
 as achievement 56
 as expressive of emotion 50-1, 66-97
 as problem solving 63-4
 essence of 45-6
 isolationist theory of 49-51
audience 93, 114-19, 123
Ayler, Albert 42, 53, 84

Bach, J.S. 44
Balla, Giacomo 138
Barrett, Terry 125
Barron, Joey 57
Batterman, Robert 24 n.
Baxandall, Michael 63 n. 33
Beatles, The 76
Beethoven, Ludwig van 69
Bell, Clive 48-9, 51-2, 60-1, 76
Benacerraf, Paul 102-4, 111
Berliner, Paul 64 n. 34
Bernazzoli, Laura 24 n.
Bernstein, Richard 157
Blackburn, Simon 31, 89 n. 23, 144 n. 23
Blakey, Art 76
Boccioni, Umberto 138
Boghossian, Paul 90 n. 24
Braque, Georges 138, 140
Brogaard, Berit 36 n. 11, 43 n.
Brown, James 21-2, 45, 71
Brown, Lee 65 n.

Budd, Malcolm 19, 93
Burge, Tyler 137

Cage, John 15, 41
Calvin, John 96
Carnap, Rudolf 47, 153-4
Carroll, Lewis 98, 119
Cezanne, Paul 15, 48, 61, 138
Cherry, Don 42, 53
Chomsky, Noam 128 n. 9, 156, 179
Chopin, Frederic 66, 71
Coker, Wilson 94
Cole, Julian 65 n.
Coleman, Ornette 53, 58, 84
Coleman, Steve 45
Collingwood, R.G. 44, 61-2, 115
Collins, Peter 177-8
Coltrane, John 21, 44, 45-6, 55, 72, 84
composition as performance 74-5
consistency proofs and circularity 27 n. 2
content expressionism 68-9, 78-84
content vs. cause 50-51, 74, 117-18
Copland, Aaron 94
Corea, Chick 47, 55, 88
Critical Anarchism, *see* Critical Monism
Critical Monism 124-50
cross-genre comparisons 22
Crowbar 76

Danto, Arthur 1, 22, 41, 31 n. 1, 51-3, 138-9
D'Arms, Justin 97 n. 34
Davidson, Donald 58-9, 62, 63, 82, 124, 126
Davies, Stephen 68 n., 95-6
Davis, Miles 45, 116-17
Debussy, Claude 21, 22, 71
de Chirico, Giorgio 12
Dedekind-Peano axioms 100, 102-5, 132
de Kooning, Elaine 121

184　　　　　　　　　　Index

Derrida, Jacques 156
Devereaux, Mary 1-3, 5-6
Devo 21
Dewey, John 157
Dickie, George 22 n. 40,
 40-3, 174
dictionary 8, 16, 174; *see also* art and language
DiMeola, Al 88
Dolphy, Eric 53
Donne, John 22
Duchamp, Marcel 12, 40
Dummett, Michael 154
Dutton, Denis 56
Dvorak, Antonin 21, 76
Dworkin, Ronald 10 n. 18

Eagleton, Terry 8-13, 20-1
Eisenman, Peter 64
Eldridge, Richard 53 n. 16
Eliot, T.S. 55
emotion, *see* expression of emotion
emotivism 9, 42
Evans, Bill 116-17
Everett, Walter 82 n. 15
explanation 81, 108-9, 126, 165-7;
 and interpretation 136-7, 147-8, 136
 and objectivity 166-7
 and ontology 81, 101, 119, 151, 166-7, 174
 conservative 11
 vs. justification 86-8, 171
expression of emotion 50-1, 55-6, 66-97
external standpoint 25-43; *see also* inversionist explanation; Nagel, Thomas

Farrell, Daniel 65 n.
Feynman, Richard 23
"firstorder" vs. "higher-order" claims 9-10
Field, Hartry H. 129 n. 9
Flower, Mitch 150 n.
Fodor, Jerry 36 n. 13, 82, 117 n.
formalism 48-51, 77-8
 vs. isolationism 51
Foucault, Michelle 39
Freud, Sigmund 11, 40, 42, 110, 136, 149, 156
Fry, Roger 15

Fuller, Tim 97 n. 34

G., Kenny 44
Galileo 153
Gauker, Christopher 97 n. 34
Gauss, Charles 15 n. 26
Geach, Peter 144 n. 24
Geertz, Clifford 159-60
Geison, Gerald 163
Giacometti, Alberto 130
Gibbard, Allan 149 n. 25, 166
Gioia, Ted 45, 54-7, 65 n.
Gombrich, Ernst 61
Gould, Glenn 116
Gracyk, Theodore 22
Graves, Michael 64
Green, Grant 47
Greenberg, Clement 12-13
Grice, H.P. 180 n. 7
Gris, Juan 175
Groshong, Rick 24 n.
Gupta, Anil 173 n. 25

Habermas, Jürgen 133, 135
Hacking, Ian 39
Haden, Charlie 53
Hagberg, Garry 62 n. 32, 180
Hall, Jim 57
Hampshire, Stuart 1
Hanslick, Eduard 21 n. 39, 66-7, 94, 96-7
Hanson, Duane 98-101, 107-9, 111, 113-14, 118-19, 123
Hartung, Bruce 65 n.
Heidegger, Martin 70, 157
Hellman, Geoffrey 58 n. 26, 65 n., 103
Hendrix, Jimi 81-2
Higgins, Billy 53
Hirsch, E.D. 155
Hockney, Donald J. 128 n. 9
Hoffman, Patrick 24 n.
Holiday, Billie 50
holism 134-5
Horwich, Paul 166
Howell, Robert 23
Hume, David 30-2, 36, 89, 101, 144

Irvin, Sherri 22-3, 108 n. 9
improvisation 177; *see also* jazz as conversation
intention, artist's 99, 107-8, 180-2
interpretation 98-120, 121-50;

Index

indeterminacy of 130–2; *see also* Quine and translation
intuitions 105–6, 112, 114, 132
inversion of the conditional 28–40
inversionist explanation 25–43
Irvin, Sherri 22–3, 108 n. 9
Isenberg, Arnold 11, 143

Jarrett, Keith 45
jazz
 and aesthetic theory 44–65
 as conversation 18–19, 57–65
Johns, Jasper 51, 141–2, 144, 149, 152
Johnson-Laird P.N. 177–8
Johnston, Mark 89 n. 23, 167–71
Jordan, Ryan 97 n. 34
Jost, Lawrence 67 n. 2, 97 n. 34

Kant, Immanuel 157
Katz, Jerrold 29–34, 39, 41, 102–6, 111, 129 n. 9, 132
Kaufman and Jonze 12
Kirk, Rahsaan Roland 50, 74, 116
Kivy, Peter 20–1, 129–30
Kline, Franz 121–5, 138, 152
Kool and the Gang 80
Krantz, Wayne 18
Kraut, Ian Matthew 97 n. 34
Kripke, Saul 28–34, 39, 41, 144, 172

Lance, Mark 65 n.
language, *see* art and language; aesthetic theory and linguistic theory
Lawson, Bill E. 49 n. 9
Led Zeppelin 21
Leger, Fernand 22, 140
Levinson, Jerrold 65 n.
Lewis, David 79 n. 14, 131–2, 139 n. 14
Lichtenstein, Roy 13
Liszt, Franz 94
Lipman and Marshall 13 n. 25
Locke, John 156
Lovibond, Sabina 16
Lycan, William 65 n., 132 n. 14, 149 n. 25, 150 n.

McCarty, David 21 n. 38, 24 n.
McDowell, John 70, 86, 88
McDuff, Jack 45, 47, 57

McGriff, Jimmy 57
McLaughlin, Brian 117 n.
Mackie, John 9
Magritte, Rene 12, 63
Malevich, Kasimir 140–1
marginalization of aesthetic theory, *see* aesthetic theory
Martino, Pat 18, 57–62, 117–18
Matisse, Henri 138
minimalism 170–1, 173; *see also* Johnston, Mark
Moisa, Cristina 43 n., 97 n. 34, 111 n.
Monaco, Tony 65 n. 36, 85, 20 n. 36, 117
Mondrian, Piet 12
Monet, Claude 139
Monk, Thelonious 74, 119
Montgomery, Wes 49, 75
Mozart, Wolfgang Amadeus 20, 93–5
Murphy, John 165
Mussorgsky, Modest 55, 66, 72, 80, 88, 152

Nagel, Thomas 10, 27–8, 35–6, 41, 106 n. 8
Nehamas, Alexander 125 n. 4
Neufeld, Jonathan 97 n. 34
Neurath, Otto 11
Newman, Barnett 15, 121–5, 127, 132, 138–9, 146, 152, 169
Newton, Isaac 153
Nirvana 22
No Exit 10, 27–8, 31, 34
No Return 11; *see also* No Exit
normativity 9, 29–30, 37–8, 41, 77, 84, 117, 166, 181 n. 10
Novick, Peter 155–7, 164

objectivity 151–76; *see also* realism
ontology 11, 17, 23, 39, 40, 68 n. 8, 77–8, 80, 82, 89;
 and explanation 119
 and interpretation 98–120, 119–20
 and objectivity 151–76
 as codification of practice 174–6
 as ground of normativity 41, 77, 119, 169–70, 175–6
 indeterminacy of 102, 111–13

Parker, Maceo 45
Pastorius, Jaco 18

Patel, Aniruddh 178
Patterson, Don 57
Peacocke, Christopher 90 n. 24
Peruts, M.F. 163
Picasso, Pablo 10, 22, 44, 55, 138, 140
Pinter, Harold 4
Plantinga, Alvin 96–7
Plato 70, 156, 157
platonism 69, 132
Plaxico, Lonnie 45
playback 25–6, 28, 32–5, 37–9, 43
pluralism, *see* Critical Monism; relativism
Podlaskowski, Adam 43 n. 20
Pollock, Jackson 56, 139, 177
possible-worlds semantics 172–5
Powers, Lawrence 172 n. 24
pragmatism 154–5, 157, 162, 164–5, 167–8, 171; *see also* Rorty, Richard
Pratt, Henry 24 n., 43 n., 65 n., 97 n. 34
process vs. product 55–6
projectivism 89–90, 145, 153
Putnam, Hilary 47, 129, 137, 160

Quine, W.V. 78;
 and analyticity 32–3
 and convention 32
 and mentalism in linguistic theory 180–1
 and normativity 37–9, 181 n. 10
 and physicalism 164
 and translation 61, 127–9, 131–2, 153
 and underdetermination 112–13

Ra, Sun 84
radical interpretation 79–80; *see also* Quine and translation
Rauschenberg, Robert 42, 51, 53
Ravel, Maurice 22
realism 136, 143–5
reduction 30, 35–8, 81–3, 165
relativism 110, 112, 123, 152
response-dependence 89–92
Ridley, Aaron 5, 75 n. 8
Ries, Christopher 99, 106, 110
Rimsky-Korsakov, Nikolai 88
Rivers, Sam 84
Rives, Bradley 91 n. 25

Roach, Max 57
Robinson, Jenefer 71, 97 n. 34
Roholt, Tiger 19–20
Rorty, Richard 70, 86 n. 21, 106 n. 8, 129 n. 9, 154–5, 157–64, 167–9
Rosenberg, Jay 37–8
Rothko, Marc 42, 53, 139
Rubinstein, Arthur 116
Russell, George 53 n. 13

Satyendra, Ramon 97 n. 34
Saunders, Pharoah 20, 46, 84
Schieber, Curtis 85
Schiffer, Stephen 180 n. 7
Schubert, Franz 71
Scofield, John 115
Scruton, Roger 7
Searle, John 129 n. 9
secondary properties 52 n. 12, 89–90; *see also* response-dependence
Seinfeld, Jerry 91
Sellars, Wilfrid 37–8, 70, 86, 137, 180–1
semantics 177–82; *see also* aesthetic theory and linguistic theory; possible-worlds semantics
Seurat, Georges 64
Severini, Gino 138
Shabel, Lisa 24 n.
Shakespeare, William 44
Shapiro, David 109, 113–14
Shapiro, Stewart 3 n. 8
Sharrock, Sonny 53
Shepp, Archie 84
Shorter, Wayne 45
Silverman, Allan 24 n.
Skinner, B.F. 156
Smith, Dr. Lonnie 85
Smith, Jimmy 44, 45, 115
Smithies, Declan 43 n.
Stecker, Robert 53 n. 16
Steinberg, Leo 141–4, 152, 155
Stitt, Sonny 53
Stone, Sly 45
Stravinsky, Igor 21, 42, 55, 67, 71–81, 83, 88–9, 91–2, 94, 97
Sullivan, Louis 22
supervenience 81–4
Swindler, James 65 n.

Tarski, Alfred 4, 58–9, 179
Taylor, Cecil 84–5, 152

Index

Tchaikovsky, Pyotr Illyich 94
Tennant, Neil 24 n., 27 n. 2, 43 n.
Thales 156
theistic commitment 34, 42–3, 58 n. 26, 80, 96–7, 105, 167–8
Tolstoy, Leo 56
Tower of Power 76
translation 110, 117–18, 140–1; see also Quine and translation; art and language
Trivedi, Saam 19
Tsamous, Louis 65 n.

Ulmer, James Blood 53

Vachon-Kraut, Robin 24 n.
Vivaldi, Antonio 66
Von Neumann 104

Wagner, Richard 20, 93, 94
Walton, Kendall 24 n., 61 n. 28, 65 n., 130
Warhol, Andy 40, 51, 53
Whistler, James 99
Williams, Martin 58
Wilson, Mark 94–5
Wittgenstein, Ludwig 62, 70, 144, 157
Wolterstorff, Nicholas 1
Wooten, Victor 18
Wordsworth, William 22

Yanni 76

ZZ Top 88
Zangwill, Nick 67
Zermelo, Ernst 27, 104
Zemach, Eddy 65 n.